THE LITERATURE OF PHOTOGRAPHY

THE LITERATURE OF PHOTOGRAPHY

Advisory Editors:

PETER C. BUNNELL
PRINCETON UNIVERSITY

ROBERT A. SOBIESZEK
INTERNATIONAL MUSEUM OF PHOTOGRAPHY
AT GEORGE EASTMAN HOUSE

A MANUAL

OF

ARTISTIC COLOURING,

AS APPLIED TO

PHOTOGRAPHS

By ALFRED H. WALL

ARNO PRESS

A NEW YORK TIMES COMPANY

NEW YORK ★ 1973

Reprint Edition 1973 by Arno Press Inc.

Reprinted from a copy in
 The George Eastman House Library

The Literature of Photography
ISBN for complete set: 0-405-04889-0
See last pages of this volume for titles.

Manufactured in the United States of America

———◆———

Library of Congress Cataloging in Publication Data

Wall, Alfred H
 A manual of artistic colouring.

 (The Literature of photography)
 Reprint of the 1861 ed.
 1. Photographs--Coloring. 2. Photography--
Portraits. I. Title. II. Series.
TR485.W28 1973 770'.284 72-9244
ISBN 0-405-04948-X

A MANUAL

OF

ARTISTIC COLOURING.

A MANUAL

OF

ARTISTIC COLOURING,

AS APPLIED TO

PHOTOGRAPHS:

A Practical Guide to Artists and Photographers.

CONTAINING

CLEAR, SIMPLE, AND COMPLETE INSTRUCTIONS FOR COLOURING
PHOTOGRAPHS ON GLASS, PAPER, IVORY, AND CANVAS, WITH
CRAYON, POWDER, OIL, OR WATER COLOURS;

WITH CHAPTERS ON THE PROPER LIGHTING, POSING, AND ARTISTIC
TREATMENT GENERALLY OF PHOTOGRAPHIC PORTRAITS;
AND ON COLOURING PHOTOGRAPHIC LANDSCAPES.

By ALFRED H. WALL.

———

LONDON:

THOMAS PIPER, PHOTOGRAPHIC NEWS OFFICE,
32, PATERNOSTER ROW.

———

1861.

" The fact is, we none of us sufficiently appreciate the nobleness and sacredness of colour. Nothing is more common than to hear it spoken of as a subordinate beauty; nay, even as a mere source of sensual pleasure: but such expressions are used for the most part in thoughtlessness, and if the speakers would only take pains to imagine what the world and their own existence would become if the blue were taken from the sky, the gold from the sunshine, the crimson from the blood (which is the life of man), the flush from the cheek, the darkness from the eye, the radiance from the hair ; if they could see, for an instant, WHITE human creatures moving in a WHITE world, they would soon feel what they owe to colour. The fact is, that of all God's gifts to the sight of man, colour is the holiest, the most divine, the most solemn."—RUSKIN.

PREFACE.

How many persons, earnestly desiring to gratify their passionate love of Painting, and produce Pictures for their own delight and amusement, are compelled to lay down the brush with a reluctant sigh, because, ignorant of drawing, and without the necessary leisure for the laborious drudgery of the beginner, they cannot hope to produce works worthy of their own ambition, or their friends' respect! For such this little Work has been written and published.

I have written for the Photographer, also, by whom the Professional Colourist is employed, to show him what constitutes real artistic excellence in this new branch of Art, that he may so raise the standard of its productions.

I have written, too, for those desirous of adopting Photographic Colouring as a Profession, that, while instructing with my best ability, I may also honestly show how they may rashly waste time and energies if they do not consider the difficulties in their way, and the time and study which must be expended, ere

they can attain sufficient ability to earn a decent livelihood by its practice.

Portions of the substance of these lessons have already appeared in a photographic journal. The haste with which, however, the contributions to a periodical are necessarily prepared, precludes the complete arrangement desirable in a book of progressive instructions. I have, therefore, in rewriting and extending the lessons availed myself of the opportunity of adding such hints as have been suggested by correspondence with pupils during the periodical appearance of the lessons. I may here, perhaps, be permitted to thank many such correspondents for their flattering assurances of benefit received from these instructions in their cruder form.

My own successful career as a Photographic Colourist and a Teacher of the Art, my previous practice as a Portrait and Miniature Painter, and the long experience and familiarity of daily practice, will, I hope, tend to render this little work useful to the professional student, the amateur painter, and the photographic colourist.

A. H. W.

35, WESTBOURNE GROVE, BAYSWATER,
September 20, 1861.

CONTENTS.

———◆———

Manual of Artistic Colouring.

CHAPTER I.

INTRODUCTION.

In publishing these instructions I have endeavoured to combine the principles of harmonious colouring with the more mechanical rules, believing that the theory and practice of any art should always travel hand in hand. I have tried to avoid being too technical, and have not been afraid to enter into descriptions and explanations of such simple matters as are generally left unexplained by writers who, while endeavouring to teach the elements of colouring to those who desire to learn, yet address their readers as if they had mastered all the theories and technicalities of the art, and only required a little of that knowledge which they themselves had gleaned from their own absolute practice.

Such practitioners of our elegant arts as have never before thought much on the subject of photographic colouring will, perhaps, be surprised to find the amount of artistic culture and knowledge essential to its higher order of excellence; and may be induced to look upon this pursuit with more interest and respect, even if they

B

do not direct their own efforts into the same channel.
Many amateurs, who vainly endeavour—with their
limited opportunities—to grasp the power of represent-
ing both form and colour, would do well to take up
earnestly the study of the latter, leaving the former to
the unerring fidelity of the camera, as used either by
themselves or by some *artistic* photographer. The
world of colour is full of loveliness and poetry, and
opens a wide field to the ambitious artist; while there
is nothing more illegitimate in painting upon a good
photograph, than there was in the practice of Leonardo
da Vinci, Rubens, Titian, Raphael, Guido, Fra Botelemo,
and numerous other eminent masters, who painted upon
the abozzo, or sketch in dead colour, which, to all intents
and purposes, was neither more nor less than a warm-
toned photograph.*

Unfortunately, photographic colouring has, to sadly
too great an extent, fallen into the hands of a class
of mechanical daubers, employed because they work
cheaply, and yclept "*print colourers;*" whose gaudy
inartistic colouring, and crude, raw and hard style have
brought the art into no little disrepute; by which,
also, it has been sometimes most unfairly judged. The
technical phrase for such "colourists" (?) is "paper-
stainers." They are the greatest enemies both to pho-

* A fact vouched for by Sir Joshua Reynolds, Merimee, Field,
Sheldrake, and many other high authorities; by the discovery of
unfinished pictures executed by the old masters and their pupils;
and by the examination of injured pictures of lofty repute.

tography and photographic colouring; for of this I am sure, directly any art becomes degraded in public estimation, it speedily sinks even below the level assigned it.

Coloured photographs occupy an undeservedly questionable situation: the artist curls his lip at them, because, as *he* says, they are not paintings; and the photographer sneers at them, because, as *he* says, they are not photographs. They are peremptorily denied admittance to galleries of paintings, and it is continuously and frequently urged that they should not be admitted to photographic exhibitions. Why, then, is this poor art to be an outcast among its brethren, unacknowledged and denounced by both artists and photographers?

The photographer admits the beauty of colour in a painting, and admires it as warmly as need be. The artist admits the truthfulness of the photograph, and admires its wondrous delicacy of detail, faithfulness of drawing, and perfection of chiaroscuro just as warmly. Why, then, should an art which combines the truth of the one with the loveliness of the other be thus unsparingly denounced by these two important classes?*

Unity is strength, and the beautiful can have no

* Copy a photograph by any one of the simple and purely mechanical means of pouncing, tracing, &c., and then paint it, and it will be said to be a work of art, and unhesitatingly accepted at the public galleries; while the mere omission of such a mechanical process renders it that pariah in the world of art—"only a coloured photograph."

better mate than the truthful. Let the scientific man of the camera, and the tasteful son of the palette, throw aside all their childish jealousies, and combine their efforts for the production of works valuable both for fidelity to nature and for artistic merit. The best interests of photography are served by advocating its union with art, in demanding for it a much higher standard of worth than it can ever claim as a simple mechanical acquirement, calling for no greater intellectual effort than that implied by carefulness and manipulatory skill; to which condition there are those who now labour, mischievously or ignorantly, to reduce it.

To those who are desirous of adopting photographic colouring as a profession, I would urge the following considerations :—

1st. The market is full of inferior colourists, who jostle and elbow each other at every turn ; and these are working at such absurdly low prices, that a decent livelihood is, for such, almost out of the question.

2nd. Beware of a class of advertising quacks, who pretend to teach the art perfectly in four or six lessons. Several young persons of either sex, anxious to secure a genteel if humble livelihood, have, to my personal knowledge, been induced by such deceptive advertisements to expend their little all in procuring materials and lessons, and in supporting themselves while studying, only to find at the expiration of the lessons, that, while quite unable to earn a shilling by the information

thus acquired, and without means of support, they were placed at the mercy of their friends and acquaintances, or of the cold hard world. These contemptible quacks may, or may not, contemplate such serious consequences; but I speak feelingly, knowing how, in one case, a most respectable young lady was thus victimized, and plunged into the most terrible dangers and difficulties.

3rd. When practising the art professionally, avoid an error which has induced some of my professional acquaintances to tease me with remonstrances and croakings of a very illiberal and ungenerous nature, during the progress of this work. Such information and instructions as mine do not tend to decrease the value of a profession by increasing the number of its professors; but, by improving the judgment and elevating the standard of excellence among photographers, really serves the profession, by driving from the field the inferior colourists, now so extensively employed, and increasing the demand for real artistic excellence. The most talented colourist will labour in vain, if his patrons are not qualified to appreciate his powers.

To show both photographers and colourists the advantages of earnest study, and the acquirement of real excellence; to instruct so that the humblest may acquire a power proportionate to his or her ability and perseverance, and to raise my art in the estimation of as large a circle of readers as I may have the good fortune to command, constitute my chief aim in writing these pages.

CHAPTER II.

THE PHOTOGRAPH.

IF you were about to paint a portrait, your chief care would be the drawing. You would, in the first place, desire a perfect resemblance to the natural model; but you would also, if governed by good taste, desire that such resemblance should be secured under the most favourable circumstances possible.

Such being the case, I presume it is no less important, regarding the photograph as our drawing, that it should be perfect in resemblance, and pleasing in its general effect. A good photograph being the chief condition of success, I shall commence my instructions by pointing out the utility of a little art knowledge in the operator who produces the picture (or " abozzo "), upon which you are about to paint, and show how such may best be attained.

Photography should stand as high in the domain of art as it does in that of science; and its professors should consider the principles and theories of great painters as legitimate a branch of their study as optics or chemistry. All who understand the philosophy of the new art of sun-drawing know the difficulties which beset the operator in combating its present imperfections; for instance, the effect of form and relief

is dependent upon the correct representation of light and shade, for, in photography as in nature, there are no actual outlines. Now, in photography, the effect of light and shade is at the mercy, first, of the collodion; secondly, of the bath; thirdly, of the exposure to light; and, fourthly, of the developer. But if the artistic knowledge of the operator, combining with his chemical and manipulatory skill and experience, brings his plate out safe and sound from all these tests, even then, an inartistic printer (if it be a negative) may render all his skill, labour, and experience nearly null and void.

Moreover, there are the dangers arising from the imperfect nature of the optical arrangements, such as the distortion of advancing and receding objects,* which, although generally patent even to the most ordinary observer, are frequently only to be detected by the pictorially educated eye; and—

"The visual eye asks guidance from within,
And as that cometh is its power increased."

Again, there is the chemical action of colours in connection with light and shade, as also affecting the artistic arrangement of chiaroscuro; but, not to pursue the subject too far, I may just add, that it is to the artistic photographer that you must look for the first element of success in photographic colouring. If the operator who takes your picture overlooks upon the ground-glass of his camera remediable errors, they are perpetuated in

* Of course I am now speaking of portraiture.

his photograph, to the injury both of your painting and his art. If he don't recognize artistic effects when he sees them, how can he produce artistic effects for your picture ?

A bad photograph can never be made a good-coloured picture, although, as will be seen, the skilful colourist may do much for its improvement.

Photographic portraiture, in its higher order of success, is no mere mechanical process, dependent only upon chemical knowledge and careful manipulation. It involves the judicious application of those rules of art which govern light and shade, composition and expression.

As the colourist can never make a bad photograph into a *really* good painting, I cannot perhaps do better than commence my work with some brief remarks upon a few points, the consideration of which are essential to the production of such a specimen as is best fitted for the purpose of colouring.

On Lighting the Sitter.—The most important element of the picturesque will be found in the skilful management of light and shade, or what the artist terms *chiaroscuro*. The portrait may stand out bold and round, with all the brilliancy and vigour associated with relief ; or it may present the tame, monotonously flat and adhesive character of a very weak and unattractive specimen, according to the attention, or want of attention, received by this most important matter.

The light should not fall upon the sitter at an angle

of less than 45°: the source from which it emanates must not be too near the sitter, or the shadows will be too intense : and, for the same reason, the light should not be too strong. That portion of the face which is in shadow may be delicately relieved with reflected light, derived from white screens, mirrors, or a surface covered with tin foil.

In lighting a sitter, the photographer has to consider not only the general rules of artistic effect, but those connected with the peculiarities of chemical action. For this reason the lights and shadows must not be too violently contrasted. Subdued lights and weakened shadows will produce in your photograph the most satisfactory results ; inasmuch as although the lights and shadows want vigour and contrast as we see them on the ground-glass of the camera, yet, owing to the tendency of our process to exaggerate the relative intensity of both lights and shades, they display no lack of force in the resulting photograph. But thence comes a difficulty. Weak lights, as a rule, give strong shadows. To conquer this enemy, then, we use the mirror, the surface of tin foil, or the white screen, according to the depth of the shadows you desire to weaken. If you use the mirror, or the white screen, be careful that you do not get the reflected light directly upon the eye of your sitter, for this will give the appearance of a cataract therein, and serve to destroy expression.

We will now turn to the consideration of the pose,

or position of the sitter, with reference to securing a graceful or characteristic effect.

On Posing the Sitter.—A beautiful or elegant woman loses more than half her charms when depicted in a vulgar and ungraceful position ; and a man may appear a gentleman or a clown according to the attitude in which he is represented. The pose should be easy and unaffected, neither vulgar nor theatrical ; and should make the best of your sitter's figure. It should be chosen also with due attention to the character, age, and most striking or important points of resemblance. Remember that it is both desirable and possible to make the most of your subject ; to select the best point of view, and the most pleasing expression. If your sitter be tall and thin, or short and stout, select a pose which may render such peculiarities least prominent ; and, above all, avoid angularity, formality, and stiffness. A sitter's personal defects may be frequently concealed by the choice of position. If your subject possesses a fine figure, an erect pose will best display its qualities ; if a bad one, a good capacious chair, which will conceal the outlines well,* is best, provided the sitter do not allow him or herself to collapse into a bundle within it. Let the pose be such as will secure the greater variety of gliding undulating lines.

The body and the head should not be in exactly the same position, except when the person is very old, and

* I mean a chair which will photograph as dark or as light as the drapery of the figure.

the action might indicate a vigour or facility of motion inconsistent with propriety of character. Do not get the figure or head so exactly into the middle of the plate as to suggest compasses before anything else to a spectator's mind; but have a little more space before than behind, and above than below, without going to the extreme in either. Let one shoulder also be a little lower than the other.

A straight angular female figure may be improved by introducing loose and flowing drapery.

In studying artistic posing, the artist cannot well go wrong if he understands the full extent of meaning implied by the terms *beauty*, *symmetry*, and *proportion*. Without attempting to enter fully into the following subjects, I may here, perhaps, be permitted to give a few hints connected with such necessary qualities of the picturesque.

The most pleasant charm a portrait can possess is—

Simplicity.—A crowd of ideas attacking the mind at once, sadly weakens the effect of the whole. For this reason we instinctively appreciate such simple objects as the eye can take in at one view. Thus a circle or oval is more pleasing than a square, the attention being less divided by the angles and abrupt changes of the lines; and, for the same reason, the square is more attractive than the hexagon or octagon. But this idea must not degenerate into a want of *contrast*, which would produce monotony and sameness.

Variety is a very valuable quality; nothing sooner

fatiguing both the eye and mind than any one thing incessantly repeated. By variety we succeed in retaining the spectator's attention longer than we otherwise should, while by simplicity we attract it. The two may be harmoniously united by symmetry.

Symmetry unites and blends into one harmonious whole, by repeating or balancing the parts, each being echoed as it were by another, although all are in their proper degree of subordination to the chief or principal. Symmetry need not be formal, as the one part which echoes or balances another should not be of exactly the same size, form, or tone. Symmetry, in short, is " the balance of harmonious opposites." In seeking symmetry, pray avoid degenerating into the formal stiffness, in which we sometimes see a pillar and curtain on one side balanced by the same on the other, and the sitter in the middle equi-distant from the two.

Contrast.—Ruskin says, " Rest can only be enjoyed after labour ; sound, to be heard clearly, must rise out of silence ; light is exhibited by darkness, darkness by light, and so on in all things. Thus in composition a curved line contrasts a straight one ; heaviness, lightness ; light, dark ; &c. Contrast, however, must not be violent, nor should its aim be too apparent ; the effect, rather than the means which secure it, being first seen and felt.

> ' A prudent chief not always must display
> His powers in equal ranks and fair array.' "

The above hints apply not only to the arrangement of lines in posing the figure, but of course to those given

also by accessories, and to the masses of light and dark in your production.

We will now bestow a small share of attention upon the management and arrangement of—

Chiaroscuro.—In arranging your light and placing your sitter, you should so contrive that all the prominent features are well lighted: the half tints and shadows will then find their places upon the retiring surfaces, and due relief be obtained. The strongest light should fall upon the upper portion of your model; when, as Fresnoy says,—

> "—— from the light receding, or the eye,
> The sinking outlines take a fainter dye;
> Lost and confused progressively they fade,
> Not fall precipitate from light to shade."

How many photographic portraits do we find in which an ill-lighted face and figure destroy the pleasing effect, which the photographer's chemical and optical experience, and careful manipulation, really deserved to compass. All our great artists advocate the vital importance of a proper distribution of light and shade; and the principles of chiaroscuro are of no less consequence to camera pictures than to those of the brush and pencil.

I have a practical acquaintance with the difficulties to be met with in the chemical action of colours, &c., but studious forethought will go far to meet them; and I am confident that sun pictures can be obtained with *all* the advantages now claimed exclusively for the painter's

productions—not easily, I grant you, nor perhaps for the remuneration now given; but as photographs assume higher rank, and take their place in the domain of art, they will readily obtain their fair value. ' Pictorial effect is dependent principally upon a quality termed " *breadth*," by which is meant a simple grandeur and beauty of appearance, obtained by grouping together in separate masses the light and dark portions (whether formed by light and shadow, or light and dark objects), and, without sacrificing the necessary relief of important parts, avoiding everything like spottiness or obscureness of effect.

One principal light and one principal shadow are preserved to give intensity and brilliancy to the whole. I cannot pause to develop the philosophy of this plan; but practice will fully demonstrate its value. Correggio, Fredrico, Barroccio, Guercino, and the Carracci, used to model figures for their paintings, in order that they might so arrange and illuminate them, as to obtain the best effect: why cannot photographers do this with their living models?

The forms and shapes of lights and shadows should be, as a whole, graceful; beautiful outlines should be relieved with light, unpleasant ones lost in shadow; half tints and shades should be skilfully grouped and blended, and the reflected lights carefully observed; for to these we owe that transparency and variation of shadow which, successfully imitated by art, forms one of the most conspicuous charms of our best pictures, but

which are too frequently represented in bad photographs by strikingly unnatural patches of opaque black. The power of reflecting light of varying intensity is, in the hands of skilful professors, of the very greatest utility.

A very capital contrivance for preserving breadth and obtaining relief is found in the use of graduated backgrounds. Numerous plans have been suggested of a very complicated, troublesome, and imperfect nature, for obtaining these backgrounds. My homely, *but perfectly successful*, plan is easily described.

Having painted the background skreen a warm grey, in "flatting" colour,* I paint in or near the centre a circular patch of a very much lighter tint, and with the end of a large brush, held at a right angle to the surface, I tap or stipple the lighter into the darker tint, until the one mingles imperceptibly with the other, and my graduated background is complete.

According as you place this behind the sitter, it may either relieve the shadowed, or spread the light upon the illuminated portion of the head and figure.

The importance of considering the colours in their relation to actinic influence, as affecting this question of chiaroscuro, must be duly considered. Suppose, for instance, a lady wearing a dark-green or black dress is seated upon a crimson-velvet chair, by a table covered with a red cloth, and before a dark background, in the usual subdued light. On the ground-glass all may appear right—the darks merging softly into the lights,

* Colour containing more turpentine than oil.

and *vice versá*—but in your photograph what will be the result? Why, there will be three white isolated spots, formed by the hands and the ghastly white face, staring out from a dense black mass which has swallowed up all the details of the dress, figure, chair, table, and background. To avoid anything so ugly, you use a lighter background, which grows darker as it retires from the focus of light in the face ; a chair which relieves the figure without contrasting its depth of tone too violently, and, permitting a stronger light to fall upon the illuminated portion of the drapery, you put the table in deeper shadow to give it force, and thus have some chance of securing, in the finished picture, at least some approach towards the grandly simple quality of breadth, with which you have also the force, round-ness, and brilliancy of tone arising from a proper amount of contrast and relief.

Having duly studied the lighting and posing of your sitter, and the importance of chiaroscuro in connection with artistic results, the aim must now be to secure that crowning charm of all, a good—

Expression.—Some of our greatest painters have demanded for one portrait as many as fifty sittings, not of course for general outlines or mere mani-pulatory details ; but for the embodiment of an ex-pression which should most forcibly depict the very soul as it were of their model. The accomplish-ment of this lofty aim is commonly held to be the great point of superiority which the painter claims

over the photographer ; but why ? The painter must
see the expression before he can catch it ; and, if you
secure for your camera that same expression, in less
time than the draughtsman needs to impress it upon his
memory or transfer it to his canvas, the art which can
depict a cannon ball in motion will seize and render it
permanently visible. Those photographers who are not
satisfied with " a mere map of the face " (as one of our
old painters used to call an expressionless portrait), may
and do frequently secure expressions as beautiful, and
far more truthfully characteristic, than any I have seen
in drawings or paintings. The great point is, either by
the art of your conversation, or some similar means, to
call into your sitter's face such an expression as may be
most pleasing in the picture.

Now this is not done by solemnly impressing his or
her mind with a nervous fear of moving—better spoil
a dozen plates than do this ; but by endeavouring to
make your sitter feel perfectly at home and unrestrained
by your presence. Nothing is more common than
photographic portraits of uncomfortable looking ladies
and gentlemen, upon whose faces we read at once a
feeling of nervous apprehension, as if they were waiting
the extraction of a tooth.

But these are not more objectionable than grinning
likenesses. Should the sitter desire to smile while
sitting, the smile should be a faint one ; for, however
beautiful it may be flitting like passing sunlight over
the face, when it is seen fixed and unchangeable, it too

frequently conveys the idea of a mere grin, or piece of affectation.

If the light received by the head be too vertical, the eyes of your model become lost in the dense shadows cast by the brows, a black patch, too opaque and hard to deserve the name of shadow, falls under the nose, and the corners of the mouth are lost in deep masses of shade descending at an angle towards the jaw, and thus your portrait has a scowling or lugubrious expression, well calculated to offend and disgust even the most amiable of sitters. This therefore must be avoided.

A very miserable expression will be obtained by placing the sitter in too strong a light, or by directing his eyes towards an object too brilliantly illuminated. That portion of your room into which you direct your model's eyes while photographing, therefore, should, undoubtedly, be dark; as you then not only render the act of sitting much less unpleasant, but improve the appearance of the eye itself by the consequent enlargement of the pupil.

The expression of the face should be carried out in the pose. Keeping or harmony is violated when, while the features express one feeling, the position of the body only serves to weaken or destroy it. To quote from a little work of my own,*—" The eyes and mouth may express vigorously active and lively thought; but if the poor tame pose be one which has no agreement with such expression, the whole effect will be lost."

* The "Technology of Art," published in the PHOTOGRAPHIC NEWS.

CHAPTER III.

ON COLOUR IN ITS OPTICAL RELATIONS.

IF any ought to excel in colour it is surely the photo-graphic painter. This bounds all his aims; towards this *one* end are all his energies, studies, and exertions directed. He " ought to love colour, and think nothing beautiful or perfect without it," for colour is the poetry of art; form, only the language in which it is written.

Ruskin advises the art-student to " give up all form rather than the slightest part of colour: just as, if you felt yourself in danger of a false note, you would give up the word and sing a meaningless sound, if you felt that so you could save the note." Opie says, " Colour is the sunshine of art, that clothes poverty in smiles, and renders the prospect of barrenness itself agreeable, while it brightens the interest and doubles the charm of beauty:" and the great Addison, dwelling on the several kinds of beauty and giving the palm to that of colours, exclaims, " What a rough unsightly sketch of nature should we be entertained with, did all her colouring disappear."

We commonly hear the expression, " a good eye for colour:" as if the power of appreciating or harmonizing colours was dependent upon no rules or *principles*, and the whole affair was a mere matter of taste.

Without attempting to ignore the fact that a disease

called colour blindness exists, or that in different degrees
it may be more common than is generally imagined, I
still think the "good eye for colour" simply means an
eye improved in its perceptive powers by the consciously
or unconsciously educated judgment. That, in short,
the "good eye" means directly, or indirectly, a mental
operation.

Laws regulating the harmony and contrast of colours
were developed by the celebrated M. Chevreul, professor
of chemistry and director of the famous dye-works of
the Gobelins, Beauvais, and La Savonnerie, in a series of
lectures, which were printed and distributed gratuitously
to cultivate the taste of the workmen. Previous to the
publication of such information in this country, the
dogmas and arbitrary assumptions put forth in one
work and another were so contradictory and confusing,
that the national taste, as displayed in the arrangement
of colours, was naturally enough wofully the sufferer, a
fact which, in the year of the great Exhibition, became
patent to the world.

Before sitting down to our brushes and pigments (or
material colours) then let us give some attention to the
abstract qualities of colour; and glance at its nature,
phenomena, &c.; so that you may exercise and strengthen
your own judgment, instead of blindly relying upon me,
or any other unknown guide, and hit at once upon the
right path, without wasting your precious time and
labour in blundering about for it in the dark.

Colour, we say, exists in the light and not in the

objects illuminated. Such colours, as you know, are only visible when light is decomposed; this you may prove thus:—Make the room dark, and admit through some such aperture as the hole in a shutter, a single beam of sunlight, which is white. Then, to decompose this beam, take a triangular glass prism, and let the light pass into your room through its sides, and fall upon a piece of white paper; when instead of a band of white light, you will see little groups of beautifully blended and brilliantly coloured lines. These lines form what is called the solar spectrum. Now place a lens between the prism and the white paper, and the lines or rays of colour will so combine in passing through it, that the light on the paper is once more white.

These colours of the spectrum have, for convenience, been divided into seven rays, or rather groups of rays, called red, orange, yellow, green, blue, violet and purple; but, strictly, all the varied tints, lines, and shades of colour observable in nature may be traced to *three* colours,* viz., red, yellow and blue; the green, violet, orange and purple of the spectrum being simply combinations; the green of yellow and blue, the orange of red and yellow, and the two others of blue and red. The last colours being due to the overlapping of one transparent colour on another; for instance, the yellow rays seen through the blue appear green.

* Of these colours, actinism, or chemical action, is said to reside in the blue, which is least luminous; heat in the red; and light in the yellow, which is most luminous.

We have nothing to do with the theory of vibrations,* to which the homogeneous character of white light is attributed ; and, in reference to the matter more immediately in hand, it may suffice to add, that when a substance is white, it is so because all the light is *reflected* from its surface ; when black, because very nearly all the light is *absorbed ;* when green, because the blue and yellow rays only are reflected, and so on : the colour of every object being given by the blending of such rays as are reflected from the surface, after the absorption, or partial absorption, of others. In tropical climates, where the light is most intense, there too are colours most intense ; and at a certain depth in water, to which light can barely penetrate, objects are nearly colourless.

So much then for the *origin* of colour.

The three colours described as pure ; viz., red, green, and yellow, are termed the *primary* colours ; because from these all other combinations are derived. By mixing these primaries we obtain three other colours ; viz., green, orange, and violet or purple, which constitute the *secondary* colours : and by again mixing these in pairs, as before, we produce citrine, russet, and olive,

* Some philosophers attempt to illustrate this theory of vibration thus :—As the Æolian harp, when swept by the invisible fingers of passing currents of air, gives out its wild melodious notes—now raised to the highest pitch, now sighing in sweet low tones, according to the vibrations imparted to its strings—so the different vibrations of light impart the various sensations of colours to the eye. The theory is a beautiful one, and to the painter very suggestive.

the third or *tertiary* colours. These are called the three orders of colours.

We have next to consider the subject of *complementary* colours.

If we place a red wafer upon a white surface, and fix the eye steadily on it, upon afterwards looking at the white paper only, a faint green image of the same size and shape as the red wafer will be very distinctly visible. Should we, on the contrary, look intently at a green wafer, the ocular spectrum, as the unreal image is called, would be red; and if at a yellow, it would be purple.

For this reason green is called the accidental colour of red, red of green, and blue of orange; or *vice versâ.**

As in acoustics, the term harmonic is applied to that weaker and fainter sound which accompanies the fundamental sound; the same term has been applied to these accidental colours, as accompanying, in a similar way, the primitive colours.

Another consideration now claims notice. If we place two coloured wafers together, each gives to the other its accidental or harmonic colour. For instance, green and red when placed together derive fresh intensity and brilliancy from the relationship; because, while green gives its accidental red to the original red, the latter improves the other with its accidental green. For this reason red

* The pupil will perceive by this that the mixture of two primary colours in due proportions produces that hue which is complementary to the remaining colour.

is called the *complementary* colour of green, and green of red.

The importance of this may be demonstrated thus: Suppose I put a green wafer beside a blue one, the first will destroy the purity of the last, by putting over it a tinge of red, and the last will give a tinge of orange to the green, making it dingy and yellow,—blue not being *complementary* to green, nor green to blue.* The practical application of these rules will however follow in the next chapter, my present purpose being to demonstrate their existence only.

I may here perhaps remind you that, if we blend the three primary colours of the spectrum, we produce *white* light; but if we mix the purest red, blue, and yellow colours we have, in the form of pigments, they merely produce *black or dark grey*. We thus see how inferior the colours of the painter's palette are to those of nature. To give increased brilliancy to these poor pigments, then, and so come nearer the glorious colouring of nature, we cannot afford to neglect such power as is given us by the judicious juxtaposition of contrasting, or harmonic, or accidental, or complementary colours.

The value of this principle may be further illustrated in the following scale. If you place, say—

* " A few years ago," says M. Chevreul, " the director of one of the first manufactories of Paris, wishing to print grey patterns upon grounds of apple-green and of rose, refused to believe that his colour-preparer had given any grey to the printer, because the designs printed on these grounds appeared coloured with the complementary colours of the ground."

Red against Blue,	{	The Red receives a	Yellowish Green.
	{	The Blue „	Bluish Green.
Yellow „ Orange,	{	The Yellow „	Blue.
	{	The Orange „	Purple.
Blue „ Green,	{	The Green „	Orange.
	{	The Blue „	Red.
Blue „ Purple,	{	The Blue „	Yellow.
	{	The Purple „	Orange.
Orange „ Green,	{	The Orange „	Red.
	{	The Green „	Blue.
Green „ Blue,	{	The Green „	Orange.
	{	The Blue „	Red.

In speaking of contrasts we must also remember, that there are various kinds of contrast; viz., the *Simultaneous*, which was described in the illustration of the red and green wafers; the *Successive*, which was described in the experiment with blue and green wafers; and the *Mixed*, which arises when the real colour of one object blends with the complementary colour of another.

" Our wives go out a shopping," says a recent writer, " they ask to look at a red merino; the shopman displays a dozen pieces in succession, all dyed in the same vat, perfectly identical in colour; yet the ladies insist that the last five or six pieces are not so good as the rest. How is this? The answer is simple,—their eyes no longer see the colours as they really are; the phenomena of successive and mixed contrasts are at work; the prolonged sight of red excites the eye to call up its complementary, green (the operation of successive contrast), which being added to the red,

tarnishes it, and the longer the eye looks at the red the duller will it inevitably appear."

Another element of contrast is found in that of *tone* or intensity. Just as green gives red, or red green, so does white give black, and black white.

If you place in juxtaposition strips of black and white paper, you will find that where the white touches the black, it appears the lightest or brightest; and that where the black joins the white, seems the darkest, or most intense. Now, when we consider how vast is the natural range of tones which connect the extreme brilliancy of sunlight with the depth and intensity of perfect darkness, it will be evident that to force the effect of black and white pigments by contrast is a very important matter.

This principle regulates our effects in all contrasts of tone or intensity, light colours appearing lighter, or losing intensity when contrasted with dark, and dark colours gaining depth and appearing darker when contrasted with light, and it is thus that this optical peculiarity enables the painter to enhance or degrade the value of his pigments,—to throw light into gloomy passages, or reduce the brilliancy of the luminous,—and gives him also that variety of tone upon which so much of his power depends.

CHAPTER IV.

HARMONIOUS COLOURING.

WE have seen how colour, as displayed in the prismatic spectrum, affects the sense of vision. From the rules and principles founded upon such discoveries, and from those developed by the wisdom and experience of the most eminent masters, we derive the power of colouring harmoniously.

I have before referred to the analogy between harmony of sounds and harmonies of colours. In music we have certain whole notes, and these play exactly the same part that the primary colours do in painting; such sounds developing more fully each other's beauties by contrast, just as the prismatic colours do. Now the proper combination of such sounds produce what is called *harmony*, as of course you know, and, just so, does the proper combination of such colours produce exactly the same thing.*

George Field tells us that—"In the choice, admiration, and display of colours, we find crude, natural, and uncultivated tastes, delighting in and employing entire and primary colours, and harsh, unbroken, or whole notes in their music; but as taste and sober

* An instrument was once announced in which each note represented a colour, tint, hue, or shade, which could be played upon with the fingers, for the purposes of composition in painting.

judgment advance, sense becomes more conciliated by broken colours, and half tones, till, in the end, they refine into the more broken and enharmonic." In further illustration of this, I may add, what Henry Warren, in his little work on colour, says,—" In the upper district of the Nile, among the Nubians of Ethiopia, above the second cataract, the inhabitants vary in colour—in shades of colour—although all are considered by us, as 'black men.' * * * Were one of these people, in the un-European simplicity of their habits and thoughts, be asked to define or specify the three grades, he would say of the first, whom we have described as the blackest—that he was 'a *blue* man,' of the second, that he was 'a *red* man,' but mark ! now comes the point, the third he would describe as 'a *green* man,' simply because being neither a blue man nor a red man, he has no other colour left of his category: he knows he is not 'a yellow man,' for by such he would mean a Northern or European, whom we should call without being nearer the truth, 'a *white* man.'"

Here it will be observed, blue is associated instinctively with darkness, and yellow with light.

Some have carried the analogy between music and painting yet farther, by comparing the seven notes with the seven colours; and the three primary sounds with the three primary colours; enthusiasts have also endeavoured to deduce from the spectrum the exact proportions which constitute the various colours essential to harmony, forgetting that the quality and relative degrees of

intensity of such colours must be influenced by the character of the prism used in decomposing the light. In short, numerous fanciful theories have been put forth on the relationship of colours; but they are of very small service to the artistic colourist, and are not practical enough to be worth our present notice.

To produce harmony of colouring we must remember that such arises from the skilful combination of opposite qualities. Contrast we must have, because our pigments are so inferior to the colours of nature, and, because it is thus only that we obtain either the luminous character of those allied to light, or the additional brilliancy and purity given by the accidental or complementary colours.

We have, as I remarked in the last chapter, to represent all the myriad hues and brilliant colours of nature with pigments, which are so far removed from the purity of the prismatic colours, that while *their* combination produces the luminous white of solar light, ours ends miserably in a dingy grey, nearly allied to its opposite extreme—*black*.*

What the colour-maker has failed to do for you, then your own brains, working out the laws of nature in art, must effect for yourself. The great painters show us how, even with these few miserable colours, great things may be accomplished. " Go thou and do likewise,"

* Compare carmine, the purest red we have, and ultramarine, the purest blue, with these colours in the spectrum, and the one will look like brick-dust and the other like ink.

remembering that if we cannot get colour pure from nature's own palette, and apply it to our canvas or paper, still with every red the colour-maker gives us, nature supplies us with a green, and with every green a red, &c.

Contrast being therefore of vital importance to the colourist, he has to consider how this quality may be secured without the crude, harsh, effect, which Fielding describes as characteristic of "natural and uncultivated taste, delighting in and employing entire or primary colours,"—how to obtain vigour without hardness, and unity without monotony. In music, when the roar of harmonious thunder swells forth in the crash of brazen instruments, and is followed by the whispered softness of some sweetly tender breathings of distant music, no ear is offended, and nothing harsh or violent is recognised ; because these opposite extremes were united by interme- diate sounds, through which the one melted as it were into the other. So in painting should the "loud" colours be united to the "quiet," by interposition of the less positive or more broken.*

I have more than once referred to the qualities associated with the prismatic colours, showing how heat and light reside in the red and yellow, and their opposites in the green and blue. In harmony with this theory, we find that some colours are said to be warm,

* The general principles of harmony are more clearly developed in music than in any other department of æsthetical science, and the colourist will do well to make frequent reference to the principles of our sister art.

others cold. Warm colours being those which exist in the colours of the spectrum representative of heat and light : and cold, those associated with such as indicate the absence of these qualities. Here, therefore, we have yet other elements of contrast ; and, consequently, the same necessity for judicious composition.

The balance of colour, as stated by Sir Joshua Reynolds, demands that one-third of the picture should be cool and the remainder warm : but there are various other principles to be found in the works of eminent colourists ; some of whom even made up their pictures of a large proportion of cold and feeble colour, with but a slight amount of the warmer and richer; and others scarcely admit a touch of cold colour in any portion of their work. Some of Turner's lovely pictures are made up of cold, pale colours, relieved by a mere touch of warm. I therefore leave this point in the hands of my reader, only supplying the basis upon which he may raise his or her own conclusions, and merely adding this hint from Ruskin, who wisely says,—" Every hue throughout your work is altered by every touch that you add in other places ; so that what was warm a minute ago, becomes cold when you have put a hotter in another place, and what was in harmony when you left it, becomes discordant as you set other colours beside it ; so that every touch must be laid, not with a view to its effect at the time, but with a view to its effect in futurity ; the result upon it of all that is afterwards to be done being previously to be considered."

Besides being characterised as warm and cold, colours are said to be advancing or retiring, rich or poor, strong or weak, luminous or related to shade.

Advancing and Retiring Colours.—If two objects, one red and the other blue, chance to be retreating from you, the first will be the longest visible ; or if you were approaching towards two objects thus coloured, the red would advance to meet your eye, or in other words, be seen first. Therefore, do we say, the red is an *advancing*, and the blue a *retiring* colour.*

Rich Colours are those which are warm, luminous, and advancing; *Poor Colours,* such as are cold, non-luminous, and retiring.

Strong Colours are such as kill by superior brilliancy, warmth, and richness, others which are poor and weak.

Luminous Colours are those which are associated with the spectrum representatives of light, or with white : and non-luminous colours are those which are associated with their opposites. If you light a candle in a darkened room, you will see the flame is first blue, then red, next orange, and at last yellow—that in the first stage of colour it gave no apparent light, in the next a faint, lurid, ineffective glow, in the third more, and in the fourth, or yellow stage, most light. Of these, therefore, yellow is the more luminous colour. But if I put my perfectly lighted

* The atmosphere imparts its own colour to that of retiring objects, so that this is only true when the atmosphere is cold, or blue ; but the atmosphere is so seldom of any warmer hue than grey, that for all practical purposes this rule may stand.

candle in the broad light of day, the *white* light is as superior to the yellow, as that was to the blue. This hint should be taken.

Colours are divided into *tints*, *shades*, and *hues*; and the two former go to make *scales* of colour. Some colours are called *pure*, some *broken*, and some are described as *reduced*.

Tints of colour are formed by the addition of white, either by direct mixture with white paint, or by rendering the colour transparent, and placing it upon a white ground.

Shades of colour are formed by the addition of black, or its equivalents.

Scales of colour are formed by colours combined with their tints and shades; the pure colour in its natural intensity occupying a centre, and blending right and left into its shades and tints.

Hues of colour are those which have been slightly modified by mixture with other colours. Thus we speak of the hues of blue, the hues of red, &c., thereby comprising many colours definitely blue, although not purely so, or definitely red, although containing, perhaps, a minute portion of some other colour.

Tones are simply the tints and shades above described, which are indicated when we speak of the tones of any colour, such as the tones of blue, red, or yellow.

Pure Colours.—Strictly speaking only the primary colours are pure, but the secondaries are usually

D

understood as being pure colours. The *hues* of these colours are also called pure.

Reduced or Broken Colours.—Colours which begin to partake of a neutral colour, either by the mixture of three or more colours, or by the introduction of black.

Value of the Primaries.—It has been usual to state the value of the three primary colours when represented of equal intensity, as five, three, and eight: the blue being the larger, and the yellow the smaller quantity; and such is said to be nearly the exact proportion found in the rainbow.

Complementary Hues.—As a general rule, when you are looking for the proper complementary of any colour you are using, consider first what relationship it has to the pure colour of the spectrum. Suppose, for instance, you are using a red, which inclines to orange; blue being the complementary of orange, and green that of red; the proper complementary of your orange-red will be a blue-green, and so right through all the various combinations until the compounded pigments lose all colour in dark grey or black.

Tones.—You must not omit in colouring the consideration of tone or intensity. I have shown the effect of black upon white, and white upon black, in the previous chapter, and it must not be forgotten that dark colours have precisely the same effect upon light. Now harmonious colouring requires that here, too, there should be no harshness or violence of contrast; and

the relative *tones* of colours are, therefore, treated precisely as in the second chapter I advised the operator to treat the chiaroscuro of his photograph. It is by no means uncommon to hear a painting in monochrome praised for its harmonious *colouring*, so much is the principle recognized as belonging to this branch of art.

Harmonies of Analogy.—Besides the harmony of contrast, as already described, we have harmony of another kind, viz., that of analogy, produced merely by the tones of one scale, by hues of colours of a similar tone, or by the general effect of some one influencing a variety of other colours.

In reference to the latter we may give, for example, the effect of red when chosen as the predominant or key colour. Under its influence, yellows incline to orange ; blues, to purple ; greens lose their purity ; and all the more broken colours become more or less warm. The effect, in short, is exactly that which would be obtainted by looking at all these colours through a piece of red glass.*

The harmonies of analogy are suited to the expression of sombre grandeur, or to the effect of richness without brilliancy ; while those of contrast better display gay,

* Frequently when it so happens that the absolute colours of the object you are imitating, although they must be rendered, have no harmony, the disagreeable effect may, then, frequently be modified or even almost got rid of, by making it partake of some one dominant tone peculiar to those by which it is surrounded.

sparkling, brilliant, or showy qualities. For some subjects, therefore, the one is best suited, and for some the other ; while the indiscriminate use of either for *all* subjects displays, as I think, *more or less*, a want of artistic feeling.*

Harmonies of Contrast.—Amateurs are frequently confused by the seeming contradiction implied in the terms harmony and contrast, or opposition, forgetting that such are technical phrases to be understood solely in reference to their application in practice, and not by the ordinary meaning of such terms.

To refer again to the harmonies of contrast. I must state that these may be secured by various means, viz., by contrasting hues of colours, and even by contrasting tones of one scale, as well as by the contrasts of complementary colours.

Resumé.—To glance back at the ground we have passed over.

The student will now understand that a coloured object will appear, when viewed separately, different to the appearance it has when viewed in connection with another of some other colour ; that by contrasts of tone, colours may appear either lighter or darker than they really are ; that in a group of colours, not only the

* Many eminent painters have fallen into a mannerism in this respect, so that *all* their pictures are recognized by some one tone peculiar to themselves. Of course, such a practice may be more or less a fault ; but that the principle is a false one will, I think, be admitted.

effect of one upon another must be considered, but the effect of each upon each considered as a whole (the accidental colour of one being of sufficient duration to affect the retina, while the eye takes in all the colours); that tones have their contrasts and harmonies as well as colours, &c., all these points having been duly laid down in the consideration of colour in its optical relations.

In the present chapter I have now shown how, in accordance with the physical sensations we experience in viewing colour, certain rules have been laid down as guides to harmonious colouring ; how contrast is essential because of the inferiority of mere pigments, and how two contrasting or opposing colours may be united by the introduction of intermediate shades, tints, or hues in accordance with the laws of beauty in form, and melody in music :* we have seen, too, what qualities have become associated with colours, their technicalities have been explained, and their various harmonies described.

To conclude. Howard, in his lecture as President of

* "The love for colour is innate, and closely allied to harmony in music. * * * Music, to be in correct taste, requires the same unity of variety as in painting, not only of notes but of its accessories. * * * The striking similarity of the principles that govern music and painting has been my motive for thus connecting them by their kindred tie of unity, in the hope that it may awaken taste to a more careful consideration of an element which enters so largely into the pleasures of existence."—*Art-Hints, by J. J. Jarves.*

the Royal Academy, says, " The fullest and richest
harmony is when the seven prismatic colours are all
displayed together :" and other eminent masters have
said the same thing. The greater the variety of colours
introduced, however, the greater necessity is there for
well-seasoned judgment and practical experience in
their combination.

To quote Howard again :—" Contrast," he says, " is
the source of all character and effect in colour as in
every other division of the art. No tint will appear
very bright unless set off with an opponent, and by this
treatment effect may be given to any :" but he also
adds, " The general tone of colour to be adopted for a
picture, together with its chiaroscuro, is the music to
which the composition is set ; and should always accord
with, and arise out of, the character of the subject.
This has naturally some fixed and inherent circum-
stance, some indispensable demand, which must first be
attended to ; as to whether it be simple or rich, playful
or grave,—whether it derive its light from the freshness
of the morning, or the glow of evening,—the quality
or costume of the principal characters, &c. Some-
thing of this kind will generally suggest the key in
which the harmony is to be involved, and lead to all the
rest.

" Thus, if there be a necessity for clothing the prin-
cipal figure in red, that must be supported by congenial
tints, carried on in some part by a smaller repetition of
nearly the same tint, and set off and harmonized by a

portion of the antagonistic, or complementary colour, more or less positive. * * * * When regulated by taste and feeling, colour will be often found capable, in a powerful degree, of expanding the poetical sentiment of the work, and of interesting the imagination and affections no less than in delighting the sense."

We may now, I think, proceed to the more mechanical practical details of colouring.

CHAPTER V.

ON COLOURS AS PIGMENTS OR PAINTS.

NORTHCOTE tells us, " It was of advantage to the old school of Italian painters, that they were under the necessity of making most of their colours themselves, or, at least under the inspection of such as possessed chemical knowledge, which excluded all possibility of those adulterations to which the moderns are exposed." But, however this may be, it is certainly no small advantage to know *something* about the chemical and other properties of the pigments you use ; this chapter I therefore devote to the consideration of such matters.

Paints or pigments have properties apart from such as they possess merely as colours, viz., purity of colour, transparency, quality of working, and of drying, body, permanency, &c.,—some knowledge of which is of evident importance to the embryo colourist.

As these instructions will combine colouring in oil, water, and powder, or dry colours, I shall now consider the various paints with regard to the requirements of these several processes.

The properties of pigments vary with the vehicles in which they are used, the grounds on which they are laid, &c.; and these properties are also modified through combination with other paints. Their colours are

sometimes injured by light, or the absence of light, by pure or impure air, by damp, by oxygen, sulphureted hydrogen, &c. : some by one cause, some another ; some more, some less. Many pigments must be altogether rejected by the conscientious artist ; but we have plenty which are good, although some of these require the exercise of judicious care. I will now give a list of the principal pigments in use, pointing out the peculiar defects and advantages of each one.

OF WHITE PIGMENTS.

White is the complementary of black, as you know ; and its tendency is to give depth to, and harmonize with, all other colours. By placing it beside another colour, white will give strength and force to it while receiving a tinge of the complementary colour.

By mixture, white forms those tints of colour, which being nearly allied to light, at once catch the eye, apparently advancing before the colours and shades about them ; as a pigment it should be pure and permanent.

In oil painting, an English white lead, called *flake white*, is most used. Too much oil should be avoided in its preparation and application, as it will otherwise become discoloured : a little blue-black should be employed with it, to counteract its tendency to turn yellow. This pigment should not be used in water-colour painting, as, when unprotected by some " vehicle," it rapidly blackens.

In water colours the best whites are the " Constant "

and " Chinese." *Constant white* is sulphate of baryta—
Chinese white is a preparation of oxide of zinc : each of
these possess great advantages. White is seldom used
in tinting with dry colours.

As representative of white light, few white pigments
are at all pure, some being yellowish, some bluish.

OF YELLOW PIGMENTS.

Yellow being closely related by its luminous charac-
ter to white light, is always very prominent and attrac-
tive in a picture. Being a very delicate colour, its
brilliancy is too easily lowered, and its primary beauty
destroyed by mixture with other pigments ; great care
should therefore be directed to the preservation of its
purity. Yellow pigments are very numerous ; some
are beautifully transparent, others opaque. I shall only
name such as are more generally used. *Perfectly pure
yellows* are very rare.

Gamboge.—A most useful colour, both in oil and
water, very bright and transparent : being a gum resin,
it serves a similar purpose to that of varnish in the pre-
servation of other colours, more particularly when water
is the medium. Although it is not quite permanent, it
could with difficulty be dispensed with, especially by
photographic colourists.*

* All the more powerful transparent colours are of great value,
as they kill the blackness, or are least degraded by the grey tones,
of the photograph ; and thus enable us to avoid the use of too
much white (see remarks on body water colours).

Indian Yellow.—A very rich full yellow (more useful in water than oil painting, being in the latter case very fugitive, but in the former tolerably permanent), a urio-phosphate of lime ; is not injured by foul air. Is sometimes (I think erroneously) called permanent.

Gall Stone.—A very powerful golden colour, more eligible for water than an oil medium, although not permanent in either ; an animal secretion, chiefly in use among flower painters. It must be used with extreme care, and well shielded from chemical action.

Cadmium Yellow. A very brilliant metallic production, permanent both in oil and water ; of tolerable power, and much used in draperies.

Naples Yellow, semi-opaque, pale, and when pure slightly greenish, should not be applied in water, although such colourists as use body colour for painting flesh tints compound most of them with this dangerous pigment; protected in oil by varnish, it is however safe and very useful, working well, drying quickly, is almost indispensable in mixing flesh tints. It must not be brought into contact with iron ; a pallet knife of ivory should therefore be used, and such colours as contain iron avoided in its application to compounded hues ; it is obtained from zinc and antimony.

Yellow Ochres are not powerful or brilliant, but are the most ancient and honest of pigments, pleasing in hue, permanent, and working well in both oil and water : they vary in colour from a rich broken yellow to a warm brown, are semi-opaque, and very useful

both in themselves and for compounding. They are earths.

Raw Sienna.—An ochre ; is permanent and of good power ; has more body than the above, and is more transparent ; a very good and useful pigment both for water and oil.

Chrome Yellows are very pure, bright and of good body, useful in oil and water : their permanency is a disputed point, but few painters reject them. In mixtures they must be used with extreme care (prussian blue is entirely destroyed by them). They are chromates of lead.

Lemon Yellow.—A delicate permanent preparation from platina. I use this instead of Naples yellow in water : it is somewhat opaque ; but works well either in touches or washes.

OF RED PIGMENTS.

Red stands pre-eminent among pigments for power, and is more nearly allied to the advancing than the retiring colours. Its effect is so great upon the neighbouring hues and tints as to demand the exercise of the utmost skill in its use ; it boldly challenges the two extremes of black and white to diminish its beauty ; and never fails to convey to the mind sentiments associated with splendour and brilliancy. We have numerous red pigments.

Lakes.—A variety of beautiful colours bear this name ; they are prepared from several substances, viz.,

Brazil wood, cochineal, lac, and the root of the madder plant, which last alone is permanent.

Crimson Lake is of a rich deep colour and very fugitive.

Scarlet Lake has the same qualities.

The lakes prepared from the madder plant are very beautiful, and are most commonly used for oil and water, although they have not sufficient power to serve all the painter's purposes.

Madder Pink and *Madder Lake* are pigments of nearly the same character.

Carmine.—A very beautiful colour, but very fugitive, works well in oil or in water.

Madder Carmine.—A beautiful and durable colour for water or oil.

Indian Lake.—The best member of the lake family, but not the most beautiful.

Vermilion.—A very useful and beautiful pigment; works better in oil than in water, but is used for both; is opaque, of good body, and very brilliant. A pure preparation of this colour is, I believe, permanent, but it is very frequently contaminated by mixture. It is a sulphuret of mercury. The vermilions called scarlet and orange are best for water; that known by the name of iodine is not to be depended on for either, although of wondrous beauty.

Light and Venetian Reds.—Very valuable either for oil or water, and are quite permanent; the former is burnt brown ochre, the latter a preparation of iron.

Indian Red.—A very rich iron ore, of a lakey tone, generally used both for oil and water, of good body, works well, and is perfectly permanent. It varies in hue, but not to any important extent.

OF BLUE PIGMENTS.

Blue, among the primaries, represents shade, being by its qualities most nearly allied to black ; it is representative of coldness, and contributes its characteristics to all its compounds. Blue pigments are not very numerous.

Ultramarine.—A very brilliant permanent blue, nearly opaque, prepared from the lapis lazuli of Persia ; it is not much used in consequence of its high price ; its tints are very pure, its permanency undoubted ; it works well in oil, but is managed with much difficulty in water, in which case a *little* gum * is usually added to it. For compounding hues, ultramarine is unsurpassed ; but all these qualities depend upon its purity, and, alas ! like most other things, it is too commonly adulterated. You may test it, however, thus : add a little piece of the pigment to lemon juice, when, if it be pure, its colour is instantly destroyed. There are several imitations of this colour prepared and sold at a very cheap rate ; the most celebrated is called *French ultramarine*, which approaches the original in beauty

* Too much will destroy its brilliancy.

and permanency ; the acid test produces the same effect upon this blue as upon the original ultramarine, but *with effervescence.*

Cobalt approaches in brilliancy true ultramarine, but has less power ; it is of good body, works well in water and oil, is nearly permanent when carefully prepared, and very pure, being neither greenish nor purplish ; its greatest foe is impure air. (Blues called *smalt, mineral,* and *royal* are all cobalts.) It is prepared with metallic cobalt or its oxides. Of these blues the " royal " is least permanent.

Prussian Blue.—A bright, deep, and very transparent blue, of great body and power, but not very pure or permanent ; useful in water and oil, but liable to be destroyed by lime and alkalies ; a capital colour with which to compound greens. A lighter preparation of this colour is called *Antwerp blue.* Prussian blue is produced by combining hydrocyanic acid, iron, and alumina.

Indigo.—Prepared from plants in the Indies ; not bright, but extremely transparent and powerful, of good body, and working well in oil and water ; its durability has been disputed, but it is now generally called " fugitive." A preparation of indigo, called *Intense blue,* is the better pigment. Indigo is very generally used by painters of every description.

OF GREEN PIGMENTS.

A colour so common in nature, so refreshing to the eye, and so well beloved as to command the most

frequent use for domestic and decorative purposes, is, of all colours, the most dangerous to a picture. Place a "green picture" beside a painting glowingly brilliant with the rich hues and colours of the warm scale, and we at once perceive this fact. The one *demands* notice, excites pleasurable sensations, and conveys a power which *commands* admiration; the other seems poor and mean in its unobstrusive and retiring nature; and all the attracting power it has, is fiercely ravished from it by its powerful rival. It is only when the glowing hues which attracted each spectator's eager glance begin to weary the excited retina, that the beauty and utility of the calm and quiet "green picture" reaches the eye with all its cooling and soothing power and then acknowledged beauty, thus proving the importance of what artists denominate the balance of colour. We have a very large number and variety of green pigments; but greens are so frequently compounded by the artist that but few are on demand.

Emerald Green.—Metallic: the most bright and powerful of its tribe, and the most permanent; it works better in water than in oil; is too brilliant for common purposes, is useful in oil for flesh, &c., but is generally used in water for drapery and jewellery.

Hooker's Greens.—Bright, but not quite permanent; very useful in water.

Verdigris.—Acetate of copper: very fugitive in water, but tolerably permanent in oil, especially if preserved from impure air and damp.

Terre-Verte.—A bluish-green earth, not very beautiful, but very permanent; is never used in water, but is a most useful pigment in oil.

Chrome Green.—A pigment compounded from chrome yellow, used in water with gum; not very powerful, but quite permanent; works well in oil.

Olive Green.—A compound pigment eligible for oil or water; useful for backgrounds, &c.

Cobalt Green.—Prepared from cobalt; permanent both in oil and water; very pure, but of little power; works well.

Sap Green.—A most agreeable, clear, transparent colour, prepared from vegetable sources; much used, and working well in both oil and water, but, alas! fugitive.

OF PURPLE PIGMENTS.

Purple is nearly related to shade, of which it is very frequently the representative, although poets have associated it with imperial pride and royal grandeur: hence, perhaps, the vulgar idea of purple is by no means correct, but rather tends to that of crimson as being most gorgeously suggestive of regal splendour; purple, however, has a solemn grandeur of its own, very characteristic of the mingled awe and reverence commonly suggested by the consideration of royal attributes. Purples are generally compounded by the painter himself during work; consequently, I shall describe but two of these pigments, viz.—

E

Madder Purple.—A very rich, beautiful pigment, permanent, of good power and body, and working well in oil and water.

Purple Lake.—A very bright colour, but fugitive; prepared from cochineal.

OF ORANGE PIGMENTS.

Orange is a very warm and splendid colour, suggesting light and warmth to the mind; it comes prominently forward in a picture, and is associated with gaiety, cheerfulness, and splendour. Orange pigments are not numerous.

Orange Chrome.—Chromate of lead, a beautiful colour, but it does not stand very well; is used in both oil and water. A similar preparation is sometimes called "*Mars Scarlet.*"

Orange Vermilion.—A very eligible colour in oil and water, but works badly in the latter, in which a little gum should be added to it. It is permanent and of great use.

Orange Ochre or *Spanish Ochre.*—A durable and useful pigment in oil or water.

Burnt Sienna.—A sober semi-transparent colour, hardly to be called orange; although generally classed with such pigments, it is raw sienna, burnt; is quite permanent, and is very generally used both in oil and water.

OF CITRINE PIGMENTS.

Citrine, or citron pigments, being broken yellows, represent in a minor degree the sentiments associated with yellow. Original pigments of this class are but few in number.

Brown Pink.—A vegetable lake of a fine rich colour, very transparent, and working well both in oil and water, although it dries badly in the first; is fugitive.

Raw Umber. — Another of the honest old ochre family, very eligible in both mediums.

Bistre.—A rich colour of great service in water, but drying very slowly in oil; prepared from the soot of beechwood.

OF RUSSET PIGMENTS.

The sentiments associated with "russet" may be briefly alluded to in the same manner as the preceding, viz., as partaking, in degree, of those belonging to that primary colour, to which it is most nearly allied.* The only pigment under this denomination which I use, is called

Madder Brown.—It is a very eligible pigment, perfectly permanent, and universally useful in every branch of the painter's art; its preparation is indicated by its name.

* This remark is, of course, applicable to all the colours and hues compounded from the three primaries, however broken they may be.

OF OLIVE PIGMENTS.

Olive pigments are few, and but seldom used.

OF BROWN PIGMENTS.

Brown is a name applied to a class of pigments greatly varying in character, according to the proportions of the colours which combine for their formation, but to which none of the denominations already given could be justly applied. These pigments are very numerous.

Vandyke Brown.—A rich, deep, transparent brown earth, almost as celebrated as the painter whose name it bears. It is durable, works well in water and oil, but dries very tardily in the latter.

Burnt Umber.—A pigment composed of manganese and iron, dries quickly in oil, works well in water, is perfectly durable and very useful.

Asphaltum.—Used in oil only, and in this but little, although its clear transparency and beautiful colour are strong temptations to the painter; it is durable, but variations of temperature cause it to crack in every direction; factitious asphaltum is produced by the distillation of coal at the gas factories.

Sepia.—Prepared from the sepia or cuttle-fish; very celebrated among water-colour artists, and deservedly so, as it washes beautifully, is perfectly permanent, combines well with other pigments, and for numerous purposes is pre-eminently useful. In oil, however, it is less used, in which it dries very tardily. Two different preparations

are sold, called respectively "cold" and "warm" (the latter being compounded with perhaps a little lake or other warm colour).

Indelible Brown Ink.—A pigment very useful in water, as it is not disturbed after application by washes of other colours.

OF GRAY AND BLACK PIGMENTS.

Gray is the name of a class most nearly related to black. Grays are cold, retiring, and associated with shadow; their use, however, is great, and, in every object of the painter's study, grays (or greys) occupy no small space, and deserve no small share of his attention. The beauty and general effect of all warm colours derive force from contrast with gray, from which also it derives fresh value; and the absence of grays in a painting are signs of the artist's want of truthfulness.

Neutral Tints.—Prepared chiefly for water-colour painting. As they are variously composed from other pigments, it would be useless to describe their properties.

Ultramarine Ashes.—Very excellent pigments, possessing the same properties as the genuine ultramarine, being composed from the same material; they are extremely useful in obtaining the pearly tints of flesh &c., in oil and water.

Black Lead (a form of carbon).—From which, with white, may be compounded an exceedingly fine gray, pure and quite permanent, and possessing the capital

quality of blending well with all other colours ; used in oil only.

Ivory Black.—Burnt bone, a fine neutral pigment, eligible for water and oil ; permanent in both, but drying somewhat slowly in the latter.

Lamp Black.—The soot of burnt resin, a very intense black ; permanent ; used in water and oil, but dries very badly in the last named.

Blue Black.—I use this pigment in oil with my white, to destroy the tendency to yellowness derived from the vehicle employed ; it exercises a preservative influence upon the white, both chemically and in the way described ; dries well.

Mineral Black.—Used in oil for compounding grays ; is perfectly durable, and dries very quickly.

Indian Ink.—Used in water ; is too well known to need describing.

As there are pigments fugitive under ordinary circumstances, but extremely serviceable, and capable of being rendered permanent by extreme or studious care, and as there are many colours which, although permanent in themselves, exercise a destructive influence upon other pigments, it is advisable that the earnest and conscientious art-student should acquire a better acquaintance with the subject to which this chapter is devoted, than in this series of articles I can hope or pretend to give. I would therefore recommend the study of George Field's *Treatise on Colours and Pigments*, published under the title of " Chromatography,"

from the preface of which I extract the following paragraph, as a statement no less applicable to the present than to the time of its first publication :—

" Among the means essential to proficiency in painting none is more important than a just knowledge of colours and pigments—their qualities, powers and effects ; and there is none to which the press has hitherto afforded fewer helps. There have appeared, it is true, at different times, several works professing this object, and most of our encyclopædias and books of painting treat cursorily on this branch of the art ; but not only are these for the most part mere transcripts of the same obsolete originals, unsuited to the present state of the art, but they are inadequate, irrelevant, and often erroneous, or untrue, as every one acquainted with the subject is aware."

But while strongly advising the student to make himself well acquainted with pigments, let him always avoid a class of painters who, as Shee says,

" Their time in curious search of colours lose,
Which, when they find, they want the skill to use !"

CHAPTER VI.

ONE HUNDRED MAXIMS.*

FAILURES more frequently arise from the want of a proper foundation than any other cause. Let not the student of these chapters therefore consider my preparatory pages tedious. There is no royal road to art, and impatience is not favourable to progress, as witness the old adage, "The more haste the less speed," and another famous saying, about "Slow, but sure." It is a true sign of quackery when the difficulties of any art or science are overlooked or ignored, and quackery is but the voice of ignorance. Speaking from my own experience, I say emphatically that *the thoughtful head best aids the industrious hand.* In the earlier stages of my progress I trusted to the latter almost entirely, and was reduced very frequently to despair ; but when I combined the two, then real progress was made, and I have been sanguine and progressive ever since, earnestly hoping to remain so to the end, "for art is long, and life is short," and the goal of perfection has not yet been reached in any branch of this world's knowledge. The

* In making use of some of the best maxims of artists who have written books, I must solicit the indulgence of their authors or publishers ; and trust that, in giving my pupils such extracts, I best serve the purpose these works were written to aid, viz., the advancement of "*true art.*"

true artist is always a student, and he who has acquired most is ever the most conscious of his deficiencies. The great Titian, when he had studied and painted until he was seventy years of age, *then* only *began* the best part of his career ; but on his deathbed, far, far away, there still loomed before his outstretching love the goal he had been so long nearing, still misty, still faint in the extreme distance, as it had ever been, and ever would remain ! When you think of this, can you hope to master, at once, one of the most important branches of an art which baffled for years the powers of the mightiest of its great masters ?

I shall now proceed to arrange a set of maxims founded upon the experience of some of our most successful painters. Given under proper headings, these will illustrate the principles and practice of colouring, and form one of the best introductions to brushes and colours that I could select.

I might, of course, have embodied most of the ideas in my own words ; but by so doing, I should have deprived these maxims of the weight they derive from the great names attached to nearly all of them as quotations. Each maxim is numbered, in order that we may easily refer to any hereafter, to illustrate and explain more mechanical directions.

MAXIMS FOR BEGINNERS.

1. "Outline and chiaroscuro may make a finished drawing, but it is an imperfect substitute for the totality

of painting, which comprehends the whole natural appearance."—*Barry*.

2. "Scientific rules are the only sure and easy, though deliberate, conductors of true genius."—*C. Hayter*.

3. "GENIUS, with the *utmost aid of scientific theory*, must submit to *practical application*, as rudimentally necessary to accomplishment in the practical and mechanical department of *painting*."—*Ibid*.

4. "Genius cannot supply the want of competent knowledge."—*Ibid*.

5. "Art, by practice, to perfection soars."—*Fresnoy*.

6. "Acquire a certainty of hand by deliberate attention to the natural but most characteristic properties of each *individual* object : this will prevent that sort of conclusion which is the parent of 'MANNER.'"—*C. Hayter*.

7. "Take care to use your materials so that the picture may not look *painty*."—*Ibid*.

8. "There is a degree of impiety in pleading a want of faculties, when the real want is proper industry, and method to make right use of them."—*Ibid*.

MAXIMS FOR COLOURING GENERALLY.

9. "Inasmuch as a gamut is not any distinct tune of itself, so a chromatic display of the formation of colours is not any distinguishable picture ; yet so perfectly do each develope that systematical order by which nature has determined harmony, that, without them, painting with regard to colours, as well as music with regard to

sounds, would remain to all, as they still do to all those who are unacquainted with them."—*Ibid.*

10. "The predominant colours of the picture ought to be of a warm, mellow kind, red or yellow ; and no more cold colour should be introduced than will be just enough to serve as a ground, or foil, to set off and give value to the mellow colours, and should never of itself be principal."—*Sir J. Reynolds.*

11. "The fewer the colours, the cleaner will be their effect."—*Ibid.*

12. "Two colours mixed together will not preserve the brightness of either of them *single*, nor will *three* be as bright as *two ;* of this observation, simple as it is, an artist who wishes to colour bright will know the value."—*Ibid.*

13. "I am confident that an habitual examination of the works of those painters who have excelled in harmony will, by degrees, give a correctness of eye that will revolt at discordant colours, as a musician's ear revolts at discordant sounds"—*Ibid.*

14. "Fine colouring consists of truth, harmony, and transparency of tints."—*Opie.*

15. "The true colourist first considers the nature of his subject, if grave, gay, magnificent, or melancholy, heroic or common."*—*Ibid.*

* How often do the accessories quarrel with the principal object! Jones, a journeyman tailor, looking a journeyman tailor, with the background of a palace, provokes sarcasm and ridicule; but the same subject, with a quietly characterized background, &c., is quite another thing.

16. " Colour must be employed to harmonise, vigorate, soften, and aid chiaroscuro, giving breadth and unity to the masses of brightness or obscurity, and in distinguishing by their depth, strength, or brilliancy, the principal or subordinate figures."—*Ibid*.

17. " Good colourists break up the appearance of predominating masses of colour by a repetition of similar tints."—*Ibid*.

18. " Transparency is not flimsiness, brilliancy not rawness."—*Ibid*.

19. " Flesh is not roses, nor vulgarity vigour ; character and truth are lost in the hues of flattery."— *Fuseli*.

20. " Colours, as in a prism, should emerge from and flow into each other."—*Ibid*.

21. " If the principal colours of a picture consist of green, blue, or red, all the other parts ought to possess small portions of the same to unite the whole."—*Gerard de Lairesse*.

22. " The hand that colours well must colour bright,

 Hope not that praise to gain by sickly white."— *Fresnoy*.

23. " Reflecting surfaces tincture the objects reflected on with their colour, proportionately with their distance from each other, the angle under which the light operates, and the textures of both surfaces."—*C. Hayter*.

24. " The general prevailing colour of light tinctures every object within its influence : for instance, observe the whole hemisphere at clear mid-day, or the time of

a warm sun-setting, or the gray effects of a cloudy sky,
or a fog."—*Ibid.* [This rule should be remembered
when painting any peculiar effect of light on the figure
or background. It is no uncommon thing to observe
the gloom of a storm in the background when the figure
is as brilliantly lighted as if in the full blaze of a
summer sun ; or the hues of *sunset* about the horizon,
behind a figure lighted by rays from the sun at
noon, &c.]

25. "When a white surface *reflects* on the *shadowy*
part of any colour, it looks *paler* than the *lighted* parts
of such colour ; but the power of the shadow holds it
inferior with regard to light."—*Ibid.*

26. Glossy surfaces reflect the colour of the air or
surrounding surfaces ; and, for this reason, what is
called the true "local colour," is not seen upon such
surfaces where they receive the light, but rather in the
half-tones ; objects less polished or smooth best exhibit
local colours.

27. "Every colour that is reflected on by its own
colour is enriched thereby, according to the strength of
the reflected light."—*C. Hayter.*

28. Every colour that is reflected on by its directly
opposite colour will be neutralised thereby ; such as
green against *red, blue* against *orange,* or *purple*
against *yellow,* in an equivalent degree with the power
of light."—*Ibid.*

29. "If any two approximate colours reflect the one
on the other, its tincture will approach the appearance

of that compound which the two other colours would make by mixing them."—*Ibid.*

30. *The deepest shadows are not quite black ;* for although the presence of shade indicates in its degree the absence of light, and consequently of colour, still it is very seldom indeed that they are not redeemed from positive blackness by the presence of reflected light.

31. *The mere imitation of colours is not sufficient to produce really natural effects,* because, as our highest or most brilliant light, white paint, falls (as I have before said) far short of the brightness of white light, and our *black* is as far removed from the intensity of nature's darkest shadows. Hence it is that certain painters guilty of "*exaggerated colouring*" have yet conveyed to every spectator an impression of *truthfulness ;* while others who have laboured to reproduce *with their poor scale of coloured pigments* the very tones, tints, and shades of their model, have failed to satisfy either themselves or their patrons. Howard says—"As it is impossible with pigments to rival the brightness of light, it is found necessary to adopt some method of forcing the effect of colours, so as to conceal or supply a compensation for, this deficiency, and, *apparently,* to produce the vigour of truth."

32. "Let no one think the force of colouring consists in the choice of beautiful colours alone, as fine whites, beautiful azures, green, or the like, for these are equally beautiful before they are made use of; but in knowing how to manage them properly."—*Ludovico Dolce.*

33. "We are to consider in what part any colour will show itself in its most perfect purity ; * * * different colours differ materially in this respect. Black is the most beautiful in its shades ; white in its strongest light ; blue and green in the half-tint ; yellow and red in the principal light ; gold in the reflexes ; and lake in the half-tint."—*Leonardo da Vinci.*

34. "When you want to know if your picture be like the object you mean to represent, have a flat looking-glass, and place it so as to reflect the object you have imitated, and compare the original with the copy."—*Ibid.*

35. "One painter ought not to imitate the manner of any other ; because in that case he cannot be called the child of nature, but the grandchild."—*Ibid.*

"Whoever flatters himself that he can retain in his memory all the effects of nature, is deceived, for our memory is not so capacious ; therefore *consult nature for everything.*"*—*Ibid.*

36. "When the work is equal to the knowledge and judgment of the painter, it is a *bad sign ;* and when it surpasses the judgment, it is still worse—as is the case with those who wonder at having succeeded so well. But when the judgment surpasses the work, it is a *perfectly good sign.*"—*Ibid.*

* I have introduced this maxim, and some others, to tell against a practice commonly prevalent among photographic colourists, viz., that of painting from memory, aided only by a few brief written notes, rather than from the sitter.

37. " The edges, extremities, or boundaries, of *all* shadows are *gray*."—*Howard*.

38. " From the effect of contrast, shadows appear *comparatively* of the opposite colour to that of the light."*—*Ibid*.

39. " To preserve the colours fresh and clean in painting ; it must be done by laying on more colours, and not by rubbing them in when they are once laid ; and if it can be done they should be laid just in their proper places at first, and not be touched again, because the freshness of the colours is tarnished and lost, by mixing and jumbling them together ; for there are certain colours which destroy each other by the motion of the pencil when mixed to excess."—*Ibid*.

" For it must be observed that not only is the brilliancy, as well as the freshness of the tints considerably impaired, by indiscriminate mixing and softening ; but if the colours be too much worked about with the brush, the oil will always rise to the surface, and the performance will turn comparatively yellow in consequence."—*Sir J. Reynolds*.

40. " In beautiful faces keep the whole circumference about the eye in a mezzotinto, as seen in the works of Guido and Carlo Marattis."—*Ibid*.

41. " In painting consider the object before you as made more by light and shadow, than by lines."—*Ibid*.

* " Comparatively," because liable to certain modification from the effects of atmosphere, reflected colours, &c.

MAXIMS FOR COLOURING FLESH, ETC.

42. " The painter must always keep an attentive eye upon the *tints* and *softness* of flesh ; for there are many who paint it so that it appears like porphyry, both in colour and hardness. * * * For my part, I would prefer brownness to an improper white; and would, for the most part, banish from my pictures the vermilion cheeks and lips of coral, which make the faces look more like *masks* than *nature.*"—*Ludovico Dolce.*

43. " Paint your lights *white*, place next to it *yellow*, then *red*, using *dark red* as it passes into the shadow ; then with a brush, dipped in cool gray, pass gently over the whole, till they are tempered and sweetened to the tone you wish."*—*Rubens.*

44. " All the retiring parts of flesh partake more or less of gray."—*Mrs. Merrifield.*

45. " Strong shadows should be warm, those of flesh (which is semi-transparent) always incline to red."—*Ib.*

46. " All the shadows of flesh must have gray edges. this prevents hardness and gives great richness."—*Ibid.*

47. " The reflected lights of flesh are warmer than the surrounding parts."—*Ibid.*

48. " The darkest parts of shadows are near their

* These directions are intended for oil. The principle is *very good;* but in the works of this great master we find these colours placed side by side with so little attempt to blend them, that the effect is frequently coarse and unnatural. The " cool gray " is, of course, not intended as a glaze to be carried *at once* over the whole of the flesh.

edge, the middle being lighted by reflected lights."—
Ibid.

49. "The divisions or roots of the hair being shown
prevents the appearance of a wig."—*F. Howard.*

50. The vivid spark of light in the eye falls upon the
most prominent part, and diagonally opposite it will be
found a reflected light, stronger or fainter, according to
the prominency of the eye and position of the spark,
which is, in the photograph, universally exaggerated.
The eye's transparency and life-like expression will be
obtained by carefully strengthening and studying the
position of the spark and reflected light.

51. Carefully avoid a kind of flesh painting, sometimes
much admired for its touchy, sparkling effect, which
destroys truth of texture, and makes everything appear
to be formed of polished stone or metal.

52. Remember that flesh is not as brilliant in colour
as flowers and fruit, nor as transparent as pearls, and
that the imitation of such things is not painting *flesh*,
which has distinctive character and beauty of its own,
no less difficult to represent, or less pleasing to every eye
when successfully displayed.*

53. "Avoid the *chalk*, the *charcoal*, and the *brick-
dust*."—*Sir J. Reynolds.*

* *Flattered Pictures* (if required as portraits) are a great mis-
take, they are never satisfactory, and for this reason, they are
required to be made *unlike* by flattery, and, at the same time, to
be as *faithful resemblances* as if they were *not* flattered; most artists
have experienced this vexatious fact. Resemblance under *favour-
able circumstances* is another thing.

54. Indistinctness is not softness.

55. " Let those parts which turn or retire from the eye, be of broken or mixed colours, as being less distinguished and nearer the borders."—*Sir J. Reynolds.*

56. " Let all your shadows be of one colour, glaze them till they are so."—*Ibid.*

57. " Use red colours in the shadows of the most delicate complexions, *but with discretion.*"—*Ibid.*

58. " Avoid long continued lines in the eyes, and too many sharp ones."—*Ibid.*

59. "Never make the contour too coarse."—*Ibid.*

60. " Avoid all those outlines and lines which are equal, which make parallels, triangles," &c.—*Ibid.*

61. " The parts which are nearest to the eye appear most enlightened, deeper shadowed, and better seen."—*Ibid.*

62. " Keep broad lights and shadows, and also principal lights and shadows."- *Ibid.*

63. " Where there is the deepest shadow it is accompanied by the brightest light."—*Ibid.*

64. " Let nothing start out or be too strong for its place."—*Ibid.*

65. " Bright colours may be lowered to any tone required ; but *dirty* colours can never be made to look bright."—*Mrs. Merrifield.*

66. The figure should always stand prominently before the background, which should consequently be unobtrusive and retiring, with but few details, and no pure colours ; dark backgrounds give the more forcible

effect; but they should not contrast the lights too harshly.

67. "Take care to give your figure a sweep or sway, with the outlines in waves, soft and almost imperceptible against the background."—*Sir J. Reynolds.*

68. The liberty taken with the "horizontal line" of perspective in the background of portraits is great and common. As this indicates the height of the spectator's eye, it should be placed at that portion of the picture which represents the height of the camera by which the portrait you are colouring was taken.

69. The shadows thrown by the diffused and strongly reflected light of open day are less dark than those within doors, where the reflections are less numerous and weaker.

70. *The painter who knows his pr*[*ssion from principles*, may apply them alike to *any* branch of the art, AND SUCCEED IN IT.

71. "To produce force, solidity, and strength, some part of the picture should be as light and some as dark as possible; and these two extremes must be harmonized or reconciled to each other by a proper introduction of gradatory tints and demi-tints."

72. "Truth of colouring consists, not in giving to objects their precise local colour, but in so contriving that they shall seem to have it."

73. Broken colours in the background give value to the purer colours of the flesh.

74. " Simplicity and keeping are the basis of purity and harmony."—*Fuseli.*

75. A pale subject may receive warmth, a red or brown one pallor, from the colours of your background.

76. Backgrounds give excellent opportunities, not only for distributing colour to produce effects of harmony or contrast, but also in extending or concealing form, &c.

77. " Strong colour requires deep shadow to support it."—*Burnet.*

78. " Variety of tints, very nearly of the same tone, employed in the same figure, and often upon the same part, with moderation, contribute to harmony."—*Du Piles.*

79. " In a single head we often have but one light; it is therefore necessary to get it to harmonise with the shadow in the background or upon the dress. Rembrandt, accordingly, frequently painted the light of the dress the same colour as the shadow side of the face, thereby keeping up a union and simplicity."— *Burnet.*

80. " Colour holds the station of middle tint. * * * * The proper situation of strong colour is neither in the high light nor in the deep shade, for it would destroy the character of either ; but if it is made use of as an intermediate link, it will unite both."—*Ibid.*

81. " No object, of whatever kind it be, were it executed with the greatest perfection, will ever pass for

being a 'good choice,' if, by the unskilfulness of the painter, it be placed upon a ground of one single monotonous tint."—*Francois-Xavier de Burtin.*

82. Every tint and shade should be subservient to some one general tone of colour previously determined on as most in harmony with the subject, its sentiment, or effect, as Fielding says,—"In every harmonious composition of colours there is a principal tone, key, or predominant colour to which its other hues refer subordinately, as in music."

83. To prevent any appearance of the figure being "*inlaid*," Sir Joshua Reynolds says,—"The ground must partake of the colour of the figure, or contain such a mixture as to exhibit in it something of every colour in the palette."

84. "When a form is beautiful, it ought to be shown distinctly ; but when, on the contrary, it is uncouth in shape or hue, it may be lost in the background. Sometimes a light is introduced, to join and extend the light on the figure, and the dark side of the figure is lost in a still darker background ; for the fewer the outlines which cut against the ground, the richer will be the effect ; as the contrary produces what is called the *dry manner.*"—*Sir J. Reynolds.*

85. "By mellowing skill thy ground at distance cast,
 Free as the air, and transient as its blast ;
 There all thy liquid colours sweetly blend,
 There all the treasures of thy palette bend,
 And every form retiring to that ground
 Of hue congenial to itself compound."—*Fresnoy.*

86. " If objects are introduced into the background they should be few in number, and should be kept subservient to the figure. Landscape backgrounds should consist of broad features and few details, and should be kept low in tone. The introduction of a few warm tints into the sky near the horizon serve to repeat the colour of the flesh. The horizontal line should not be placed too low."—*Mrs. Merrifield.*

87. Distance is obtained by diminishing the intensity of *colours.*

88. Powerful contrasts should be avoided in parts requiring *quiet* and retiring qualities.

89. " There may be the most perfect combination of beautiful colouring, which, if inappropriately applied, would not only fail to produce a pleasing effect, but would destroy the whole harmony or truthfulness of the picture."—*Wyke Bayliss.*

90. " It is the background which forms *the picture*, and its use is *not merely to throw out the principal object*, but by its tone and colour to control and harmonize the whole."—*C. W. Day.*

91. " When the flesh colour of your sitter is a very bad one, you will find that a background of dull green will give it its full value—that is, it will, by contrast, show the reds to the best advantage."—*Ibid.*

92. " A good background never obtrudes itself on the eye or observation, but in all cases is subservient to the effect of the portrait or figures ; therefore, a back-

ground should be simple, broad, and in all cases partaking of an atmospheric tone, neutral and retiring, but not cold."—*J. S. Templeton.*

93. Graceful lines, harmonious colouring, contrast and relief, may be helped materially by your treatment of drapery—with, however, especial reference to the colour and character of your flesh.

94. Folds in the photograph are—by mere chance, perhaps—very frequently too numerous for breadth of effect, or too ungraceful; judicious alterations are therefore permissible.

95. A painter should form his rules from pictures rather than from books or precepts; this is having information at first hand—at the fountain head. Rules were first made from pictures, not pictures from rules. In giving this maxim to the world, Sir Joshua Reynolds does not state that the student must first learn the language in which these rules are written, but this once done, then follow out such excellent advice.

96. Use a rich full pencil for the lights of your picture (when colouring in oil), and keep the shadows thin and transparent.

97. "When the three primary colours are placed before us, our eyes accept the vision with a certain degree of pleasure; but we are *most* gratified when the intermediate colours are properly introduced, and the whole scale of the colours which constitute a ray of light is presented to them."—*Phillips.*

98. "Another point requisite to produce harmony, is

that the colours used to produce it, be of the same degree of strength in the scale."—*Ibid.*

99. "The principles whereon depend the means productive of good colouring, when employed by the man of genius, are truth in imitation, unity in their shade, and consequently in their half tint, harmony of arrangement and colour, with contrast and reflection, to enrich and invigorate them."

100. Remember that in nature there are *no outlines*, and that the less like lines yours appear, the truer will they be to your model; but do not run into the opposite extreme, or what is usually termed "woolliness."

Thus, from the best sources, have I, at some expense of time and trouble, collected together valuable maxims scattered over the pages of numerous volumes, and I have now to submit the results to your indulgent consideration, thoroughly convinced of their great value and extreme utility. These precepts may be looked upon as so many direction posts, put up by great travellers who have passed over the tract you are about to trace; and have thereby reached the goal you, I presume, are anxious to attain. Their use will be appreciated best by those who, having taken wrong roads, have recovered the direct path by their aid; and least by those who would rather trust to their own inexperience (or ignorance) than *condescend, or take the trouble* to receive tuition from another's wisdom. It were very little use to supply the means of travelling if there were

no roads, and roads themselves may confuse and delay if they are not provided with *direction posts.* Just so with these articles on colouring: it were but little service to my readers if I told them how to use brushes, or mix and apply colours, if I left them ignorant of such principles as develop the end and aim of all true art, viz.—*the perfect representation of nature.*

The simplest and easiest style of colouring is that applied to glass positives and daguerreotypes. To this, therefore, I shall first direct attention in the next chapter.

CHAPTER VII.

COLOURING WITH DRY OR POWDER COLOURS.

DAGUERREOTYPES and glass positives are generally coloured by a very easy process with dry brushes and powder-colours, by the aid of which some of our more skilful operators produce effects closely allied to those of coloured crayons.

The method of manipulation is so very simple that, save in the selection of tints and colours, there is not much to teach, and consequently not much to be mastered by the pupil in the shape of mechanical difficulties. Until very recently, powder-colours were prepared with so little reference to the surface to which they were intended to adhere, that this branch of photographic colouring occupied a very insignificant position ; and the only directions of *a practical nature* that could be given for their use, were simply to *dust* on a little pink or flesh colour here, and *dust* it carefully off there, blow it gently to remove the *very* loose particles, and—that was all: the powder once on in the form of *dust* of a certain colour could not be retouched, because every attempt to add more colour merely removed that already applied. Under these circumstances, it was only colourists who prepared their own pigments with a

knowledge of the peculiar requirements of this process, and the means of meeting them, who were really successful.

Now, however, if the amateur meet with such difficulties, it is his own fault; for although bad powder-colours are very extensively sold, some of our best colour manufacturers have undertaken their preparation, and thus bestow a really artistic power in their application to the collodion or silver surface. I find in practice that the colours are best applied before and after varnishing.

THE MATERIALS.

The colours are sold in small bottles, and their tints and shades are indicated by names (suggestive of their use) and numbers. If a box of these be purchased it will be provided with a set of earthenware saucers to contain the colours, or a palette of velvet for the same purpose, brushes, gold and silver shells, &c.

The brushes or pencils should be carefully selected. In oil or water a somewhat inferior brush, being aided by moisture, may do; but the dry brush will not retain its point unless it be of good material and carefully made. As softness is one of their most desirable qualities, the *dark* and not the red French sables will be found best. They must be carefully preserved from dust, well rinsed after use, and pointed with the lips before being put aside to dry. It is desirable to keep a good supply of brushes, as they soon lose their fine

point when in use, and this can only be recovered by moisture, after which they are not again fit for service until *perfectly* dry. A camel-hair brush, called a " duster," will also be required.

The Blower.—An india-rubber bottle with an ivory mouth-piece, used to remove loose superfluous colour.

Varnishes, &c.—A varnish prepared expressly for the reception of dry colours should be selected, as very few indeed of the ordinary varnishes (if any) take the powders well, being too hard and smooth. A varnish for coloured glass positives is needed to be something more than a brilliant transparent protection to the film. Many of the ordinary positive varnishes serve the protective purpose perfectly enough, but they are worse than useless for the purpose of the colourist, who requires a surface to which his powder colours will adhere when properly applied. The majority of the varnishes are, as I have said, too hard and glassy ; whilst some few, into which Canada balsam and turpentine enter, do not set properly, but are tacky, and cause the colour to adhere in patches. They, moreover, rapidly discolour. Select, then, a varnish which does not lower the whites of the picture much, and which, instead of presenting a smooth glassy surface, affords sufficient texture to which the colours may adhere. A black varnish is sometimes used for " backing up" the glass positives, the principal effect of which is the utter destruction of depth and transparency in the shadows, the changing of the purest whites into a leaden gray,

and the imparting of a dull, heavy, and metallic appearance to the whole picture : such a photograph will *never colour well.* The best material for " backing up" is a dark maroon velvet, which having depth in itself *and colour,* is no small assistance both to the photograph and the colouring.

THE FIRST COLOURING.

Your picture duly selected, with a clean, well pointed, and *quite dry* pencil, take up very little colour, and apply it with a *gentle* rubbing motion in a circular direction. As is usual, commence with—

THE FACE.

Take up the pale orange, or the " horizon tint," and mix with a little white : with this colour (a pale, warm yellow) strengthen the high lights (see Maxim 40) which will be found upon such portions as are most prominently exposed to the more direct rays of the light, such being of course the top of the brow, the cheek bones, and the nose, and chin, upon the lighted side of the face : soften this into the " local" tint of the flesh, which may be represented by either of the prepared " flesh tints," with or without the addition of a little warm brown, orange, or carmine, as the complexion to be imitated may determine. Darken the local tint as you approach the half-tones, carefully avoiding the *darkest* shadows, which *the powder colours always destroy.* Where the skin is thin the blue veins will tinge the flesh with their

own colour, therefore touch a little pale blue upon the corner, between the eye and nose, the temple, &c. : a stronger blue, green, or purplish gray, if your subject be a man, may be required about the upper and lower jaw. With careful touches, colour the lightest part of the upper lip with a little crimson, and that of the lower lip with pink, finishing it with carmine. If the eye be blue or brown, put a touch of either colour, *with extreme care*, into the iris diagonally opposite the " spark " or gleam of strong light in the eye (see Maxim 45). Should the hair be light, a little of the requisite colour may be worked over the lighter portions.

THE HANDS

A little white, to strengthen the shining lights upon the knuckles, is first used ; then a little carmine for the nails, knuckles, and other pinky portions ; and then a little pale blue for the veins, leaving the other tints for the present.

DRAPERIES.

Begin with the lighter folds and darken as you soften into the shadows ; in silks and glossy fabrics put in the highest or whitest lights with a tint very little removed from white, by which the effect will be much enhanced in the finished picture.

BACKGROUNDS.

If your picture is small, a plain background with a light about the head to secure breadth is best. (See

Maxims Nos. 16 and 52). If a larger picture, you may introduce a background of clouds, sky, and distance, with very good effect ; curtains and architectural objects are also frequently introduced. See Maxims 50 and 51.

SKY AND DISTANCE.

If the positive has a darkish gray background, it will, with a few touches of various grays (greenish, brownish, and bluish), be converted into a very artistic " bit of distance," the horizon tint being used to form its boundary. Work this tint (the horizon) upwards into a pale warmish gray, and this again into the high lights of warm white, or small fleecy streaks of fleshy clouds, or into the azure. If desirable, the sky may be composed entirely of pale and dark, warm and cold grays, which form a very effective background to a vigourously-marked head or military costume. Curtains are seldom nicely managed ; but architectural objects may be touched in with grays and browns, leaving the surface of the plate (if dark enough) to form the shadows. Having finished the first colouring, take a clean well-pointed pencil, and remove any stray colour which during your progress may have obscured the shadows or outlines.

THE SECOND COLOURING.

Your next step is to varnish the picture, as the first colouring is on the collodion itself—for which reason, by the bye, great care should be used to avoid

scratching the plate by rubbing it too hard, or suffering the quill or tin ferule of the brush to touch the surface.

The varnish having dried, or the moisture evaporated, as the case may be, the carmine—strong or faint as may be necessary—is then applied upon the cheeks; and will most probably also be required, more or less, upon the nostrils, bridge of the nose, lower portion of the brow, and the chin. If a faint blush of colour be required for a very delicate complexion, use a little pink, with or without a touch of carmine; or should the pure carmine be too bright and powerful, combine with it a little flesh: or again, should it approach scarlet, add a very slight touch of pure orange. Take the colour labelled "horizon," and, with white, mix a warm pale tint to strengthen the high lights, making it more or less white, or more or less yellow, as may be most consistent with the local colour of the flesh; and this done, the retiring shadows may be slightly and carefully touched with a warm gray, compounded of flesh and green. Finish the hands with light flesh and pink. Repeat the colouring of your drapery, avoiding the darkest shades—using, however, a pale tint of the local colour for the highest lights, instead of the light tint recommended as a ground to strengthen their effect in the first colouring.

G

TO COLOUR A VERY DELICATE FAIR FACE.

Use white for the high lights, place the pale horizon tint next to this ; blend this into a third tint, compounded with the second and a little carmine ; and this again into a fourth tint, composed of light flesh and a little blue. This treatment should also be adopted for ladies' hands, necks, and bosoms.

TO COLOUR A VERY DARK FACE.

Use for the high lights a strong tint of orange and white, blend this into a second tint of orange and carmine, and this into a third of warm brown, orange, and carmine, reducing the whole, if too brilliant, with a tint composed of carmine and green.

THE EFFECT OF VARNISHING

Is to modify and subdue the first colouring—which should, therefore, be more brilliant than the second—and according to the quality of the varnish, to lower the whites, which consequently require some few light touches of white to indicate (as the photograph itself seldom does) the high lights of linen or white drapery. Certain colours, also, are affected to no small extent by the varnishing, some being rendered very much too strong, others being almost destroyed. Those least affected are the yellows, reds, and greens. A little practice will, however, best explain this difficulty.

SCARLET COATS AND JEWELLERY.

In colouring a scarlet coat with powder colours, your great difficulty will be found in preserving its folds and roundness; the opaque nature of your pigments* destroying the half-tints and shadows in the same degree as they produce the force and brilliancy demanded for a truthful effect. In this case, therefore, more than common care is requisite. Select a colour for your high lights first. This should be a scarlet of a somewhat orange*tone ; and be careful that in obtaining it you use *no white*, which would effectually destroy the purity and beauty of your colour. The next colour is the local one, viz., scarlet; the next, carmine : and the shadows are coloured with crimson, which, upon *the darkest shades*, should be applied *before varnishing only*. You will find that the local scarlet is a colour somewhat difficult to meet with.

Jewellery is too generally touched with the gold and silver sold in shells, which, unless used with no little skill, produce a very coarse and untruthful appearance. The simple fact of the jewellery thus touched having lights and shadows of its own continually varying with the light in which the picture may be placed, and perfectly independent of the light and shade upon the

* To claim transparency for powder colours, in themselves, is a common mistake. When ground to an impalpable powder and slightly applied, they, by the fineness of their particles, *seem* almost transparent, but of course cannot be really so.

image itself, should denounce the vulgar taste displayed
in its use, and confine it to the studios of a class of
"photographic artists" who laud the fact of its being
"real gold" to their sitters, as an inducement for the
outlay of "tuppence" more for a ring, or "sixpence" for
"a gold chain." I have seen a minute touch of the
silver applied with singularly good effect to the spark of
light in the eye, but it perishes as the silver blackens.
Gold is best executed with water or oil colours. In this
case take Naples yellow for the high lights, yellow ochre
for the local colour, bistre and burnt sienna for the
shadows, and orange chrome or deep cadmium for the
reflected lights. *Diamonds* are best represented by a
vividly bright touch of pure white (water colour), and
coloured stones by the same upon the local colour,
opposite a touch of this local colour mixed with white,
to represent their transparency. For *silver*, use white
for the lights upon a ground of warm pale gray with
somewhat warmer shadows. For *pearls*, use a brilliant
touch of white, very minute, diagonally opposite another
similar touch of white and Naples yellow. *Coral* may
be painted in with lake and vermilion for the local
colour ; pure lake for the shadows, and pure vermilion
for the lights ; the highest lights with the same and a
little white.

THE USE OF WATER COLOURS.

Upon glass positives water colours should be seldom
used, as their effect upon such surfaces will always be

strikingly inharmonious and offensive to good taste
(although a touch or two may sometimes be carefully
applied to produce the sparkling high lights of jewellery,
lace, &c., as I have already stated), and are also, as I
shall explain, necessary in the treatment of certain
defects.

TO COLOUR AND IMPROVE AN INFERIOR POSITIVE.

To do this may very frequently (as in the case of a
bad picture being the sole relic of a deceased relative
or friend) be most desirable. Suppose, then, we have
before us one of those leaden-hued ghostly positives,
which somebody has bought very dearly at an exceed-
ingly low price. Here it is in all its ugliness, either
pallid and indefinite in a thick white fog, or sooty
and begrimmed in a black one. Suppose it to be the
former. In the first place, if necessary, we " put in the
eyes," with a fine sable pencil and a little Indian ink,
carefully strengthening the line round the iris, and
touching in the pupil with a neat clean touch; the
eyelids and lashes may be marked with the same, and,
if required, the nostrils and line dividing the lips also.
This done, take the powder colours, and with a little of
the dark gray, strengthen the barely visible half-tints,
doing the same for the lights with the white, being
careful *not to touch the wet with the dry colours,* as the
latter would adhere to the former far more strongly
than to the collodion surface, and would not admit of

softening. The hair may be strengthened with the Indian ink, and then the varnish can be applied; after which, proceed to colour as usual.

And now suppose we have the "under-developed" and "under-exposed" positive (the black one) to operate upon.

The sockets of the eyes are a dense black mass, in which the optics are nearly or entirely lost. To bring them out, use Indian ink and Chinese white (water colours)—the former for the markings or drawing of the eye; the latter, with *very* light careful touches, for the lights and white portion of the eye. Next, take your dry white and work it into the high lights, and, mixed with a little gray, into the half-tints, until the image begins to show some little signs of roundness, although it will now appear a very coarse chalky smudge. After this, varnish and colour as usual.

But although thus much may be done to remedy these defects, *such* productions cannot be *much* improved by any process.

COLOURING GLASS POSITIVES IN OIL.

Oil colours are used with most effect and greatest ease on paper; but as they are also frequently used upon collodion, I may as well inform you that it is advisable to coat the picture with pale drying oil, and allow it to dry before commencing the colouring. Practical details may be looked for in my future chapters upon colouring in oil.

COLOURING ALABASTRINE POSITIVES.

Although these positives have a delicacy and beauty peculiarly their own, they have, when badly managed, a cold chalky appearance both before and after colouring.

The method of colouring already given is that to be adopted in the colouring, except that a general increase of warmth in the tints is desirable. Black varnish *quite* destroys the beauty of alabastrine pictures; they should, therefore, be backed up with a rich maroon velvet. In fitting them into cases, SECURE them from the air with gummed paper.

NON-INVERTED CHROMO-PHOTOGRAPHS.

Alabastrine pictures, after being coloured, may be treated with a preparation sold by Mr. Newman, of Soho Square, under the name of " Penetrating Varnish," which has the effect of rendering the colours visible upon the side contrary to that upon which colour has been applied. These pictures, apart from the advantage of being non-inverted, retain the minutest details of the photograph, which is in this case *on* instead of *under* the colour. It is evidently important that the whitest glass should be used, and that the tints selected should be from the more powerful, as also from those which receive the most permeating power from the " penetrating varnish." Some few experiments will best decide the latter point, as the results are variable.

COLOURING ON PAPER WITH DRY COLOURS.

I have seldom seen a very pleasing effect* produced upon paper by the use of dry colours; and it seems to me that these colours are as unfit for paper as oil colours are for collodion: in either case, however, both are used.

The albumenized paper is best, and before applying the colour it is sometimes rubbed with very fine pumice-stone or rather cuttle-fish powder. The process of colouring has been already described.

ON THE TREATMENT OF IMPERFECTIONS, ETC.

There are certain defects to which the pictures of the best of operators are liable, in the shape of black and white spots and other markings. Various mixtures of water colours, opaque or transparent, as may be necessary, are used to conceal these. For white spots, Indian ink, with or without a little madder brown or sepia, is best; for dark, white with a little Naples yellow, Indian ink, Venetian red, burnt sienna, &c., may be used, mixing two, three, or more of these colours to a tint which approximates most nearly to the tone of the photograph, or the colours of the part. If these spots are on the collodion, they are best touched out *after*

* The best pictures of this kind I have seen were the productions of M. Mansion; and they were, certainly, very beautiful and delicate.

varnishing, inasmuch as this would so affect the water colours that, however invisible the touches were when dry and dead on the collodion, they would start prominently into sight upon varnishing, and probably defy all future attempts to conceal them. When the spots occur upon the flesh, try the effect of your mixed tint upon the corner of the picture before applying it, remembering, if the spot be a black or transparent one, that the thickness of colour must give a surface just as opaque as that of the collodion.

It does sometimes occur that, owing to the greasiness of its surface, the lighted parts of the hair will be unpleasantly white, or in the eyes of some horror-struck sitter, GRAY: a coat of Indian ink, carefully applied with a somewhat dry brush and a very little gum-water, will remedy this. Indian ink may also be used to strengthen the outline round the iris, when, owing to the milky blue of the sitter's eye, it is nearly or quite invisible, or, from other causes, lacks definition and sharpness.

In architectural backgrounds, sharp, clean, dark lines are sometimes required. These may be got by placing a straight edge over, but not in contact with, the surface of your picture, and drawing them in with a fine-pointed clean brush, which clears away the colour, and at once gives the line required.

UPON COLOURING HIGHLY.

The pictures best adapted for a process of colouring which resembles pastel paintings are large heads. It

should be remembered, more especially with regard to highly-finished work, that the best of dry colours are so slightly tenacious that the surface upon which they are applied cannot be too quickly secured under glass. With ordinary care, however, the colouring of these pictures is tolerably permanent. Moisture will injure them, and they must not be exposed to strong sunlight, and, of course, much must depend upon the choice and preparation of your pigments in this as in every other branch of colouring.

With a few rules for the student's guidance in finishing highly, I shall quit this branch of my instructions for the next, viz., water colours.

To obtain brilliancy, increase the body of colour by repeated applications. See Maxim 17.

For the retiring portions of your flesh, and to most of the finishing tints, add gray. See Maxims 37, 41, 70.

In highly-finished pictures, colour the shadows, even the deepest; but only before varnishing. See Maxims 42 and 43.

Keep the background near the head lower than the half-tints, and lighter than the deeper shadows. See Maxim 53.

Let your last touches be given with a *very light hand*, and let them be more definite and forcible in effect than their predecessors.

Select for this process such pictures as have strong shadows and well-defined half-tints—an over-exposed picture being perfectly useless, inasmuch as the body of

colour would soon bury the outlines beyond the chance of recovery.

Carefully preserve the purity of your tints in the highly-lighted passages.

To finish highly requires no mean skill, great experience, and good artistic knowledge; and when all your difficulties are mastered in this branch, the effect obtained will never, to my thinking, be so satisfactory as that to be secured in one-half the time by the use of either oil or water colours.

CHAPTER VIII.

WATER COLOURS.

ALTHOUGH we are fairly afloat in our practical studies, you will not, as I have before said, derive much benefit from my instructions if they are merely confined to material colours, their uses, and modes of application. In its place, I have already spoken of the relative value of colours, of their effects in combination, their characteristic peculiarities, &c. (see preceding chapters). I must here, however, say a few words on the proper perception of colour in nature. It is so common, in observing the various objects about us, to take for granted certain general ideas as to their respective colours, that a more thoughtful habit of perceiving is one of the first and most important qualities to be acquired by the student. As the colourist learns to see artistically, and catch

" Those tend'rer tints that shun the careless eye,"

he will experience no surprise at the raw, crude, unnatural appearance presented by his early efforts, nor any longer feel at a loss to account for such failures.

The education of the eye *must* accompany that of the hand, or all my efforts are vain; and all the time you

may spend in reducing these instructions to practice
will be so much of man's most precious gift—time—
wasted.

The best means of acquiring what is familiarly known
as "an eye for colour," is by the thoughtful and careful
observations of every object around you, and the study
of such paintings* as are celebrated for their colouring
—not the first without the last, nor the last without the
first, but *both*—not slightly, briefly, and at long
intervals, but deeply, lingeringly, and frequently. You
must be thoroughly in earnest, or you will fall into that
mechanical drudgery something better perhaps than
house-painting; but infinitely less respectable, and
far, very far below anything artistic. There is no
medium.

There are those who *will* unfortunately preach that
old-fashioned pernicious doctrine that "Artists are born
and not made"—whose mischievous appeals to egotism,
idleness, and ignorance, find with the many too ready a
hearing. Some hug it to them, because it flatters their
vanity—"*they* are the chosen of the earth;" others,
because it is a salve to their consciences for procrasti-
nation—"Oh! I can do it in no time, when I like:
there's no hurry." Others, again, because it is an
excuse for failures due only to a want of perseverance
and energy. To refer to a quotation already given in
my maxims:—"There is a degree of impiety in plead-
ing a want of faculties, when the real want is proper

* See Maxims Nos. 13 and 95.

industry and method to make right use of them."
Labour is the only price of excellence in every depart-
ment of our knowledge; and if you are prepared to pay
the price, and come to your work with a bold heart and
patient love, I will guarantee you a ·measure of success,
fairly proportionate to your efforts. It would be easy to
illustrate my opinion on this subject by reference to the
lives of eminent painters; but this, of course, would
lengthen my digression too seriously. Believe me,
I do not speak ignorantly, but like that young old
gentleman in "Bleak House," "from the deep wells
of my experience." Without being controversial or
disputative, I desire, as a trust-worthy master, to deal
honestly with you; and this I should not be, did I
fail to warn you against this pretty piece of fanciful
theorising, which age and popularity has rendered so
mischievous, as this of providential partiality certainly
is. A predisposition for the study of art may have
its origin in peculiar circumstances connected with
early life; but with average intellect, manly courage,
and a more than ordinary share of perseverance, I can
see no reason in nature, why victory should not crown
the " good fight."

To return, if you possess a photographic camera,
examine the image of any object or person in sunshine
upon the ground-glass, and mark well the wondrous
brilliancy of the mysteriously blended tints and colours,
and the countless variety of shades and tints which go
to make up that which the uneducated eye recognizes

in a misty indefinite idea as " flesh colour." Such images are capital studies.

But when you examine either paintings, optical images, or the realities of nature, bring to the task the principles of art, which have been discovered or supported by the great artists of past ages, *and test their value for yourself, humbly yet boldly;* for there is no real energy, no true perseverance, without *conviction.* The traveller who is *conscious that he knows the right road travels quickly;* but the wayfarer in *an unknown path goes with slow, hesitating steps, and is often brought to the extreme verge of the gulf*—despair.

In studying from pictures, beware of indiscriminate imitation, and never copy the style or system of any one master, until you have carefully matured your own judgment on his productions.*

With these few preliminary remarks by way of advice and encouragement, we will enter upon our lessons in water colours.

The method of execution adopted in water colours varies with almost every artist who uses them ; I shall more particularly recommend that species of manipulation with which I am most familiar.

The first thing to be done is to select materials.

* See Maxim 35.

MATERIALS.

Brushes for water colours are prepared in hog's-hair, camel's-hair, and sable; in quills, and in tin or german silver ferrules: some are long and tapering, others short and thick; some flat, others round. The hog's-hair brushes are of service in the use of body colours to lay broad, flat tints; the camel's-hair for large washes of colour; and the sable for the finer work, for which also select the best French sables. Sable pencils are dark brown and light red in colour—the former are the softer, and the latter the stronger kind. With the exception of such pencils as are necessarily very small, for the putting in of minute markings and outlines, choose as large a brush as you can conveniently work with; as by so doing you obtain a full, broad touch, infinitely superior to the " scratchy effect" caused by the use of those which are too small and fine. When purchasing pencils ascertain, in the first place, that the hairs are of a proportionate length; then dip their ends in water, work them to a point on your thumb-nail, and ascertain if it forks or divides, and see whether, after pressure, it springs back to its original form; if thus tested, and it neither forks nor fails in its elasticity, it is a good and valuable servant and must be retained. A flat camel's-hair brush or two should be procured for washing and sizing. Be careful not to leave them in the water, and rinse them from colour before putting them aside. A stiffish

brush, somewhat worn at the point, is best for "hatching."

PIGMENTS.

The pigments which are most eligible for water have already been fully described. It is well to become thoroughly acquainted with the power your pigments possess in combination, and a little time devoted solely to the compounding of hues, shades, and tints, will by no means be thrown away. Pigments are prepared moist in pans and tubes, and in dry cakes: for large washes I prefer the moist colours, in pans; for the more delicate colours, those in dry cakes; and because the madder pink generally comes too slowly from the cake, and yet must be preserved pure, I choose this moist in a tube. Select the following colours:—

Madder Pink	Gamboge	Sepia
Crimson Lake	Yellow Ochre	Vandyke Brown
Purple Madder	Naples Yellow	Neutral Tint
Brown ditto	Indian Yellow	French Blue
Vermilion	Raw Sienna	Cobalt
Extract of ditto	Burnt ditto	Indigo
Light Red	Lemon Yellow	Prussian Blue
Indian Red	Cadmium	Ivory Black

For the chemical and other qualities, peculiarities of working, &c., of the above, see the chapter on colours as pigments.

GUM.

A solution of gum in distilled water, one part of the best white gum and seven of water, to which add a piece of loaf sugar about half the size of a filbert.

H

PREPARED OX-GALL.

This is generally used to destroy the effect of grease on the surface of your paper, it is used with the water.

WATER.

It is essential to obtain this free from such ingredients as would injure your pigments ; spring or mineral water would quite destroy the more delicate vegetable colours, therefore use rain or distilled water.

PREPARATORY PRACTICE.

To acquire perfect freedom of hand and a dexterous method of using the brush must be your next aim, and to acquire this I do not know that I can recommend any better practice than what is known among photographers as " touching" (which is a method of " working up" photographs on plain paper in india ink, sepia, or a mixture assimilated to the colour of the photograph). Inasmuch as you will find that errors of execution are more readily detected, and consequently remedied in the use of one colour than many, I shall therefore include a lesson upon this subject, although I hold that a good untouched picture is greatly superior to the touched, for truth of texture, *chiaroscuro*, and general effect.

TOUCHING.

The native truthfulness of a good photograph is so superior to the smoothness and laboriously stippled

prettiness of an india-ink drawing, that creating the last upon the first seems to me a display of the most erroneous judgment and bad taste. The excuse generally tendered for the " touching" of photographic portraits, or in other words making them resemble india-ink drawings, is, that it gives them "*finish*," by which is evidently meant smoothness. But Mr. F. Howard shall say a word upon this subject in the following quotation from his chapter upon finish in " Imitative Art." " This (finish) does not consist, as appears to be a prevalent erroneous notion of the present day, in smoothness of surface, or tea-boards would be the most finished production of art. Sir Joshua Reynolds could not be said to have finished any of his pictures. Texture would be worse than of no value ; but varnish would be the artist's best friend. Nor does finish consist in another kind of smoothness which results from the careful blending and softening of all the touches, so that the method of execution shall not appear. Nor does it consist in minute detail, but in *the complete expression of character.*"

In this sense what can be more finished than a perfect untouched photograph ? Does it not indicate in detail every variety of texture, the rough, the polished, the smooth, and all the varied surfaces of nature ?

In touching, therefore, aim not to smooth and even up the tints and shadows, but rather to preserve and strengthen every trait in the photograph, more particularly if, as I recommend, you merely com-

mence this branch as an introductory study to that of colour.

A pale print of a cold tone is best, if you intend to finish in india-ink; a warm or cold brown if you intend to touch with warm or cold sepia; and, if you please, you may compound a tint resembling that of the photograph, which, if it be of the usual purplish black, may be got with madder-purple, and india-ink, or madder brown and india-ink; to which, if necessary, may be added a little indigo, or a little indian-red, lake, or burnt sienna. Let the print be upon plain salted paper, not albumenized.

Having selected your photograph and mounted it upon Bristol board—which, having a hard, smooth surface, is best for the purpose—size it with parchment size, and let it be "rolled," that is to say, pressed with great force between cold steel cylinders. Any hot-presser will readily do this; and the process not only improves the smoothness of the surface, but so hardens it, that it is not easily disturbed. Your colour mixed (clean water and hair pencils being ready), pin down your picture upon a drawing-board. Imagine your teacher at your back, resolve to gratify him, and raise yourself in his estimation, and commence. With a touch so faint and light, that it is only after several applications that you can perceive its effect, begin to strengthen what I call the outlines, although in a good photograph, as in nature, there are no outlines. To put in these *apparent outlines at once* would be to produce

distinct lines, resembling nothing else but lines, which is
a very common mistake, not only with beginners, but
even with some who pretend to professional experience.

THE EYES.

Take, then, the eyes first; carefully and patiently
strengthen the lines of the upper lid; don't hurry, speed
will come with confidence, and confidence with practice.
Is the lash of the upper lid dark and long, remember
that it falls upon and blends softly with the shadow upon
the cornea or white; if it is light, remember that it is
made visible by the self-same shadow, and can never be
truthfully represented by a mere black line. As the
cornea retires from light, observe that it falls into
delicate shadow, rendered thus faint and delicate, because
from the nature of its surface, it receives a strong reflected
light. The iris is outlined, sometimes with a clearly-
defined line, and at others with a faint touch dying into
the white; identity of expression is in no small measure
dependent upon the due preservation of this peculiarity
—a fact I first discovered from studying photographic
portraits, and one strangely overlooked by many very
eminent artists, all of whose eyes are defined one way,
viz., either with or without a distinct line round the iris.
In such points as this it is that photography becomes
the artist's best teacher. With tender touches gradually
strengthen the shadows beneath the brow and that below
the eye, or the lower eye-lid, if the latter be full. Upon

the proper depth of this shadow depends the charac-
teristic prominency of the eye, its consequent expression,
and, therefore, the preservation of likeness. Now, with
a few vigorous touches, put in the pupil of the eye;
finish the iris, carefully preserving its transparency by
strengthening the light reflected through its shadowed
side from the lighted portion (see Maxim 46). The
gleaming character of the fluid found in the corner
nearest the nose must be faithfully preserved. Re-
member that what is called "the white of the eye" is
not by any means white, for, being overshadowed by the
thickness of the eye-lid and the length of the projecting
lash, and being in part concealed from light by its
receding nature, it exposes a very minute portion of its
surface to direct light; therefore, retain the delicately-
shaded appearance it has in your photograph by keeping
it down, and strengthening its shadows and tone in
exactly the same proportion with the rest. The gleam-
ing spark of light found on or near the pupil is put in
with a minute touch of Chinese white. In the pho-
tograph this will very probably be represented by a
glare of white, destructive of all expression, and giving
the appearance of "a cataract." Much as this has been
decried by artists, *it is truthful.** Painters, to give
unnatural prominency to the spark of light, place its

* I remember reading in, I think, the "Quarterly Review," a
most ably and powerfully written article upon photography, in
which the writer, mistaking these broad white lights for posi-
tive high lights, ridicules them as exaggerated and untruthful.

representative dot of white in the midst of dark touches ; but in nature we find the spark of intense light reflected from the eye, is situated in the centre of another light of increased magnitude and diminished intensity. Photography seizes the larger and inferior light, and represents its intensity *truthfully* with *white,* and, therefore, lacks the means of representing the increased brilliancy of the minute spark, which is consequently swallowed up in the white patch representative of the less intense light. *Bear this in mind, if you please, especially when your photograph represents polished surfaces.* Painters having only white to represent the most brilliant light, have recourse to art to force the brilliancy of their white pigments ; but photography can claim no such assistance from its own resources. (See Maxim 31.)

If you place your spark of light as the centre of another light graduating into the local colour or shadow of the iris or black of the pupil, you will produce an effect which I think is most true to nature ; if you place it in the midst of dark touches you will obtain an effect most striking and pleasing to the uneducated eye. Without comment I leave to you the choice, which a few experiments may best aid you in making.

The cavity of the eye is generally observable—some-

This author should have remembered that it is only by the degradation of minor lights that painters make white serve to represent the high lights ; and although photography, lacking this power, cannot give high lights, the lights given are none the less truthful, both in regard to size and intensity.

times very distinctly, sometimes faintly, but always more or less. It is sometimes indicated by lines, sometimes by a mass of half tint, and sometimes by a very delicate and scarcely perceptible shadow. In either case its faithful rendering is of importance; so pray don't overlook its preservation.

THE NOSE.

Let us now take our lady or gentleman by the nose. Say we have a three-quarter view of a face to work on; the nose is relieved against the "cast shadow" * or the shadowed side of the face. Strengthen with the same patient care I have before advised, the shadow which outlines the nose; do so tenderly, with a light hand, and a delicate touch, or we shall have a hard streak of black paint instead of a sweetly graduated shadow. (See Maxim 7.) This done, bring the shadow softly into the delicate tones between the nearest eye and the nose —*don't hurry*. Now touch the shadow under the nose, remembering that it is not a mere black patch, but is composed of intense touches of dark, which give vigour of effect and of reflected light, and half tones, which prevent harshness or crudity. Examine your photograph carefully, and, if it be a good one, you will see

* Shade is understood to indicate the absence of light, and cast shadows are understood to describe such shadows as are formed by the shapes of projecting surfaces. Cast shadows are always the darker.

that this is the case. This done, touch in the aperture of the nostril, gradually strengthening it until it is of the required intensity; it must not be too black, because not only is light reflected into the opening from below, but also through the semi-transparent flesh below the bone of the nose. In delicate children and women, it will be lightest; in men and aged persons, darkest. Trivial as some of these points may appear to the unthinking, the thoughtful artist has learnt to appreciate them at their full value; and I do not urge them upon your attention without having good reason for so doing.

THE MOUTH

Next claims our attention. Before touching this most important feature, carefully study its formation, and the various half and intermediate tints, which, betraying *the exact degree* of muscular action, rule the expression. Then, with the same tender care as before, begin with the upper lip, preserving its exact tone and shape, but strengthening the delicate reflected lights which play in soft minute touches about the centre of the shadowed half of the upper lip near the corners, and parallel with the line dividing it from the lower lips, and give delicacy, roundness, transparency, and truth of texture. The lightest portion of the lips, when compressed, will be found near the centre, because the muscles then draw them inward from the light as they approach the corners. The amount of projection

in the lips will be indicated by a soft shadow cast
by the upper one upon the lower, and by a strong or
faint light upon the latter; it is therefore important
to preserve the exact relative depth of the shadows here,
as a want of this care endangers the likeness. The
upper lip is always, more or less in shadow. A deli-
cate reflected light will be found tracing the outline of
the lip, faintly or strongly, according to its peculiar
form. Remember the remarks made upon the treat-
ment of polished bodies in photographs, and lower the
large light upon the lower lips to receive a smaller
high* light of exactly the same shape, which may be
either be left out or touched in with a little Chinese
white.† Of course this light will, by its form and bril-
liancy, indicate the lip's true contour and prominence.
The hollow (which indicates a smile), at the corners of
the mouth will give a shadow on the light, and receive a

* Highest or brightest lights—those nearest the illuminating
source.

† Be sure that this pigment is pure, as otherwise it will darken,
or blacken, and destroy your picture. Many Chinese whites (so-
called) prove to be no better or more permanent than the common
flake. If I was addressing a pupil in person, I should not hesitate
to inform him where I procured the best water colours; and in
despite of fearful delicacy, I will here state, that my first and only
master, the late highly respected and deeply regretted, Mr Charles
Foster (one of the best of a now-decaying school of miniature
painters, and a clever artist to boot), recommended me to purchase
Newman's colours, which I have ever since used, and have never
found surpassed. The fact is of sufficient importance to the
amateur to justify this notice, although I may risk unpleasant
comment by so doing.

faint soft light on the shadowed side. The strength of the shadow cast by the lower lip indicates its fulness, and, less distinctly, its shape. The darkest portion of the lips melt imperceptibly into the general shadow on that side.

HAIR, EYE-BROWS AND BEARD.

In beginning any part of your picture always consider its nature and effects. Hair is the most glossy when smooth, and very much less so when rough; the high lights will (by their degree of brilliancy) therefore go far to indicate this point. Don't let it appear as if newly greased and combed. Preserve the character of the photograph in the larger divisions of the hair and its high lights, shadows, and reflected lights, but never attempt to individualise particular hairs by putting in a series of fine lines, as many painters do. All effect, and all the charms of this really beautiful subject, will otherwise be destroyed. (My aim is not elegant composition, but effective teaching, therefore I again repeat my frequent caution, viz., do not let your lines be hard, and do not attempt to put any of them in with one stroke of the brush, or at any rate *not yet*.) Remember that hair partakes of the nature of polished bodies. Soften the outline of the hair into the background, but do not give it a softness foreign to nature (nor make it woolly) in the attempt. A flowing grace should characterise its masses, and a vigorous marking of its high lights and deep shadows give additional

softness (by contrast) to the rounded semi-transparent contours of the features. But again, with vigour it must not acquire a character of solidity, as if nothing less than a tempest blast could raise it, but while as hair it must be light, as a polished surface, it must have strong shining lights and intense darks, and then again as a transparent mass it must possess extreme softness. Every lock should be traceable to its root. I have given you a difficult task, and one which very few master, for hair is indeed one of the most difficult things to paint well.

The Beard or Moustache.—The latter will be lightest, being the most prominent; preserve the transparent character it has where thin, and remember that it can never (naturally) be quite as dark as the hair, for not being so thick, it is consequently modified by the skin being seen through.

The Eye-brow must be put in with a touch suggestive of its smooth and silky, or rough and irregular character, &c. Its darkest portion will be found nearest the nose. Do not destroy the faint or strong shadow observable beneath it, neither in shape nor depth.

BRINGING OUT THE HEAD.

You have now secured the principal features, but, before proceeding, examine your picture side by side with a good untouched print upon albumenized paper,*

* Prints upon albumenized paper invariably give more detail and better gradations.

to convince yourself that the true form and expression have not been in any degree destroyed. The greatest difference should be found in the increased transparency of the shadows obtained principally by strengthening the " reflections," and a greater force of effect in your " touched " picture.

THE PRINCIPAL LIGHT.

A well-lighted head will have the highest or brightest light upon the top of the forehead, and the faintest upon the chin, and between them the high lights will graduate according to the prominency of the surface upon which they fall. This rule should never be lost sight of. The light upon the forehead is brightest because nearest to the illuminating point ; and that on the chin faintest, because farthest from the same. In treating all lights, therefore, proper subordination to that which is the principal becomes of great importance.

REFLECTIONS

Constitute one of the most important elements of round-ness.* The following experiments will do more to illus-

* A point which I have, in a preceding chapter, strongly urged upon the attention of photographers, who have sadly neglected this source of beauty and effect, and thus originated in the minds of clever men, not practical photographers, a belief that the power of our art is so limited as to be unable to secure the proper order of artistic effects. See the article I have before referred to in the " Quarterly Review."

trate this, and impress it clearly and forcibly upon your attention, than all I could write upon the subject.

Take a white globular form and place it in the direct light from any aperture. Where the rays of light fall you will of course find the "highest" or "principal light," and from this point the tints of the surface will deepen in proportion to its receding character, until where it becomes darkest it will again graduate into a shining reflected light.

This reflection will, however, by contrast, appear much stronger than it really is, and to prove this try another experiment.

Lay a roll of writing paper on a piece of white card immediately before a window, and bend up the card on the side farthest from the light, until you get the reflections as *strong as possible*, then compare the reflected with the direct light, and you will immediately see how great a difference exists in their relative strength or power.

Reflected lights will be found near the extreme edge of the shadows on the side farthest from the illuminating point, and in or near the centre of such shadows as are formed on surfaces shielded by their projection from direct light.

With the utmost attention to the preservation of the photograph, then judiciously strengthen the reflected lights, by touching tenderly upon the masses of shadow, modelling with the same faint touch until the head begins to assume the roundness of a marble bust.

BLACK AND WHITE AS LIGHT AND SHADE.

Considering the form of the head as very similar to that of a globe, you will at once understand how small a portion of its surface is exposed to direct light ; and as this portion of direct must be represented with white, it will be apparent to you that such photographic portraits as are nearly all white (as but too many are), must be thoroughly false to nature. Take white as representative of your highest light, black as the representative of your deepest shadow, and between the two blend as many tones as will give (nearly as possible) that insensible gradation from light to shade which exists in nature. Many photographers, either by the printing, exposure, or developing, absolutely *endeavour* to produce the flat effect obtained by too great a preponderance of white, and it is only on such pictures that the process of touching becomes a positive necessity ; for if they (the operators) will not or cannot get truth in the camera, as they certainly may, they must from the brush.

METHOD OF WORKING—WASHING.

In applying the first strengthening tints, do so with a few *faint* " washes," avoiding either too full or too dry a pencil, calculating the space you have to cover, and taking up just enough colour to do it with, using a small or large brush according to the quantity required. Your " wash," as colour so applied is called, cannot be

too pale, although it is bad policy to repeat this process frequently, because it disturbs the surface of the print. A small piece of paper may be placed beside you to test the strength of your tint before applying it to the photograph. Let one tint be lost in another as gradually and imperceptibly as you can. In graduating a wash, either take up water or colour, according to your desire, whether it be to graduate it from pale into dark or the contrary. In graduating with touches, do so by repetition, carefully observing the minutest gradations, and using but little colour.

The first wash should be allowed to dry before the application of a second. If it prove too dark, wash it with clean water, and absorb the moisture with clean blotting paper.

HATCHING.

This is a process of working with oblique lines, forming lozenge-like apertures, and indicating by their degree of curve and regularity the form and character of the surface represented. The lines should taper to a point at either end, as they then blend better into an uniform mass. In line engravings and chalk drawings, hatching exhibits great power of expression, every line representing the alternations of the surface and being capable of describing its texture; but in flesh these lines by being repeatedly crossed in different directions assume all the appearance of a stipple, and thus serve to express the smoothness as well as the transparency of

flesh.* Carefully avoid crossing the lines at right angles, as you would then obtain the effect of net-work, and do not make them long. Commence with short, broad, tender touches, placed at regular intervals, and in a nearly horizontal position, beginning with a rather firm pressure, and finishing with a lighter one; with the same touch cross these lines horizontally, and repeat the process at slightly-varying angles until the requisite depth is secured. Avoid leaving little blotches of colour at the ends of the lines, and do not cross one set of lines with others until the first are dry. The part where the lines intersect will, of course, be darkest, but should not be strikingly so. Hatching is a far more artistic mode of working than "stippling;" but the latter is frequently blended with the former to increase the "smoothness," or what is vulgarly and erroneously called "finish." Stippling is, to my thinking, only legitimate when it is used to even up any small space which has been left too light in the process of hatching.

STIPPLING.

What some folk would do without stippling I don't know, for, like charity, it "covereth a multitude of sins" —sins against common sense and every quality of truth.

* Hatching enables you, as it were, to look below the surface; or, in other words, gives that depth and transparency which could never be obtained by repeated washes.

It is painful to the real artist to hear the high praises constantly lavished upon productions breaking every rule of art, and displaying no better quality than that evinced by patiently and laboriously dotting over with a pin-point pencil a certain small space of paper. I'm sure I ought not to denounce it, for when I first began to experimentalise upon the public, that same mechanical stipple did me a world of good service; and there are many very worthy fellows, profoundly ignorant of painting, who support themselves most comfortably, and with an immense amount of self-satisfaction upon their stock of patience, dealt out in the shape of stipple to an admiring public at the rate of so many guineas per square inch.

Stippling, then, is simply the covering of a surface with a vast number of minute touches or dots.

It is, of course, much easier than hatching, and *perhaps*, by its adoption, you may obtain smoothness and softness—qualities which I have no fault to find with if they do not blind the student to those of a much higher order, if they are in their proper place, and do not originate that thoughtless laudation which is so seriously dangerous to real progress. Most of the worst-drawn pictures I ever saw were stippled highest, and there is nothing in the use of this stipple which may not be won by the veriest " 'prentice han'," if its owner will not grow weary of the interminable and monotonous dot, dot, dot, dot, dot, of the process. Hatching educates the hand and eye, and implies a knowledge of form and

texture. Stippling educates neither, and implies a knowledge of —— what ? For rudimental study at least, therefore, pray adopt the method of hatching.

DRAPERY.

If the head has been properly lighted, you will find great roundness in the folds of the drapery and its gradations of shadow, which it must be your especial care to preserve. Remember to graduate the strength of your high lights, and preserve the relative intensity of the shadows, deeper shadows being, of course, associated with the fainter high lights, except where powerful reflected lights moderate their intensity. Keep the more prominent folds lightest, that the effect of retiring surfaces may be increased ; and if the number of folds appears destructive of breadth, judiciously omit such as play no important part in the expression of form or texture, and are situated near the larger mass of light. Seeing that the particular quality and character of drapery is indicated by certain peculiarities in the folds, be careful not to destroy this effect. You will find small narrow folds have a tendency to angularity, and larger folds to curves ; do not, therefore, give the one species a characteristic peculiarity belonging to the other. The specific quality of surface being (as I have said) indicated by peculiar lights and shadows, and by characteristic folds, you will perceive the danger of making any alterations in a good photograph, in which

all these qualities are displayed in such wonderful perfection. However, to assist you in recognising (and consequently preserving*) these important points, I will just note down a few of their peculiarities.

CLOTH.

The folds in cloth (being a rather thick and soft material) have much beauty, are broad, rather flat, and greatly varied in their character. The lights, unless where the surface is very glossy, are not strong, will be easily discovered upon the most prominent parts, and are very soft in their character. Shining lights will be found tracing the channels formed in the hollows between the folds, or in their breaks; which lights are more abrupt than high lights, and very nearly as strong. The reflected lights are weak. Without advocating a servile imitation of various stuffs, I certainly think each should be so represented as to leave no doubt in the spectator's mind as to what the drapery is really composed of.

SATIN.

The folds of this material are somewhat conical and are frequently broken into crescent-shaped terminations in consequence of its stiffness. Its reflected lights are

* The reader will have noticed the constant repetition of this word, purposely introduced to impress upon his mind a principle which should never be out of the colourist's view. *Carefully preserve* may, indeed, be called the photographic colourist's motto.

strong, its high lights brilliant and well marked, and its shadows seldom very intense, in consequence of the presence of reflected lights of a more than usual strength and number. The masses of light and shadow are generally very picturesque, and may be judiciously strengthened by a proper gradation of the lights, shadows, and reflections, from the lighted to the shadowed portions.

VELVET,

Being seldom photographed well, demands more attention than other surfaces. It is very picturesque when well managed, and is so strikingly different from all other materials as to be easily recognised. The prominent parts are darkest, and the lights are found near the edges of the folds or receding parts, and wherever the undulations of the surface cause the pile to catch a stronger light. Velvet being very thick and soft, the folds are massive and rounded in their contours, and the breaks are more gradual.

FUR

Is very perfectly displayed in good photographs, and should not be destroyed in the colouring. Its character resembles closely that of velvet, and the lights are discoverable *near*, but not so *close to* the edges, because the surface of hair is more raised and open than the pile of the velvet ; for the same reason its edges are

more transparent, and blend imperceptibly with the surface upon which it lies. The prominent parts of fur are dark, its reflected lights strong, and its folds large.

I do not think I need offer any further remarks upon the subject of drapery here, as you are sure to be correct if you adhere closely to the photograph, and duly consider the nature of the surface to be rendered, whether it be rough, smooth, or polished. And thus end my remarks upon " touching " photographs.

CHAPTER IX.

WATER COLOURS—ON MIXING THE PIGMENTS.

THE principles which guided you in the use of black and white only are just as necessary for your practice in using colours, and I therefore hope you will not neglect the instructions contained in the last chapter. But, although the gradations of colour are quite as delicate and imperceptibly soft and harmonious as those of light and shade, still there is this great difference, that while in the one case you merely strengthen or weaken the single tint in use, in the other every change is not only a change in the quality of light or dark, but also a positive change in tint or colour. Now in changing the tone of a colour, or in any way altering its character, it is important to keep all your hues, whether nearly pure or frequently " broken,"* clean and fresh. You must, therefore, in mixing your pigments use such as will not only produce by mixture the requisite tone, tint, or hue ; but you must be careful to mix such only as blend kindly together, so as to produce a clean and pleasing result (to assist you in doing this, I gave

* Colours are said to be broken when mixed, or, in other words, not pure.

in a former chapter a full description of all the pigments more commonly used, with their peculiar qualities in reference to this aim). When, however, the particular effect desired cannot be obtained by merely mixing the pigments, one is hatched or stippled over the other. For instance, should you desire to preserve the purity of a delicate colour, and yet subdue its brilliancy, you will secure this by hatching over the same with, say, blue, because certain minute but undetected portions of the colour already applied over the whole surface retain their original purity, although an equal portion of the same is subdued, and two colours which would not work kindly together when mixed in solution, are thus harmoniously blended without muddiness or manipulatory difficulty.

If you have adopted the plan given in these instructions, you ought now to possess some knowledge of the scientific theory of colour, of the chemical and working properties of your pigments, of the principles which rule the practice of our best artists, and of the importance of light, shade, and reflections. You ought to know how to preserve the truthfulness of a photograph, how to strengthen and increase their more prominently artistic qualities, how to wash (don't joke), how to hatch (pray don't), and how to stipple—consequently, we may at once commence practice with water colours.

THE PHOTOGRAPH.

Select a good one. Don't let it be a flat white-faced image ; but tell the printer of that same specimen to produce you a faint delicate picture, with as little black as possible, and with all the gradations of shade un-altered. Of course the printer will look at the negative before he promises to produce such a proof ; but if the negative be satisfactory, he can do it ; and your per-suasive power must make him say he will.

A pale warm gray is the best colour for the print, and it can be got with ease on both the plain and the albumenized paper. The whites should be as pure as they can possibly be preserved. It should be mounted with gelatine, starch, or thin glue, on good stout London board, and (unless you have a machine yourself) sent to the hot pressers to be rolled (not *hot* pressed).

PREPARATION OF THE PHOTOGRAPH.

The albumenized prints are not so frequently chosen by colourists as those on plain salted paper, because the colours adhere better, and the washes can be repeated with more safety on the latter than the former ; but some exquisitely beautiful effects have been obtained on both the one and the other. The albumenized paper gives softer gradation and better detail in the print. To assist the colourist in securing for the latter all the advantages of the salted paper, Mr. Newman has recently prepared a

solution which, while it answers admirably for the pre-
paration of the prints on both papers, has the excellent
quality, when used with water as a medium for your
colours, of enabling you to repeat the washes without
fear of their being disturbed.

Many means of preparing the print have been adop-
ted, some using ox-gall, some isinglass with two or three
drops of ox-gall, some a weak solution of gum. Others
use parchment size, containing a very small portion of
alum ; and others, again, a combination of distilled vine-
gar, borax, and gum-arabic; but I have found no pre-
paration to surpass that already spoken of as New-
man's. In preparing the salted paper, you will find
it more or less absorbent, according to the method of
washing and fixing adopted by the photographer.
Some prints will require two, or even three coats of
size, and others but one, while some may be used
without any preparation. In spreading the sizing
solution, do it evenly and thinly, that it may not
assume the appearance of a varnish, and let one coat
dry thoroughly before applying a second.

THE GUIDE.

This is a second print, much darker than the first,
which the colourist places beside that he is about to
colour upon, as a guide to assist him in preserving the
drawing and details of the photograph. It should be
printed upon albumenized paper, with every scrap of

detail unmistakeably secured. When the negative is of that peculiar character in which the drapery has been sacrificed to the proper definition of the head, or on the contrary the head to the drapery, two guides should be printed, one for the head and the other for drapery.

PRACTICE.

You have taken your seat at your desk, resolved to be very patient and particularly careful, or we will suppose you have done so. The water, brushes, colours, ox-gall, gum-water, and palette are at hand, in a clean condition for work. The picture before you is, say, a portrait of a fair person of the fair sex. I would recommend you always to colour from the life, and never, unless impossible, to do without a sitting for the colouring; as the results will always be more satisfactory, and the practice infinitely more advantageous.

The recommendation of colouring from the life is important, as you must see, if you glance from your photograph to its living representative, and listen to the few words I will now take the liberty of addressing to you. Examine the more luminous tints of the sitter's flesh, and then turn to the photograph. Now, with nothing but transparent colours, and upon nothing less brilliant than pure white, can these be well imitated. Of this you may be sure. The tints which are luminous in the next degree being harmoniously associated with the first are still brilliant; therefore, the tints indicating

these in your photograph must not be too dark or too powerful a tone, if you would approach the real truth and beauty of such a surface. The exquisitely delicate pearly demi-tints seen in various portions of the face can never be obtained on sooty grounds, if such be the character assumed by their representatives in your photograph; of this, again, you may also be sure. Moreover, too cold or black patches, in the darker shadows, destroy their warmth and transparency, qualities essential to artistic results. For these reasons, therefore, it is of the utmost importance to get your proof not only from a good negative but also to get it properly printed.

Now, although you may have as good a photograph as could be desired for your purpose, still most of your flesh tints will be more or less degraded by the tones of the photograph; for this species of colouring, therefore, one of two methods must be adopted, viz., the use of opaque colours, which absolutely destroy the photographic shadows altogether; or, the use of such of the more powerful transparent and semi-transparent pigments as, without endangering the likeness by destroying the shadows, will only kill their more objectionable qualities. Thus it is that a scale of colours and tints are requisite for photographs entirely differing from those used for ordinary miniature painting.

As you are about to begin the flesh of your subject, it is only fair that you should first study its character.

Let us say the model is before you. She is a lady. Her complexion is fair and delicate, although not sickly.

I desire you to study her face, note the peculiarities of local colour, and how it changes under the varying circumstances of contour, bone, muscle, blood, veins, &c. So you turn and look very earnestly into the lady's charming face.

The fair young creature cannot sustain your thoughtful but continued gaze, and down go her silken eyelashes, while up flushes the rosy blush. There is lesson No. 1 for you, viz., the transparency of the material. Now, do you think this transparent surface, so beautifully pencilled with the tender tracery of veins, and so eloquent of the flowing blood beneath, can ever be obtained by the use of pigments mixed with white? which, as Barnard justly says, would give you the appearance of "a woman who uses a cosmetic, and dusts her face all over with it, producing a mealy whiteness, which will never bear a close scrutiny." For this reason again I use transparent colours.

But the lady, your model, feeling it ridiculous to blush under the gaze of an art-student examining her simply as he would a beautiful flower, an evening sky, or any other such exquisite piece of nature's handiwork, is now seized with a desire to laugh, and, raising her fan, presses it upon her lips to restrain the laugh, although the bright eyes (saucily asserting their independence of the mouth) are full of arch merriment none the less: and here is lesson No. 2 for you, viz., the amount of solidity possessed by the material.

The appearance of partial transparency and that of

due solidity must, therefore, be properly blended, if you desire to obtain the real quality of flesh in your colouring. (See Maxims 35, 42, 44, 47, 52, and 53.)

Observe, in the next place, the glossy surface of the skin, as evidence of its smoothness, and be sure you preserve this characteristic. Unless the lady be a sweetheart or wife, you must of course take the softness of this very beautiful surface on faith only, otherwise an application of the essence of tulips would, as an old joke says, prove its existence.

Turning again to your model, observe that where the bones are most visible under the skin the lights are whitest, but with somewhat of a pale yellowish tinge; that the delicate carnation of the cheek is not a smooth, even tint, but is full of inequalities and beautiful variety.

Above all, note the effect given by the scarcely apparent down covering the skin, modifying the tones of the demi-tints, blending and harmonising the local colours, giving a peculiar softness to the outlines, and a bluish tinge to the retreating surfaces, which is very apparent. This down being so nearly white in a fair person, has much to do with the great delicacy of the face. If you place your hand so that it is partially in shadow you will see how the down covering it is darkish in the direct light, and catches the light as it retires into the shadowy parts, just as the raised pile of velvet does.

You will also perceive that where the pinky hue of the cheek nears the jaw, this tint is broken with peach-like hues, violaceous and bluish grays, and greenish and

warm demi-tints, melting into and emerging from one another with the same imperceptible gradations

Turn once more to your model and examine with care the high lights of her face. Are they warm or cold? Now, nearly all, if not all, teachers will tell us they are warm; therefore, you must receive my statement with all due caution, when I tell you that, on the contrary, they are *cool*, if not cold.* I put this assertion forward with some little hesitation (although I have reached this un-orthodox conclusion through a long and studious observance of nature), because I am opposed therein by high authority. Still, flesh certainly partakes of the nature of polished surfaces, the high lights of which are admitted to be cold. Without dwelling upon the point, however, I will merely recommend you to seek the truth where that quality ever exists, although there it is not too often sought for, viz., in nature.

Having devoted so much study to the model herself, you probably turn to your work with a feeling of despair, hardly daring to hope that with mere pigments and paper you can approximate, however remotely, to the exquisite delicacy of the lady's complexion; and as your eye recognises the infinite variety of tones, tints, and shades of colour which compose the shadows and half

* I quoted in the Maxims some brief directions given by Rubens to his pupils, as transmitted to us by the Chevalier Michel. "Paint your lights *white*," said that great master (see Maxim), and then adds, "Finish by passing gently over *the whole* with a brush dipped in *cool gray*." Now this would certainly render the white high lights unmistakeably cool.

shadows, demi-tints, grays, purples, and violets, you perhaps wish you had not undertaken so difficult a task. Now, I hope you have these feelings of despondency (unpleasant though they may be) ;—they are glorious signs, harbingers of bright hopes, and heralds of the highest order of success. But, if you have them not, why then you will be more comfortable in your mind, and that is a blessing too—is it not ? In the first place, you will think with me that photographic colouring is really artistic, and demands genuine study and persever-ance. In the second place, you will think, with the author of *A Guide to Painting Photographic Portraits*, that " the process of colouring photographs is by no means so difficult a matter as you might at first have apprehended. There are certainly some obstacles to be encountered, but they will soon be overcome," &c. As a rule, however, beginners are much inclined to think it is remarkably easy (and discover their mistake after-wards) rather than the reverse, and I therefore warn you to prepare for the difficulties you will inevitably encounter. The man who goes unarmed into a battle-field, thinking his enemy will fly at his approach, is very likely to find himself speedily conquered.

THE PAINTING.

The process I am about to describe is one essentially adapted to the beginner.

With a faint wash,* composed of madder pink,

* Washing, hatching, and the other technicalities here used, have been fully explained in the preceding chapter.

slightly modified with a very small portion of raw sienna, go over the whole of the flesh. In doing this, charge your brush with sufficient colour to complete the wash without a pause, otherwise it will (as I have already pointed out) be irregular, and assume the appearance of hard edges in the most undesirable places, which you will not easily get rid of. Next take a little Indian yellow and madder pink, using but a small proportion of the former, and strengthen your flesh wash by hatching upon it, leaving the high lights untouched. Now strengthen all the lines, such as the eyelids, division of the lips, nostril, &c., with Indian red, either pure or mixed with a little cobalt ; or should the same be very black in the photograph, with pure vermilion, used thin. Do not forget the necessity I have already so often urged, viz., that of doing all this gradually, and with faint and repeated touches.

If your photograph should chance to be one of those dull specimens which would entirely destroy the purity and character of the transparent flesh wash recommended, adopt another, composed of madder pink and pale lemon yellow or Naples yellow (the first is the better because most permanent), and then proceeed to hatch upon this with the tint of the first wash, &c., as described. This second wash, being semi-opaque, will cover and kill the gray tint of a bad or indifferent photograph better than the wash of purely transparent colours. If Naples yellow be adopted, you must remember that there are two preparations of this pigment —the one cold and greenish, the other warm—named

respectively No. 1 and No. 2. The warm is the better for flesh tints; but if you use the cold for the wash in question, it must be corrected with a larger proportion of madder pink. Beginners should use the warm. At this stage your photograph should be but faintly tinged with colour ; and if the colours appear too positive or strong, reduce them by working upon the surface with *pure* water only ; or wash them partially off with a *soft* clean brush and water, using blotting paper to absorb the superfluous moisture—adopting the latter plan, if all the colours applied are too powerful ; and the former, if such is the case in parts only. After washing off, the surface of the paper (especially if the plain salted paper be used) is sometimes found to be rubbed up ; to harden and smooth which take an agate burnisher, and placing your print upon a sheet of polished plate glass, lay over the surface thus disturbed a piece of *clean* smooth writing paper, and firmly, and with an even steady pressure, rub it down with the burnisher until it is again glossy and hard. The burnisher may of course be used for this purpose whenever necessary. To such colourists as labour long at a picture, or wash frequently, it is indispensable.

THE GRAYS.*

Now mix a little Indian yellow and cobalt, using just enough of the former to give the latter a *slightly*

* See Maxims 44, 40, 42, 43, 13, 19, 16, 46, 32, 37, 54, 55, 56.—Mr. C. W. Day justly observes, in his cheap little work "On the

greenish effect, and with this hatch over such of the demi-tints as by careful attention in examining your model you find assimilate to the hue obtained in working with this over the corresponding tints of your photograph. Here, as before, substitute the more opaque lemon or Naples yellow for specimens which are either bad ones, too dark, or ill-printed. In this and all other directions for compounding the tints of flesh (more especially the grays), you must consult your model, inasmuch as they not only invariably differ in different complexions, but also in their different positions; where the skin is yellow, they are most green; where white, most blue; where ruddy, most purple; where pink, of a violet hue, &c.; but *in all parts of the flesh they abound.*

Having worked in this slightly-greenish gray, take next a little ochre, cobalt, and madder pink for such grays as are to be found upon the edges of shadows or upon the retiring surfaces. The same mixture will be useful in softening the eyebrows into the flesh, and working near or upon the outline of hair which cuts against the brow or cheek. On the cheek, owing to the presence of the carnation, the gray will be composed

Art of Miniature Painting," that "in observing the colour of the human face, the uneducated eye sees nothing more than the general or local colour, making no nice distinctions between shadows, 'demi-tints,' 'pearl,' or 'gray tints;' yet such gradations and varieties do exist; and very much of what is called 'flesh colour' is composed of purples and grays."

of cobalt and pink madder; and the same hue may be used in rounding that part of the chin which is pinky in colour; it may also be selected for the half-tints of the eyelids, and used near the corner of the eye which is nearest the nose; on the receding outline of the nose itself, &c., as due examination of your model may decide. A little more or less of the pink or blue will be used in this mixture according to the effect desired, and sometimes a little Indian yellow may be added to destroy to some extent the purplish tone. In applying these colours, the tints covered having their part in securing the desirable effects, you must not use them unmodified for putting in such half-tints as, although not secured in the photograph, exist in nature.

SHADOWS.*

Now, unless the photograph be a pale one, work upon the half shadows† with a *thin* mixture of Venetian red and Chinese white, using *very little* of the latter, your object being merely to destroy the coldness of the photographic hue, and assist in converting it into a warm grayish tone.

A few delicate touches of pure vermilion (thinly applied) may be next used in the shadows, and a little madder carmine ‡ may be combined with it for the

* See Maxims 48, 37, 30, 38, 43, 56, 57 62, 63, 69, 77, 82.

† The half shadows will be found between the lighter half-tones and the shadows, uniting harmoniously the first with the last.

‡ In the list of pigments, given in a former chapter, this colour was forgotten.

more intense darks, over which may also be worked
a mixture of madder carmine with cadmium yellow
and Indian red, until the blackness gives place to a
warm transparent effect, which, if these colours be
judiciously used, will soon be apparent. Still, re-
member what I have so constantly urged, viz., *don't
hurry*. If any shadows require defining more strongly,
use for the purpose madder brown: those which are
called "cast shadows," and which will be found upon
the shadow side or beneath projecting features or
surfaces, will be sure to require strengthening in
parts with this pigment.

THE EYE. *

We will suppose the eye blue. Put in the pupil
with indigo, or indigo mixed with a little lake and
sepia; the iris with cobalt, outlined with a little
cobalt and indigo; touch in the reflected light with
cobalt and Chinese white; strengthen the markings
of the lower eyelid with Indian red or madder brown
(the latter if the photograph be faintly printed), and
touch in the lash with "warm sepia;" this latter
colour may be also used for the eyebrows. The edge
of the upper eyelid must be warmer and less dark
where nearest the nose. Soften the edges of the
shadows at the corners of the eye and under the lower
eyelid by hatching and stippling upon them with

* See Maxims 40, 50, and 58.

cobalt and light red. Work into the socket of the eye a faint, delicate lilac tint with a little madder pink and cobalt. Take a little cobalt over the white portion of the eye, and work some of the same between its corner and the nose. Put a few touches of vermilion and madder pink into the corner of the eye nearest the nose.

THE CHEEK AND LIPS.

For the lips and cheek a colour is made by mixing vermilion and madder pink, using most of the one or the other pigment according to the requirement of your model. For the complexion you are now painting, or supposed to be painting, use rather more vermilion than pink. Hatch and stipple the colour into the cheek with patient care, and with faint and oft-repeated touches, preserving the purity of the colour, and avoiding every appearance of an artificial effect, by softening and diffusing the pink into the grays around. This done, colour the lips with the same, using a little lake and vermilion for the upper or shadowed lip, softening the edge of the lower lip with great care, and preserving the high lights, half and reflected lights, toning down the colour as it recedes from the light, but, at the same time, securing a fresh, bright, moist appearance. Owing to the light's chemical " effect defective," the lips are almost invariably too dark, and the high

light too large, as I explained when speaking of the treatment to be adopted for polished bodies; for this reason, rather more vermilion may be used for the lips than the cheek; and sometimes it will be necessary to prepare the lips for colouring by working upon them with thin washes of Chinese white, slightly warmed with a little vermilion; upon which, before proceeding with the colour, it may be as well to use the burnisher, but do not do so until the colour is perfectly dry. If the white is put on too thick, it will work up and spoil your colour. In applying the colour over the white, use that recommended for the cheeks, and less vermilion. The division of the lips and the darker touches may be given with a little lake and burnt sienna.

THE CHIN, NOSE, ETC.

The chin will partake of just a little of the colour applied to the cheek, so will the nostril and the ear. The aperture of the nose may be touched in with a little Indian red and madder carmine, and strengthened with a mixture of lake and burnt sienna.

Madder pink may now be stippled *delicately* over the whole face, excepting only the principal lights, but should by no means produce a positive effect.

THE HAIR.*

As the colour of this will materially modify the general effect, you had better at once wash in the local colour. Indian yellow, with a slight portion of Venetian red, as your subject is fair, will form the wash. This must be used strong to kill the photograph, which is sure to be very much too dark, unless you have induced your printer (who is, however, not always very manageable in an artist's hands) to procure you a proof in which the hair has been rendered rather more opaque in the negative, or (by the aid of some very useful bits of wool) printed but faintly in the positive you are colouring. A little warm sepia will serve for the darker portions; and the same, used stronger, will also answer for the darker shadows and divisions. The high lights may be put in with white and yellow ochre, between which and the shadows place a cool gray, formed with cobalt and Venetian red, with a slight touch of madder pink. This same gray will answer admirably for softening the outlines of the hair into the flesh; for you must remember that the hair should never cut sharp and hard against the flesh. If you just think about the matter, you will see that the edge of the hair must necessarily be thin and transparent; that it also casts a shadow nearly as dark as itself, and that

* See Maxim 49.

it, therefore, must melt imperceptly into this shadow.
Then, again, as all the shadows of flesh have their edges
softened into the lighter passages with grays, from the
edge of the cast shadow to that of the hair, must be a
series of very minute but delicate gradations.

When the combinations of colour given above do not
give the desired effect for the hair, you may choose from
the following list that mixture which most nearly ap-
proaches its apparent hue :—Raw sienna—warm sepia
and Indian yellow—raw umber, or ditto with Indian
yellow—burnt umber—yellow ochre and burnt umber—
cold sepia or Vandyke brown. Many other mixtures for
this purpose will suggest themselves in the course of
your practice.

Refer back to remarks upon this subject under the
head of " touching."

THE NOSE.

Work (with the same tenderness and faintness of
touch which I have so continually recommended) a
little cobalt and Indian red* over the shadow, tracing
the outline of the nose, preserving the edges as in-
definite and soft as is consistent with the due preserva-
tion of form. Put in the aperture of the nostril, in a
series of faint touches, with vermilion and Indian red,
and, with a touch or two of lake and burnt sienna,
indicate the darker portions of this aperture as you find

* This must not be mixed to a cold or slaty hue.

them in your " plain guide." The high light upon the
tip of the nose may be got with a touch of Chinese
white, and the less brilliant but conspicuous light
running down this feature opposite the shadow may
be obtained by leaving it out when you are strengthen-
ing the tints about it.

THE CHIN, ETC.

The chin is to be carefully and gradually rounded
out with the tints already given. Detecting the faint
reflected light beneath the shadow, you may, by
strengthening the first, give it more effect; and, un-
less the colour of the object reflecting this light decide
otherwise, keep it warm.

Hints.—Having proceeded thus far, pause, and care-
fully examine your work. If any lines appear hard and
harsh, soften them by working upon their edges with a
series of tints and colours, selected with a view of
softly and harmoniously uniting the two edges, which
are so abrupt in their meeting. If this gray, that pink,
or this yellow hue are too positive, do not harmonise,
or want keeping; subdue them with the same patient
care so urgently and frequently desired. If a shadow
has so hard an edge that it looks more like a patch
of paint than a shadow, soften it into the lighter
portions with warm and cool grays, using the warm
first and the cool last, and keeping the first nearest
the edge of the shadow, &c. Remember that all the
flesh tints should melt imperceptibly into each other ;

that the touches must be very lightly applied, and without overcharging the brush with colour. Work up the dark tints very gradually. Put on the washes *very* pale ; endeavour to keep them even and flat ; and, to soften their edges, just touch upon them with a brush merely moistened with pure water ; apply a wash as expeditiously as you can, and do not disturb it by touches until dry. I am repeating myself again! you say. Well, and so I must, if I want to make an impression upon such material as beginners are generally composed of, as drops of water do on stone.

You are now to continue your work until you have obtained the requisite degree of finish, roundness, and force of effect.

BACKGROUNDS.*

Although I have taken the features separately, they should really all progress together ; and although I have described the painting of the head first, you should have got in progress other portions of the picture, as, when all parts advance simultaneously, there is less chance of mistakes in the *chiaroscuro,* relief, or arrangement of colours. The background may be washed in with any of the following colours or mixtures :—

FOR A GREENISH BACKGROUND.

Burnt sienna and prussian blue.
Blue, burnt umber, and raw sienna.
Yellow ochre and indigo.

* See Maxims 66, 68, 73, 75, 76, 79, 81, 83—92.

Sepia, gamboge, and indigo.

Indigo and gamboge, with or without a little burnt sienna
(as the *photographic* background may decide).

Yellow ochre and lampblack.

Lampblack, gamboge, &c.

Raw sienna and cobalt.

Bistre and prussian blue.

FOR A SKY BACKGROUND.

Indigo and cobalt.

Cobalt and madder pink or French blue.

Prussian blue and madder lake.

Cobalt, madder pink, and Chinese white (used thin).

FOR CLOUDS, HORIZON, ETC.

Yellow ochre, rose madder, and cobalt.

Sepia, rose madder, and cobalt.

Lampblack and indigo.

Black lead.

Sepia and cobalt.

Lampblack and lake.

Payne's gray.

Vandyke brown and indigo.

Vandyke brown and raw sienna.

Raw sienna.

Raw sienna and brown madder.

Yellow ochre alone, and with brown madder.

FOR WARMER BACKGROUNDS.

Raw sienna and Vandyke brown.

Sepia and brown madder.

Purple madder.

Burnt sienna and sepia.

Raw sienna, brown madder, and indigo.

Light red and sepia.

Brown madder and indigo.
Indian yellow, burnt sienna, and indigo.
Lampblack and lake.
Sepia and purple madder.
Vandyke brown.

FOR A COOLER BACKGROUND.

Lampblack and French blue.
Lake, indigo, and Indian yellow.
Payne's gray and burnt sienna.
French blue, brown madder, and burnt sienna.
Vandyke brown, lake, and indigo.

I have given you these mixtures, but their proportions and selection must, of course, rest with yourself; and you must be guided by the effect you wish to produce in making the last or mixing the first, remembering that your picture's artistic value is dependent, to a great extent, upon a judiciously-managed background. (See Maxims.)

Say, you are working a greenish background—well, you have to avoid making it of too uniform a colour, too cold or too flat (from the want of light and shade) ; and having laid on your wash, and evened it up, if necessary, with a hatch or stipple, or both, continue to work upon it until, without appearing to be perfectly unconnected with the figure, it throws the portrait well before it by its quiet and retiring character. That it may look as little like paint as possible (see Maxim 17), hatch different colours over the whole, making it warmer or cooler here and there, as the colour of your drapery or

nature of the subject may suggest. (See Maxim 53.)
A dark background produces the most forcible effect,
but it should not be so dark as to kill the deeper
shadows of the flesh.

Or, supposing you desire a sky background. Begin
with your wash, and hatch or stipple it into various
gradations of light and dark, warm and cold, working
in clouds, if desirable, by leaving the space for them
untouched by the first wash, and then touching them in
with the colours given for the purpose. These clouds
frequently enable us to extend the light or dark; to
vary the colours, or repeat "bits of colour" which might
otherwise appear patchy; for it is a rule in art that in
one bit of colour unsupported and unbalanced is a
patch, whereas, when repeated by similar colours, it no
longer attracts attention by its rarity and singleness, and
consequently does not tend to destroy unity in the com-
position. The first wash for the background should
always be more pure and bright than it is intended to
remain, and should be one which may be used for this
purpose with ease and certainty; every mixture of colour
for the washes should be made with due reference to the
cold or warmth, and the light or dark character of the
photographic ground you are about to cover. For a sky
background the photographic ground should be light.

When the background is so good in the photograph
that it is merely desirous to change its tone, a clean,
clear, simple wash will sometimes answer. There is a
pigment prepared from red chalk which washes with

singular smoothness and flatness, but which is not kept by all colour makers.

Opaque backgrounds may be secured with washes of body colour, which are usually applied as follows :— The tint is mixed with as little water as possible, in order that the colour may not be too fluid ; and the mixture must rather be too dark than too light. The background is slightly damped, and the tint applied as a wash. You must be very careful not to go twice over the same spot till it is quite dry. A very good colour for this purpose is made with ochre, lampblack, and Chinese white. I do not admire, however, nor recommend opaque backgrounds. Such grounds may be also obtained by simply rubbing in powdered crayon with the finger, using a stump* to bring it up to the outline of the figure.

If your subject be pale, that pallor may be prevented from appearing unpleasantly ghastly by causing your background, by contrast of colour, to give it warmth. If too red, by the introduction of some accessory of a brighter and more powerful red you may make this defect appear less striking. If too brown, you may improve the appearance by introducing stronger and more decided browns in the background, and so on, without at all violating the truth of nature.

If you desire any objects introduced behind the figure, they must (as I have before said) be very simple and unobtrusive in their character and few in number ;

* Prepared, with pointed ends, of leather or paper.

their details, too, must rather be slightly indicated than closely imitated. Study must also be devoted to the background as associated with the character of your subject.

For instance, here, say, is a picture of a graceful girl, with light gauzy drapery of summer fashion floating in swelling, tremulous clouds of transparent material around her. It is the production of an *artist* photographer, and he could not conscientiously represent anything so fairy-like with strong lights and powerful shadows ; so, with true artistic feeling, he has secured the most tender and delicate gradations he could obtain by a skilful arrangement of his blinds and reflecting screens, without endangering the existence of that roundness and relief necessary to avoid flatness. Now, if you put behind this judiciously-treated production a strong dark background, all this beauty becomes transformed into flatness, harshness of contrast, and a poor, weak, washed-out, ineffective result, as unpleasing to the educated as to the uneducated eye.

Again, say, the picture is one as artistic, of a fine intellectual male head, starting from the surface with its bright high lights and strongly-marked vigorous shadows. Place behind this a pale, delicately-rendered background, and it immediately becomes a sooty and offensive affair, which few would even tolerate and none admire.*

* These remarks are, of course, as applicable to taking photographs as colouring them ; and I shall be proud and happy if any

Another warning I must also give is against introducing lights or shadows in unnatural proportions or positions, for the sake of some conventional or even otherwise legitimate effect. Shadows cannot always be soft and tender, or strong and deep : faint lights and faint shadows cannot exist together. Where the lights are broad and strong, the shades must necessarily be faint ; and with feeble lights, the shadows must be proportionately strong.* The character of the light and shade of your object, then, should regulate that of your background, if you desire your picture to be truthful, as all real art should be.

There is a kind of background frequently seen in coloured photographs, which was introduced, I believe, by some of our French and German colourists, which is thus obtained :—

A cool, but not cold, gray, bodied with white, is thinly washed over the whole,† upon this, when dry, the interior of a room, or a garden, or other out-door scene, is faintly indicated by a few smart dexterous touches of light and shade of a similar character ; a thin glaze of colour—just the merest indication of colour—is then got with a carefully-applied wash ; and,

remarks of this character which I have made or may make should induce some of our photographers to give more attention to the artistic in their studies.

* This should be remembered by such of our composition printers as use several negatives to produce one picture. It is a rule frequently violated in their compositions, in which a variety of conflicting lights and shadows may often be discovered.

† All body colours dry lighter than they appear while wet.

L

by way of finish, a little colour of a more positive
description is secured by the use of crayons, for which
purpose I can recommend nothing better than Mr.
Newman's "polycolour crayons," a few spirited touches
from which will produce an especially good effect.

It is sometimes desirable to obtain backgrounds
which are intended to embody the characteristic asso-
ciations of your subject. Thus, military men are
frequently represented with the plain of a past or
coming battle spreading behind them to the horizon,
on which the tents of an army are visible, with piled
muskets, cannon, or any other relics of, or preparation
for, the fight. A sailor loves a background of sea and
rock, or the deck of a vessel. An artist or literary man
will perhaps prefer something indicating his pursuits
or particular studies. The scientific man, that which
indicates the peculiar branch of science he most
affects. Many sitters have particular hobbies which
they especially desire to be in some way or other
associated with their portraits; and in theatrical-
character pictures, a characteristic background consi-
derably enhances the general effect. Such backgrounds
require very judicious treatment and skilful manage-
ment. Nothing must attract attention from the figure
by its undue prominence (see Maxims); and spottiness
of colour, or of light and shade, should be carefully
avoided. All the colours should be broken and sub-
dued. I might add pages of information upon this
subject, and describe many methods of securing effects

which, according to my own experience, have been very pleasing ; but, lest these articles should prove tediously long, I refrain. I shall content myself in quitting backgrounds by adding, that these should not be attempted by colourists who have no knowledge of drawing ; as by so doing they may merely spoil their more successful results in the face and figure. If you are not a good draughtsman, with due knowledge of the laws governing composition and *chiaroscuro*, you cannot do better than adhere to the plain backgrounds which I have described. Well-executed pictorial backgrounds are very seldom seen, and failures are but too generally of the greatest and ugliest.

DRAPERIES.

Having forwarded the background, it will be as well, before finishing the face, to do as much for the drapery. Now, here you have your main chance both for effecting a good arrangement of *chiaroscuro* and colour. In the treatment of this portion of your subject a great opportunity exists for the display of judgment and taste. Inelegant folds or breaks may, as I once before said, be lost in shadow, altered, or painted out ; and any details which chance to be injurious to the general effect may also be rendered less conspicuous, or altogether removed. Folds which have value for their pictorial or descriptive qualities should be preserved with the most scrupulous care ; but others, if of a superfluous character, and having a tendency to destroy the breadth,

may be destroyed. (If necessary, the printer can assist you in effecting the removal of folds too deeply marked to be readily concealed with your water colours, but this will not often be the case). The more massive, graceful, and flowing your folds, the better their effect; but their character, as expressive of texture, must never be lost in attempting to secure such qualities.

Now, with regard to the colours of your draperies: these should not be a mere matter of imitation, but rather one of careful selection and thoughtful composition; therefore, it is as well to obtain from your patron, where necessary, some latitude for your own taste and skill.

Please to lay down your brush awhile and go back to Chapter IV., which was dedicated to the consideration of the principles of colouring, and then let me chat to you upon the subject for a short time longer.

You know what the key-note is to a musical composition, of course, and its importance in the realization of harmony. Now, just as important in regard to the same result, and of exactly the same character, is the key-tone of a composition of colours: that is to say, the tone given by some predominant colour to which all the others have a subordinate relation.* Thus, supposing the key-tone be orange, any colours you introduce will be duly made to harmonise with it: the purples by becoming warmer or more red, scarlets and yellows more or less orange, greens more yellow, blues of a warm gray tone, and, in short, all colours will be

* See page 35, and Maxims 21, 24, and 82.

modified by the introduction of orange into the composition, either directly or indirectly, according to the peculiar qualities of the colours and pigments.

The harmonious effect thus obtained is preferable, I think, to the more brilliant result given by greater contrasts, or a more striking diversity and purity of colour. We find this repose and harmony characteristic of nearly all the works of nature; in the most beautiful of which we find the fewest unbroken or positive colours. Of course nature also presents us with harmonies of contrast as well as analogy; but the former are but few, very few, compared with the latter. Take, for instance, the beautiful colours flowing into and from each other in the rainbow, the clouds at sunrise or sunset, &c. In the best pictures of our greatest masters, the primary colours are very sparingly employed. But do not mistake my meaning, and neglect the important principle of variety in colour; I merely wish to impress upon your mind the importance of connecting affinities. The harmonies of analogy and of contrast have, however, been touched on in a previous chapter, and, therefore, need detain us here no longer.

I have seen some charming results from the following colours judiciously combined in their proper proportions:—

> White, pale sea green, and rose colour.
> Light yellow, purple or violet, and blue.
> Pale green or blue, yellowish white, and red.
> Orange, purplish violet, and blue.
> Pale green, purple, and pink, &c. &c.

In adopting the above arrangements, remember that the proportion of cold colour should not be large, but only just sufficient to counterbalance the warm. You should calculate their (the colours') relative degrees of power (see Maxims 10 and 98), and may consult the geometrical rules which have been adduced by various experimentalists for this purpose ; for the present take the following as a guide :—Red is to green as 5 to 11, yellow to purple as 3 to 13, while blue and orange are generally considered as of very nearly equal power (see the chapter on "Harmonious Colouring"). You will discover that certain colours must be kept apart, such as purple from red, red or green from yellow, blue from green, purple from blue, and so on ; and that too large a proportion of pure colours impart a very gaudy and inelegant appearance to your picture (see Maxim 14).

FINISHING.

Returning to the face, hatch a thin pale tint of blue (cobalt) over the receding or rounded portions of the face and about the jaws; soften the outlines of all shadows, keeping the edges cool and gray ; destroy all hardness in the lines of the eyes, mouth, hair, ear, &c., and continue working upon the flesh until, in point of roundness, gradation, softness, and fidelity of resemblance to nature, your eye is tolerably satisfied. Then work up every other part with a similar feeling and result, tenderly preserving, with extreme care, the more

subtle transitions from light to shade. If you are colouring on the salted paper, the application of the burnisher, as already described, will be frequently necessary, during progress, to keep the surface hard and smooth.

You will discover frequently that while in the light in which it was painted, your picture looks soft, smooth, and even, in the reverse light it will appear coarse and rough; to avoid which effect, in the course of your work, turn the picture upside down now and then, and even up the colours with very tender, delicate touches (taking great care not to deepen them too much), by working into the interstices. Preserve the proper proportions of depth or tone with the greatest care.

The instructions given relate to painting a fair complexion: for a darker one use, for the flesh-wash, Venetian red and Indian yellow, keeping the shadows and half-tints greenish if the complexion incline to the sallow, or purplish if the complexion possess more of the red hues. If the complexion be very dark, use a little burnt sienna or yellow ochre in the flesh-wash. [See previous remarks upon the half-tints and shadows of flesh, and also the " Maxims."] It would be so difficult, without models, to convey any idea of all the many modications of colours and tints necessary for imitating the great variety of complexions, that these few hints, with the many others already given, must suffice. With study and practice the student will duly learn to secure all the effects of nature; and without such aids what I have said already is more than enough for his guidance.

TINTING.

A less elaborate method of colouring, which will demand less time, knowledge, and study to secure a pleasing effect, may be adopted as follows :—

Commence by working over the retiring shadows and half-tones with washy touches of cobalt, mixed with a very little Naples yellow, making this tint more or less blue according to the character of your sitter's complexion. Then work over the deeper shadows with a little Indian red, combined with a very slight touch of vermilion. Now take a little pink madder and put the colour into the cheek, lips, &c. When these colours are dry, carry over the whole, with a light touch and a rather full brush, and general wash of raw sienna and pink madder, or Venetian red and Indian yellow, with a touch or two of Chinese white, or madder pink and Indian yellow, or what other mixture may seem best for producing the complexion to be imitated, keeping the colour clean and bright, and not too deep in tone. Whilst this is drying, a wash of any of the colours for hair which have been already given may be applied, but be careful not to use it too fluid, lest it should stray into the flesh tints and destroy their purity and beauty. The eyebrows and lashes may next be touched in with a little sepia ; or sepia, lake, and indigo mixed to a rich purplish or bluish black, preserving their softness and delicacy with the greatest care. With this last tint,

touch in, vigorously, the pupil of the eye, and outline the iris of the same with a little indigo or sepia : the former if the eye be blue or gray. A little vermilion and madder pink, or maddder pink or lake, as the model will determine, may be stippled over the lips ; and a little brown madder and pink used to strengthen the deeper portions of the shadows (used with a little gum water). With a delicate stipple now proceed to even up or deepen the tints, adding a little cobalt to the grays, a little cobalt and madder pink here and there (see previous directions with reference to the violet and blue tints in the flesh), and a little Indian red to warm out the deeper shadows. Tinted pictures are generally left with the flesh only coloured.

ORNAMENTS, DRAPERY, ETC.

Gold.—Lay in with Roman ochre ; for the shadows, use a little bistre and burnt sienna ; for the high lights, a little yellow ochre and white, with a touch of cadmium; the highest or more sparkling high lights, with a little cadmium and white ;* reflected lights, orange chrome.

Silver.—Local colour, black, white, and burnt sienna; shadows, cobalt, sepia, and madder pink ; high lights, pure white ; reflected lights, Naples yellow.

Pearls.—Local tint, ultramarine, sepia, and lake ;

* Increased brilliancy may be obtained in the high lights by laying the white on first, and glazing, when dry, with a little gamboge.

burnt sienna and ultramarine for shadows; ochre and white for reflected lights; high lights, pure white.

Lace.—It is as well to paint this over the colour it is supposed to cover, this colour being painted as if in shadow. The local colour for lace is a yellowish white, upon this place the lights with white. Use sepia with a touch of cobalt for the shades.

Feathers.—Say the feathers are white: use for the local colour, ultramarine, ochre, and madder pink; the same, deeper, for the shades; and pure white for the high lights. Carefully avoid harsh touches in laying on the lights, working with a series of faint and tender touches to preserve an appearance of feathery softness and looseness in the particles. For the stronger shadows and markings, use a little warm sepia.

Velvets.—Black velvet: local colour, black, with a little gum; lights, white, lampblack, and a touch of French blue; shadows, lake, sepia, and indigo, with gum; highest lights, white, black, and a touch of blue, using more white. Put in the fainter reflected lights with the colour for the lights, but glaze over them, when dry, a little madder brown and gamboge. Keep all the lights soft, but strong. For *Green Velvet*, use prussian blue, cadmium, and Venetian red as the local tint, laid on with a good body; use white, prussian blue, and a little gamboge for the lights; white and French blue for the highest or brightest high lights, and glaze over the whole with sag green. *Crimson Velvet;* lake and madder brown for the local colour, laid on with a good

body ; shades, lake and sepia ; high lights, white and a little vermilion ; glaze with carmine. (For a more detailed description of the method of treating velvets, refer back.)

COLOURING ON IVORY.

Photographs are produced on ivory more or less successfully by various processes ; with which, however, we have here nothing to do. In colouring them, the same process as I have already described may be adopted, avoiding all the less transparent mixtures. In working on paper, your progress will be more rapid than it can be on ivory, as, in consequence of the latter not absorbing the colours, additional care must be given to their application, lest one touch should remove that previously applied. For the same reason you will not be able to apply wash over wash, and must obtain depth of colour rather by patient repetition than at once.

The ivories are sold prepared for immediate use. Select such pieces as are not too coarse in the grain and are not of a cold, chalky, opaque appearance, but rather warm, mellow, and transparent ; a more life-like effect being got upon the latter than the former. Avoid such as have strongly marked wavy lines, and are therefore of an inferior quality, such as are of a deep yellow hue, and also such as have specks or holes, which may be easily detected if held up to the light.*

* Sometimes, when the ivory is freshly cut, its apparent quality proves deceptive in consequence of the change it soon undergoes.

As it is sometimes an advantage to prepare your own ivory, I here give the usual method of doing so. First, scrape the surface well with an eraser* to remove the saw marks. Then take a mixture of tripoli and water, and with a small glass muller even up the surface by rubbing the tripoli on the ivory with a firm pressure and a circular motion. Finish with a piece of good cork and some very fine cuttle-fish powder, and wash clean with pure water.

The Ivory is prepared for painting by being fastened to a piece of Bristol board at the four corners with gum. The board should be thin, as it is liable to warp when thick, and so affect the ivory.

The Colours are best taken from an ivory palette, because the tint then presents exactly the same appearance before and after application to the miniature.

The Scraper or Lancet is an implement used for removing the colour from the surface of the ivory without the necessity of applying a wet brush, and is very useful to take out minute lights, remove touches which are too dark, &c. The point of a needle is sometimes used for the same end.

In applying the colours, nothing but experiment can show you the degree of fluidity required for this surface;

I have sometimes tumbled over an unfortunate piece of ivory of a horny peculiar nature, upon which all the colours looked dull and opaque.

* Some use fine glass paper, a fine file is also sometimes used, and sometimes an old razor.

the brush should be rather more dry than it is when used for paper ; always use a little *weak* gum water, it being a *sine quæ non* in this department.

Instead of photographing on the ivory itself, many of our miniature painters, selecting a more than usually thin and transparent piece of ivory, place a paper picture underneath it, and so begin by tracing the outline, and putting in the light and shade before colouring.* Indian red and cobalt are mixed for this purpose, or you may use madder brown. Another method sometimes adopted for getting the outline of the photograph upon the ivory is that of rubbing on the back of the unmounted picture powdered vermilion, and, placing this face upwards upon the ivory, going over the outlines with an ivory tracing-point, and so getting them transferred. Be careful, however, in using the tracer, that it has not too sharp a point, or that you do not press with too much force, as, in either case, you may scratch or indent the ivory.

Beware of dust, which is almost as troublesome to the painter on ivory as the painter in oil.

* Ivories expressly prepared for this purpose are kept by some dealers.

CHAPTER X.

COLOURING IN OIL.

I CERTAINLY think oil colours the more permanent when applied to photographs, and have good reason for believing that few water pigments remain long on such a surface without fading or changing more or less. With the most scrupulous care in choosing my pigments, and while conscientiously using none but colours of reputed permanence, I have found very few of my water-coloured photographs remain long in their original condition, and have found my own experience that of my professional friends also. The reader may have noticed the same fact in observing the specimens in water colours exhibited at the doors of photographic artists. I therefore recommend you to give attention to the lessons I am now about to commence.

It is frequently supposed that more skill and knowledge is required to colour in oil than in water; but, judging from the progress made by my own pupils in the one and the other, I think the idea altogether an erroneous one. A little may be done as easily in the one as in the other; and to do much will require about the same time, perseverance, and appli-

cation. Oil colours are not, as is commonly supposed, more opaque than water, unless you use so little medium as to apply the colours on your surface with a most unnecessary and injurious degree of solidity and thickness. Before proceeding further, it would be as well perhaps if I enter upon the explanations, &c., of a few terms, technically used by painters, in reference to oil painting.

GLAZING.

This is one of the most important of the oil-painter's methods, inasmuch as effects are produced by glazing which cannot be emulated or equalled by any other process. It represents the most valuable feature in this branch of colouring. To glaze, you apply very thin films of transparent colours, for the purpose of modifying, altering, deepening, softening, or rendering more brilliant, as the case may be, colours already applied. By glazing you may render parts cool, or warm, strengthen or decrease effects, or soften and subdue crude, hard masses of colour. Transparency can seldom be secured in a painting without its aid;— in its use it should be regarded more as a species of coloured varnish than anything else. The medium* with which you glaze should flow freely from the pencil, but not so freely as to spread beyond its intended limits; and the colours should be as transparent as possible, unless, as is sometimes the case,

* Vehicle in which colours are used.

a glaze of semi-opaque colour is essential to the desired effect.

A glaze is applied when the picture is just dry enough to prevent its being lost in the colours already on the surface: when the paint is too dry for glazing, the colours will run off as water does from a greasy surface. When this is the case, the glazings will not prove so thoroughly permanent as they would if they formed a closer union with the colours beneath; but the glaze may be made to lie even and smooth, either by breathing on the picture, applying a little poppy oil and magilp, and then wiping it off by using a few drops of alcohol with the colour, or by washing the part with a little alcohol and warm water. Glazing gives to a whole picture a more natural, mellow, and subdued appearance, destroying in a great measure its painty effect. In glazing, due attention must be given to the fact that the glazings are apt in time to assume a deeper and more yellowish tone than they have when first applied; some allowance should, therefore, be made for this fact in selecting your colours. For instance, in painting blues, they should partake rather of a purple tone than a greenish, because, otherwise, the oil in the pigment, turning yellow with time, would inevitably make the blue very green indeed, and so destroy its effect. For the same reason use as much varnish and as little oil as possible in glazing colours.

While urging upon your attention the really great importance and beauty of judiciously-applied glazings,

you must yet understand that such are in a great measure dependent upon the painting over which they are placed, which should in its turn have been executed with due reference to their after-application—the earlier colours being, with this view, lighter in tone and more opaque.

By way of hint, I may here add, that among the pictures of our great painters we find a judicious combination of solid and glazing colours best serve the purpose of permanency and lasting effect. For instance, Sir Joshua Reynolds, the beauty of whose flesh tints have been so enthusiastically praised, always depended upon his glazings. Sir Thomas Lawrence, on the contrary, seldom glazed at all. The changes undergone by the productions of both these painters are a common source of regret, while those of Vandyke, who combined impasting and glazing, are least affected by the test of time.

Some recent writers upon photographic colouring have, in their simplicity, argued that the photograph being perfect in light, shadow, and drawing, simple glazing would suffice to colour them. Without adverting to the thoroughly inartistic and unsatisfactory effect which would thus spoil a plain picture without making it a coloured one, I may tell you that such glazings would become discoloured and horny in a very few months.

M

SCUMBLING.

This is a process of glazing with thin opaque colour, and is very useful indeed to modify, subdue, soften, or alter the tone, texture, or crudeness of your painting. It is generally made use of in the second, as glazings are in the third, or finishing painting. In your background scumbling will aid you in securing the effect of atmosphere, and in all parts of your painting you will soon learn its value.

In adopting it, use the colour with a full brush, and without too much vehicle. Hard outlines may be got rid of by its use, and it serves more effectually than glazings do to destroy that painty appearance which I have before advised you to avoid. Scumbling may be adopted to alter the ground, when necessary, for the reception of fresh glazes; in which case the opaqueness is increased by the addition of white. Crude, raw colours may also be subdued by this process. Upon glazing and scumbling nearly all your richness, brilliancy, and transparency will be found dependent. Scumbling should be avoided, if possible, in the shadows. In dark photographs, however, it is necessary, although great care is requisite when using it in such parts.

IMPASTING.

Impasting, in the hands of the inexperienced photographic artist, requires such extreme care, and is so

likely to destroy the likeness, if he has not that know-
ledge of drawing which would enable him to preserve it,
that, by such, it should be but partially adopted ; and
then its effect should be obtained by continual appli-
cations, with intervals for drying after each, rather
than by laying the colours on thickly at once (see
Maxims 12 and 39). Impasting is too valuable to
be altogether dispensed with : by its aid we get more
freshness, clearness, and brilliancy ; and, moreover,
solid colour is essential for rendering permanent ; pre-
serving the beauty of your original painting, and aiding,
by contrast, the effect of transparent colours in the
shadows—its use being of course confined to the lights.
So effectual in securing brilliant high lights has this
method proved, that many are tempted to carry it
beyond reasonable limits, and lay the colour on so
thickly as to produce an actual protuberance, which,
casting its own shadow, produces a false effect, and
conveys a more prominent idea of a lump of paint
than of anything else. In large heads impasting is as
frequently done with the palette knife as the brush—
the blade being of assistance in securing a flat surface
to the pigment.

HANDLING.

To a certain extent handling may be regarded as
a mechanical quality ; but its power of securing
texture gives it also a much higher attribute, every
variety of surface having its expression secured by

certain peculiar and characteristic methods of touch. A good style of handling cannot be obtained from any source but that of experience and practice ; it may, therefore, be enough if I here advise that in the first colouring a bold, dexterous way of laying on the tints, clean and distinct, and placing each in its position with as little labour as possible, be used ; that a more careful and laborious style of pencilling follow ; and that a small pencil, with thorough attention, patience, and thoughtfulness, be adopted for the finishing.

You have to be cautious that your mode of handling does not degenerate into the mannerism of being the same for all surfaces, giving but one texture for the ruggedness of granite and the polish of marble, as is lamentably common with the vulgar "tea-boardy" productions exhibited at some of our "finish" (?) loving photographers' establishments. Hatching and stippling are useful in the last painting ; but these terms I have fully explained in the chapters devoted to water colours.

BLOOMING.

A technical term to describe the effect produced by applying a soft varnish when the surface of the picture is not thoroughly dry ; or when the operation is performed in cold damp air. It is sometimes called chilling, which is the more expressive word perhaps. To remedy such a defect, rub it off as soon as it appears, with a piece of old silk and a little poppy oil.

OILING OUT.

As there is very great danger in varnishing a picture too early,* a little drying oil is sometimes used, instead of varnish, to bring out the colours. This practice is known under the above term.

VEHICLE.

It may be as well to say that this term simply implies that varnish, oil, magilp, or other mixture, which may be used to make the colours flow from the brush.

MATERIALS, ETC.

I would advise you to purchase these in the sets sold by our respectable dealers. A box fitted complete with all the necessary materials may be procured for a small sum, and this I think the better plan. You will require the magilp; colours; sable, hog-hair, and badger brushes, both flat and round; palette, palette-knife, a glass slab and muller; a small lancet, oils, varnishes, a brush-washer, a dipper, and a mahl-stick. A rack drawing-desk, or small table easel, is best for small pictures; but for large, an ordinary easel will be required.

Palettes.—The best palette for *our* purpose is a white

* See concluding remarks on varnishing.

japanned one, because then the colours and tints appear
on the palette as they do upon the white surface of the
paper. If you use a wooden one, it should be soaked
with as much raw linseed oil as it will absorb before use.
For smaller pictures, the palette is best fastened tempo-
rarily to the desk; for larger, it is balanced on the hand
by placing the thumb through an aperture for the
purpose. It should be thin, light, and balance well.
Keep the palette cleaned regularly after use, and never
suffer the pigments to harden upon its surface. Two or
three China tiles, a few inches square, will be of use for
tints which it is desirable to keep clean and pure, as in
working other colours on the palette some mixture may
inadvertently be so soiled as to be of serious consequence
to the beauty of your colouring.

The Glass Muller and Slab.—The slab of ground
glass (fitted into a wooden frame) and a muller are used
to regrind the colours before applying them to your
palette—a practice which I recommend you to adopt, as
more delicacy and smoothness will naturally be looked
for in pictures so small as photographs usually are, than
would be expected in large ones on canvas.

Mahl-stick or Hand-rest.—This is used to steady the
hand or arm in putting in minute work; and so shield
the surface which, being in a wet state, does not permit
the hand to touch it. For smaller photographs, it is
best to use a piece of wood, a few inches longer than the
breadth of the picture, raised at either end by small
blocks, which enable you to lay it over such parts of the

picture as are not dry, by merely touching the desk on either side of it.

The Easel.—These are of various descriptions. The jack easel is the most convenient, and it is made large to stand alone, or small for the table: instead of the latter, I use and prefer a rack drawing-desk, to which I fasten my photographs with pins, and hang my palette on the same.*

The Dipper is a small tin cup, made to fix upon the palette. I use two, one to contain oil, and one varnish.

The Palette Knife should be thin, tapering and becoming more flexible to the end. It should also be heavier at the handle than blade. Its use is to temper and rub down the colours before use; and sometimes, as I have shown, it may be used with effect for impasting.

Brushes.—All I have said on this subject, for water colours, might here be repeated. For photographic colouring in oil, such nicety of touch is required, and such care in manipulation, that the selection of really good brushes is one very important element of success. Brushes are of hog, sable, badger, fitch, and goat hair. All of these are of service to the artist, and I am fond, myself, of having by me as great a variety of brushes as I can secure. To describe all the purposes best served by various brushes would demand too much space, although such information might prove very serviceable,

* I find a sheet of glass running in grooves on the desk, so as slide over my palette when set, a capital protection from dust.

so I will merely add, that you may begin with a few red and brown sables, of the usual sizes, and a few hog-hair tools for backgrounds.

Sable Brushes should be chosen as already directed ; and in painting such small work, I prefer, as is generally done, those made more particularly for water-colour miniatures.

Hog-hair Tools are round or flat ; they should be strongly made, and neatly finished ; the ends should be of an equal length throughout, without having been cut to such ; as, in this case, a coarse scratchy effect will be produced. You may test for this by the touch : if the ends feel flexible and soft, all is right.

Badger Tools are generally recommended, but few use them ; a clean, soft, ordinary brush answering the purpose better. A few long-haired camel-hair pencils will be useful for the purpose. The badger tool is sometimes known by the significant name of " softener," or " sweetener." If this tool be too frequently or in-cautiously used, the beginner will speedily either lose the likeness, or produce an effect usually denounced under the term " woolliness."

The Brush Washer contains turpentine for rinsing and cleaning the brushes during or after work.

The Lancet is such as miniature painters generally use, and will be of service in removing any little lumps of colour, dust, or flue that may chance to make their unpleasant appearance during progress : cleanliness, delicacy, and finish being essential for small pictures.

THE COLOURS.

Flake white	Indigo	Indian red
Naples yellow	Terra verte	Rose madder
Yellow ochre	Green oxide of chro-	Scarlet lake
Roman ochre	mium	Ultramarine
Transparent gold	Emerald green	French ultrama-
ochre	Brown pink	rine
Roman ochre	Verona brown	Cobalt
Raw sienna	Vermilion	Ultramarine ash
Brown sienna	Extract of vermi-	Black lead
Cadmium yellow	lion	Ivory black
Chrome yellow	Mars orange	Lamp black
Lemon yellow	Venetian red	Vandyke brown
Indian yellow	Madder lake	Cappagh brown
Gamboge	Crimson lake	Bitumen
Italian pink	Madder purple	Raw umber
Prussian blue	Do. brown	Burnt umber

Remarks on these colours will be found in an earlier chapter, both in regard to their working, their drying, and their chemical qualities.

Oils, Varnishes, Magilps, &c.—The word vehicle, already explained, would comprise all I now proceed to offer a few practical remarks upon. Great research and investigation have been recently devoted to this subject. Sir Humphrey Davy has done much in reference to the materials used by the ancients; and Sir Charles Eastlake has written learnedly and well upon the subject. For me, therefore, it must suffice if I confine myself to such articles as are more commonly used in absolute practice. W. B. Sarsfield Taylor's translation of M.

Mérimée's work on the *Art of Painting in Oil*, published by Whittaker and Co., Ave Maria Lane, 1839, by-the-by, will also be a most excellent work to procure. In painting in oil we meet certain difficulties, the proper combating of which (if you be an honest man) should always be made a matter of thought in your practice. Vehicles containing oil have more or less a tendency to discolour in time, and for this reason varnish and turpentine are added to as great an extent as is consistent with their proper manipulatory qualities. Being of great importance to the purity and brilliancy of your tints, the more colourless your vehicle the better; but I should prefer a vehicle which, although slightly coloured at first, underwent but little after-change, to one that, colourless to begin with, darkened upon exposure to light and air; because in the one case I might, during work, aim at counteracting its tendencies, and in the other I could not. I have before referred to the yellowish-brown, leathery appearance assumed by photographs coloured with oil glazings only, in consequence of the quantity of vehicle being in undue proportion to the amount of pigment, but without due and proper care the same defect will mar the beauty of even a solidly-painted picture. To ascertain the character of your vehicle in this respect, try it with a little white. When in old pictures you see the delicate purity of a fair face changed to a tawny yellow, some brilliant azure sky turned to dingy green, or

drapery once white, the colour of wash leather, you may set it down to the injudicious use of certain vehicles, and make up your mind to a careful and studious avoidance of such for your own work. That these defects, common as they may seem, are not absolutely inseparable from the use of oil colours, is proved by the fact that the pictures of Titian, and so many of the Venetian masters, still retain nearly all their original loveliness and purity of colour. Great attention has been recently directed into this channel, and we now have a great variety of excellent vehicles or mediums prepared and sold for use.

You have heard, perhaps, how our photographic brethren talk about collodions: one denouncing A's, but praising B's; another extolling A's, and sneering down B's; while a third laughs both to scorn, and cries " Who's equal C's ? " Now much the same thing is done by artists in . recommending vehicles; one praising this, and another that. A vehicle now much used by artists of position and talent is copal varnish thinned with turpentine. This I cannot use; but that is no reason why you should not try it. Miller's glass medium is another vehicle which many of my brother painters denounce, but which I use and like vastly: its chief defects are that it hardens very slowly, and dries rather too rapidly during work. You cannot knock the colour about with impunity in this vehicle. Its great fault is that it is a long time before you can put a second painting over your first.

But it is quite colourless; does not appear to be greatly altered by time; leaves your whites *white* and not buff, and, *when dry*, is very hard. Again, there is a "marble medium" sold for use with oil colours, by Robertson, invented by Mr. Parris (an eminent photographic colourist) for repairing Sir James Thornhill's pictures, in St. Paul's, which dries very hard, and without gloss. I have heard good photographic colourists recommend *this* medium very strongly; but wax, it should be remembered, becomes discoloured almost as readily as oil, and of this the marble medium certainly contains a large proportion.

By-the-by, I may as well seize this opportunity of reminding or informing you that oil colours are sure to become discoloured if deprived of light. For this reason it is very bad policy to shut them up in the ordinary miniature cases.

Having laid before you the disadvantages of a vehicle containing too much oil, I must now prevent you from running to the other extreme. Varnish, when used in too large a quantity, is a fruitful scource of cracking, because the oil of the last-applied colour being absorbed into that of the previous painting, the top surface drying quicker than the lower becomes rent.

It may be more fair—for, after all, not my words but your own good sense will be your better guide— to add that Haydon, and other eminent practical

writers on art, advocate the use of pure oils, "Honest Linseed" more particularly.

Magilps are mixtures in various proportions of varnish and oil, varying in their characteristics according to the nature and quality of the materials. Mastic varnish and drying or prepared linseed oil form a magilp which is sometimes called English varnish, which the amateur will find most manageable; but some painters prefer that prepared with copal varnish. Other oils are also used for the purpose.

Another vehicle, sometimes much valued by artists, is prepared with nut oil, litharge, and pure white wax. Take two parts of the first, one of the second, and a small portion of the latter, and with your slab and muller grind them well up together, diluting afterwards with a little mastic varnish.

A vehicle which unites some of the qualities of oil and water in a very useful way is made by dissolving one part of borax in twelve of boiling water, to which is added an equal portion of white lac varnish. This mixes readily with your oil colours, and dries very quickly, removing also some of the objections noticed in the use of vehicles more purely oil. (A little time since I heard of the above receipt being sold for rather large sums as " a great secret.")

There is a great variety of mediums and vehicles, some of which are admirable in use and result, but I might confuse you, perhaps, did I dwell upon them,

although I think it very necessary that you should try several vehicles, inasmuch as with some you are sure to work better than with others. For instance, one painter, experienced though he might be, would work with slow and uncertain touches: for such a painter a vehicle which dried too rapidly would be quite unsuitable, inasmuch as he would be unable to alter or retouch. Again, another who worked as slowly, but was more certain, would like his colours to dry quickly, in order that they might not be disturbed or altered by his after-touches; and so on *ad libitum.* Find, therefore, that medium which, otherwise unobjectionable, best suits your peculiar practice or facility of hand.

Varnishes.—Good varnishes should bring out the full force and brilliancy of the colours, and be hard enough to preserve the painting from injury. They are prepared chiefly from gums, or, more properly speaking, resins, dissolved in water, spirits, or oils, simple or compounded. Those more commonly used are mastic, copal, amber, and white lac.

Mastic Varnish is easily prepared by dissolving one part of the purest mastic in three of the rectified oil of turpentine, and adding one part of fine turpentine. As this varnish is frequently adulterated, and it is advantageous to use the genuine article, it may be worth while, therefore, to prepare it for yourself, when you cannot obtain it good.

Copal Varnish.—A harder varnish than the former,

but somewhat dangerous in use, and one which is very liable, from a variety of causes, to crack. To combat this peculiarity, a little linseed oil is sometimes used with the varnish; but this again is objectionable, as on the picture it then soon becomes dull and discoloured; such mixture, moreover, causes the varnish to amalgamate with the picture itself, so that there is no after-chance of ever cleaning or restoring the picture to its original condition. I recommend the use of pure mastic varnish to all who have an interest in the preservation of their work.

White Lac Varnish.—Composed of purified lac resin, dissolved in spirits of wine. The chief value of this varnish lies in its hardness, transparency, and absence of colour. Being a spirit varnish it, of course, requires warmth to assist in its application. The amateur will experience so much difficulty in using it, that he will be scarcely wise to undertake the management of a material so intractable; but it may be used in preparing the photograph for the reception of your oil colours, and it can be applied as follows:—Warm the surface of the photograph; then pour a little varnish into a saucer, and apply rapidly and lightly with a soft linen rag, which has also been warmed. In a few seconds it will be hard and firm enough so work upon. This varnish has another use in photographic colouring, by which I have seen excellent results obtained, even in the hands of very inferior colourists. Wash in the flesh, as already described with water colours, and when this is done,

varnish as above; when, by simply glazing the whole
with oil colours, somewhat of the richness and bril-
liancy of oil may be obtained with the transparent
character of mere water-colour washes. The picture so
coloured will retain its beauty for very many years,
perhaps; although it must ultimately fade. Colourists
who, having no knowledge of drawing, do not succeed in
preserving likeness, cannot fail to retain the resemblance,
if they adopt this plan. In applying white lac varnish,
you must be careful that it is not too strong, that you do
not rub too hard, and that the painting beneath is
thoroughly dry and firm.

Amber Varnish has recently been used to some
extent, but I do not recommend it. It has all the
hardness and brilliancy of copal, but dries very slowly.

The Painting Room.—That is a pleasant sound to
me, for although folk curl their lip when they enter it,
with an outcry against the nasty smells of turpentine
and paint, it is to me a charming odorous bower—a
retreat from cares, anxieties, and annoyances—in which
I can come with wrinkled brow, and a fretful, impatient
spirit, and, sitting down to my work, grow calm, patient,
and happy, losing everything else in the absorbing
interest of my progressing picture, and feeling fresh
pleasures as, under my hand, it grows nearer and nearer
to the dear image of my aspirations. Oh! the painting
room is a charming place; and you must excuse my
digressing in its praise, although I have not the slightest
right to do so, or excuse for doing so.

I prefer that my painting room should have a northern aspect, because the light is then less variable, and we avoid the direct glare of sunlight. The window should be lofty, because a picture painted by a low light seldom looks well when seen by a toplight; and as the tone of your colouring will be affected by the amount of light you work by—pigments appearing different in a good and bad light—let the window be large.

Hang up your best works in your painting room, unless you have better work from other hands, as they will reproach you with mute eloquence whenever, from laziness, want of energy, or any other cause, you are going back instead of progressing. Whatever you do, keep the room scrupulously free from dust, which is the oil painter's greatest enemy. The room should have no carpet, but an oilcloth, which can be wiped with a damp cloth every morning. More than usual care is required in this respect when the work is so small and delicate in finish as coloured photographs are.

We have now, I think, quite disposed of the necessary implements, materials, &c., and may begin practice, in the first place choosing, as may best suit our purpose, a print to colour on.

THE PHOTOGRAPH, ETC.

It should be a good print, but not a dark or a feeble one. The whites must be pure—the half-tints good—the tone warm. It should be printed upon good albu-

menized paper, and mounted upon thick, hard, drawing-board, which has been hot-pressed.

Salisbury glue is sometimes used as a size for its preparation. Newman's preparation size is frequently preferred ; but I use isinglass dissolved in a very small proportion of water, by heat, strained through coarse linen, diluted with gin, and applied while perfectly liquid with a broad, flat brush. Once on the picture this forms a hard protective surface, not likely to be influenced by either moisture or heat ; but if it is applied too thickly, it may crack off. Having sized the picture, it should be hot-pressed or rolled.

You may take such a specimen into your painting room, which has been well dusted, and fasten it to your desk with drawing-pins, while I proceed to speak of preparing the palette. The late excellent artist, Leslie, said he hated a " starved palette," and I subscribe to this great man's opinion ; but beware of a dirty palette, with no one colour pure or distinct from another. You require a very small portion of each pigment, just a mere touch from the squeezed tube, and from these may compound your tints and hues at will.

It is usual with those who paint large pictures to vary the setting of the palette for each painting; but for ordinary photographs once setting will suffice, especially if the palette be a tolerably large one, so as to afford room enough for both the pure and the mixed colours.

No two artists may be said to use exactly the same set of tints and hues—preference, feeling, and individual peculiarities of practice, having much to do with the selection.

SETTING THE PALETTE.

Place the pigments on your palette, as described, in the following order, leaving some little space between each, in order that they may not, during work, become mixed and soiled:—

White	Extract of vermilion	Indigo
Naples yellow	Vermilion	Cobalt green
Cadmium yellow (1	Madder pink	Terre verte
and 2)	Rose madder	Emerald green
Yellow ochre	Indian red	Raw umber
Raw sienna	Madder purple	Vandyke brown
Gold ochre	Cobalt	Cappagh brown
Burnt sienna	Ultramarine	Ivory brown
Light red	Prussian blue	Blue black

TINTS FOR FLESH.

These are very numerous; but I select such as may be most frequently used. Modifications will readily suggest themselves to you during your practice.

For Fair Complexions.

White and Naples yellow.
White, cadmium yellow, and madder pink.
White, light red, and cadmium yellow.
White, vermilion, and light red.

For Darker Complexions.

White and yellow ochre.
White, yellow ochre, and light red.
White, burnt sienna, and madder pink.
White, Indian red, and yellow ochre.
White, cadmium yellow, and light red.

For Ruddy Complexions.

White and light red.
White, light red, and madder pink.
White and rose madder.
White and Indian red.

FOR HALF-TINTS TO BREAK THE ABOVE.

For Fair Complexions.

White, cobalt, and Venetian red.
White, cobalt, ochre, and madder pink.
White, black, and vermilion.
White, indigo, and Venetian red.
White, light red, and emerald green.

For Darker Complexions.

White and terre verte.
White, black, and yellow ochre.
White, black, Indian red, and raw umber.

For Ruddy Complexions.

White, cobalt, and Venetian red.
White, black, and vermilion.
White and purple madder.
White, rose madder, and ultramarine.
White, Indian red, and indigo.

CARNATIONS.

For Fair Complexions.

White and vermilion.
White, vermilion, and madder pink.
White, rose madder, and light red.

For Darker Complexions.

White, cadmium and madder lake.
White and Indian red.
White, rose madder, and burnt sienna.

For Ruddy Complexions.

White and madder pink.
White, rose madder, and Indian red.
White, vermilion, and lake.

SHADE TINTS.

For Fair Complexions.

Raw umber and light red.
Madder brown and raw sienna.
Vermilion and black.

For Darker Complexions.

Indian red, raw umber, and black.
Madder brown and lake.
Vermilion and black.
Vandyke brown and lake.

For Ruddy Complexions.

Same as above, but with the reds predominating.

Before proceeding, let me give a few hints with reference to the use of these tints. In the first place, *recall the remarks upon flesh painting already given, and bear them in memory while compounding the tints given in the preceding tables.*

The great difficulty, and it is indeed a puzzling one, in teaching through such a medium as the present, lies in this fact, that, although you may give the pigments which enter into combination for the production of a given tint, hue, or shade, you cannot so easily convey an impression of the exact degree of warmth or coldness, depth, &c., which is desirable. I may, as do many, call this a cold, and that a warm colour, by way of making you understand the exact nature of the colour I wish produced ; but, then, this may be warm and that cold rather in a comparative than in a general sense; or it may possess just a certain degree of the one or the other, and that only in reference to the harmonious relationship it ought to bear to those previousiy applied. All I can do for you, unless you send me your productions, therefore, is to impress upon you the advantage of considering all I have said in previous chapters concerning flesh painting, and urge upon you the necessity of a próper amount of *keeping*. For instance, in painting a yellow complexion, let yellow, more or less enter into the composition of all your flesh colours; in painting a very fair complexion, preserve delicacy and pearliness in all your compounded hues and shades; and when engaged upon a ruddy complexion, let it be expressed

in the warmth and richness of the broken and shadow tints as well as in the purer local colours. I have said much the same thing as this before; but, by repetition in varying phrases, I hope to impress upon your mind more strongly the important and prominent points to be observed in practice, and the more common and dangerous errors to be avoided. Nothing is uglier and more inartistic than the common error of blue grays in a ruddy or yellow complexion, instead of those tending, however slightly, to purple or green. Many popular miniature painters adopt one tone for all their broken tints, making them green or blue, violet or purple, gray or brown, without the slightest reference to those of nature; following blindly some conventional idea, or triumphantly pointing, perhaps, for their authority to some fine piece of work by a fine old master, in which the varnish has turned the flesh yellow, and given all the cold grays a decidedly green or greenish tone.

Well, you have now, we will say, prepared and fastened the photograph to your desk with drawing pins; set the palette as directed; got out your brushes, finding them nicely cleaned and pointed, and given them a rinse to free them from dust. You now proceed to fasten, either above or beside the photograph you are about to work upon, two others, as—

THE GUIDES.

Most colourists use one, but I generally prefer two guides. One to aid me in my treatment of the highest

lights—the exact shape and situation of which it is vitally important to preserve; and another to assist me in securing the proper degree of gradation, transparency, and reflected lights in the shadows. By *over*-printing, the high lights may be secured in a strong dark print, although the shadows are thus destroyed; and by a little *under*-printing, the shadows of another print may be got as perfect as the negative can render them, although the more delicate half-tints may not be secured. I therefore prefer, as I have said, *two* guides—one a dark, over-printed, and the other a somewhat light, and under-printed proof. If your shadows are merely intended to be certain patches of conventional " shadow mixture," and your high lights mere chance splashes of ochre and white, why, one guide, or *none*, will be as useful to you as a dozen. If you are conscientious and ambitious, and have a real love of your art, no precaution will be thought vain that aids you in your aims. I know *too well* that photographers sometimes think a colourist's asking for *two* guides, printed expressly as guides, and, therefore, useless for any other purpose, a tremendous bore; but if they want highly-finished artistic work, and perfect resemblance, two guides are as much better than one, as one is better than none. It is true we sometimes have prints to colour in which the perfection of modelling exists, and there is nothing left to desire in the exquisite amount of gradation and truth, of both lights and shadows, when colouring such one guide is as good as a score; but such are not the

general characteristics of the prints which fall into the hands of " photographic colourists."

And now, my dear pupil, the guides being in their place, you give the photograph a final wipe with the clean piece of linen rag prepared to clean your pencils with, and sit down to begin—

PRACTICE.

I shall here adopt the same plan for directing your studies in oil, that I adopted with our water-colour practice.

Take a clean, well-chosen, and small sable pencil,* remove with it a touch of the white to a clean portion of your palette, and there mix it with a little yellow ochre, and sufficient medium to make it work with a soft creamy smoothness, without being so fluid that it will not retain the exact shape your touches give it on the photograph's polished surface.† Be very choice over this dear little bit of colour; let it be clean, bright, and perfectly smooth in working; not too decidedly yellow, unless your model's complexion be so, but rather of a creamy, delicate, ivory-like hue: if it appears at all gritty, either rub it off altogether, or rub it down, until smooth, with your palette knife.

Fill your brush well with this, and with a few

* See the directions given for choosing water-colour brushes. I use water-colour sables for oil, when the work is small.

† Some use a little wax dissolved in turpentine with their medium, to secure this quality.

light decisive touches, lay it in its place upon the brightest or highest lights, so as to preserve their precise form and position, bearing in mind all I have said about these "high lights" in former lessons, where they were more fully dwelt upon.

A little madder pink may be added to this mixture on the palette, and worked into the previously applied colour, round the edges of the high lights, with light gentle touches, and as few of them as possible. This same tint may then be worked into stronger ones, compounded of the same pigments in varying proportions (see tables of tints), until you begin to meet the earliest signs of gradation into half-tint.

But we must now pause and see what we have done.

Our colour is on the lightest part of the forehead, nose, and cheek of the illuminated side of the face; but the colour on the brow is exactly the same as that upon the nose and cheek. This must now, therefore be altered.

So we take a little bit of madder pink, and mix the same with a morsel of Venetian red on a clean portion of the palette, as before. This is a thin glazing colour, and we work it (as may be dictated by a study of the model's face,* with touches of the lightest and most careful tenderness, so as not to disturb the colour already applied) over the cheek and nose, using a kind of stipple for this purpose, or applying it by a few touches placed

* In this case, as in the directions for water, I imagine you to be working from the sitter.

here and there, according to the effect desired, *taking care not to use too much vehicle.*

Now, take another clean, dark, sable pencil, somewhat larger, give it a rinse in your brush-washer, and a wipe on your linen cloth ; a rub in the magilp, and then another wipe on the cloth, and pass it between your finger and thumb, so as to flatten and spread the hairs out. This is now your " sweetener," or " badger," and a very nice one too.

Pass this, with an extremely light sweeping touch, over the applied colour, so as to blend, smoothe, and soften, without either muddling them, rendering them too uniform in colour, or working them up. Some skill and practice will be required to do this successfully, for, though the tints are to be worked in a certain degree one into the other, each must preserve its own individuality. You must be careful, too, that the brush does not remove the colour from the surface, much of your effect depending upon the lights having a good body of colour.

The lights are now impasted with " a good body of colour," and your most luminous and brilliant flesh-tints are in their places. To preserve these clean and bright must be your care as you proceed ; so avoid teasing or muddling them. The next tints are those which delicately indicate the boundaries where the lights begin to melt faintly and imperceptibly from the local* tints

* Local tints are found neither in the lights nor the shades, but in parts intermediate, lying between the two.

into the demi-tints; and in mixing these use one touch of white and one of Venetian red, subdued slightly with a third of emerald green. Over the most tender and delicate tones of the photograph let this tint be applied in a somewhat more transparent condition, and with a rather full brush, the colour being in a nice soft pulpy condition, and free from dust or grit. That this tint may glide imperceptibly into those previously applied, with very light fairy-like touches, and with a soft-haired and not too-finely pointed brush (which might stab into and drag up the colour) work a little of the mixture of ochre, madder-pink, and white into the last-mixed tint, where its edge touches that of the previously applied. If necessary the clean brush which serves as your "badger" may be swept with one or two slight feathery touches over this to aid in softening or blending the whole; but *be very careful not to sully the purity of the lights.*

Now, by the use of tints less and less luminous, secure roundness and gradation until the retiring surfaces approach the more broken or less pure tints, and begin to fall into gradations of shade and reflected light. For this purpose sets of tints have been already described; and by mixing the few pigments given in varying proportions, such sets of tints may be increased and altered to a much larger number and variety. Their places, too, will be indicated more certainly by their appearance when thus mixed than by any directions I might endeavour to provide. In applying them,

remember that one must be so slightly different from another, that it is only when placed in juxtaposition that the effect of gradation is perceived. It is much easier to use fewer tints; and the inexperienced lover of "pretty" colour will feel somewhat loth perhaps to take a subdued or broken tint, instead of those more charming ones which were mixed for the lighted and consequently more brilliant portions of the flesh: but if he would avoid flatness and weakness, and secure roundness and life-like vigour, he must not shirk the painstaking labour of securing gradation.

Ruskin says:—"Give me some mud off a city crossing, some ochre out of a gravel pit, a little whitening, and some coal dust, and I will paint you a luminous picture, if you give me time to *graduate* my mud and subdue my dust. But though you had the red of the ruby, the blue of the gentian, snow for the light, and amber for the gold, you cannot ·paint a luminous picture if you keep the· masses of these colours unbroken in purity, and unvarying in depth."*

If you have read or practised all these lessons you ought now to know the theory which governs these demi-tints—how they change in analogy of tone and colour, as well as in depth, intensity, &c.; and here is the place to apply such knowledge practically. Thoughtful study alone can help you here. If you *consult your model and* THINK, you are all right; if you do not, I cannot, in

* See Maxims, Nos. 32—52.

these pages at any rate, lend you more assistance, or help you more effectually.

Having laid in these tints, preserving the forms of the high-lights, and graduating one tint into another to secure roundness, we next come to the shadow tints.

Now the great charm of a shadow is its transparency, which can only be secured by gradation. Some authors and painters almost lead their pupils or readers to believe that this transparency means neither more or less than the mechanically-obtained transparency of the mere pigments themselves, which, of course, is a funny mistake. The shadowed passages have the same gradations as the lighted, only the tints are subdued and of more uniform tone. Parts of the shadows will receive more or less light, either direct or reflected, and parts will be more deeply overshadowed; but detail and gradation will exist *even in the deepest shades*, although more or less distinctly, according to the amount or depth of obscurity. Few photographs have the delicate beauty in their shadows which we find in nature—a fact chiefly due to their producers neglecting the study of light and shade in connection with the peculiar conditions of the photogenic process, and those of artistic *chiaroscuro*. We now pass from the shadows into the reflections.

Reflected lights are peculiar to the shadowed surfaces merely because it is there only that they become visible. Their colour will be determined both by that of the surface which reflects them and that they are

received upon. As a rule it is best to keep them of a rich warm tone. (See preceding remarks upon the same subject.)

We now use our badger once again, feathering over the tints with it, and blending their edges, or bringing down any ridges of paint, but cautious always that the brilliant passages remain unsullied, and that no tints are rendered muddled or dirty.

Add a little drying oil to your medium; and with a little Indian red brightened with a touch of vermilion, proceed to strengthen the nostrils, the lines separating the lips, the lower edge of the upper eye-lids, the darker markings of the ear and the darkest cast shadows.

Put in the iris of the eye with dark blue, brown or gray, according to the colour of the eye itself; touch in the reflected light within the iris, and opposite the spark of direct light, and lay in the pupil with black.

Colour the lips with varying mixtures of vermilion and white, madder pink and vermillion, Indian red and lake— the last being used only for the upper lip, which will be in shadow, and must receive the same treatment, as that you have given to other surfaces in shadow. Before painting the lips, refer back to what I said of them in the articles upon touching in black and white; for it is important that you should thoroughly understand what your are about—the " reason why " as well as the " method how." *

* I am compelled to refer to past lessons very frequently, or the amount of repetition would render these articles sadly too long.

Lay in the lights of the hair with a gray harmonising in tone and depth with its local colour. The hair must grow transparent towards the parting. Its reflected lights must be rather strong, and its divisions not too deeply defined, lest it should appear wiry. You must avoid anything like a hard line where the hair meets the brow by softening the one into the other with the grays, the shadow tints and the local colour of the hair. You must, in short, never lose sight of the real character and beauty of such a material.

You have now laid in the head. The lights are clean and bright, the various tints, in harmony with local peculiarities of colour: the parts graduate by becoming less and less luminous as they melt into the retiring and broken tints, and these demi-tints, as they are called, glide just as imperceptibly into the shadows. Softness, roundness, and cleanliness should characterize your work at this stage of its progress. If, however, your inexperience has resulted, as it generally does, in a failure, take your brush-rags, wipe all the colours from the photograph, and, as the child's song says, "try, try, try again!" After each trial pause and examine your work, criticising it as impartially as you can, and rejoicing in every discovered fault, by thinking how much better it is for you to discover and remedy, than for others to discover and ridicule them. See that the half-tones which break the yellowish tints are greenish; that the delicate blues are to be found only where the skin is most white; and that the grays into which the

carnations melt, are first of a lilac, and next of violaceous tone, becoming gradually colder as they retire from such influence, or begin to be characterized by other qualities of local colour. If you are painting—as I now suppose you are—a fair complexion, see, too, that the shadows are not inharmoniously red. Observe that where the bones are in more direct contact with the skin it is indicated by a slightly yellowish tinge; that the rosy hue suffusing the cheek is not of one uniform colour, but is full of charming inequalities, and that the down on the skin is truthfully indicated by its effect in softening the illuminated passages, and spreading cool light over the shadows; that the lights on the lips glisten more brightly than those upon other parts of the face, in proportion to the amount of illumination, and so on. You may sit before your work and admire it too, if you like, providing you are resolved to pick it unmercifully to pieces afterwards.

HAIR TINTS.

Light.

White, Naples yellow, and raw umber.
White, yellow ochre, and Vandyke brown.
White, black lead, burnt sienna, and yellow ochre.
Raw sienna.
White, raw sienna, and burnt umber.

Brown.

Raw umber.
Raw umber and cappagh brown.
Cappagh brown.
Vandyke brown.

O

Dark.

Black, brown ochre, madder purple.
Vandyke brown, lake, and indigo.
Vandyke brown, black, and lake.

For the High Lights of the Hair.

White, black lead, yellow ochre, Vandyke brown.
Or the above tints mixed in various proportions.

For the High Lights of Dark Hair.

White, ultramarine, and blue black.
White, black lead, and indigo.

The grays of hair will be toned down, when dry, with local colours, and richness got in the shadows by glazings. It is sufficient for the present, therefore, to lay in the colours so as to preserve the drawing and texture, but kill the too dark colour of the photograph.

ON PAINTING THE NECK, BOSOM, AND SHOULDERS.

Supposing our specimen to be the portrait of a lady in evening costume, we should proceed to lay in the neck and bust. Here the general tone should be subdued with pearly grays, but all the tints must be very clear, clean, and delicate. From the neck towards the shoulder bones the skin displays a *faint, delicate* blush of pink; but the shoulders—influenced by the bones which there are nearer the surface—are of an

ivory-like hue and appearance. The swelling bust, as it nears the breasts, also becomes more influenced by a just perceptible tinge of the carnations, but must also indicate the pale blue tracery of the veins beneath.

Should the muscles of the neck, or the bones of the bust, be too conspicuous, you are justly licensed to soften, conceal, or modify such unpleasant passages with your best skill.

THE HANDS AND ARMS.

The colours used for the face will also be used for the arms and hands; but you will only require a few of them. Let the high lights be well impasted. The same license granted you in painting the bust also extends to the arms and hands. For further information see remarks in previous chapters.

Having got in all your flesh you must now give some attention to the background. As a plain background is all you should at present attempt, I here give the following—

LIST OF TINTS FOR PLAIN BACKGROUNDS.

Black, white, Indian red, and a little vermilion.
Black, white, and lake.
Black and burnt sienna.
Black and Indian red.
Brown ochre, white, and burnt umber.
Prussian blue, ochre, black, and white.

Terre verte, raw umber, and burnt sienna.
Black, white, and burnt umber.
Umber and yellow ochre.
Black, white, and burnt sienna.

The above will provide you with almost every necessary variety. Begin by laying in the darker portions, say with black and burnt umber, using the colour somewhat but not *too* thin, and work gradually with lighter tints towards the head. The background must not be so dark at this stage as it is intended to remain. It should be varied in colour, although harmonious in effect, relieving the head, but not cutting hard and sharp against the hair, &c. [See previous directions for the management of backgrounds, and also the Maxims.]

DRAPERY.

As I have already said much on this subject, I need now only refer to the manipulatory and mechanical methods to be adopted.

TINTS FOR DRAPERIES.

Linen.

White and blue black.
White, black, and burnt umber.
And white for the lights.

White Satin.

White.
White, raw umber, and ivory black.
White, black, and Indian red.
Brown ochre, white, and a little French blue.

Blue Satin.

Prussian blue and white.
Ultramarine and blue.
Ivory black, ultramarine, white, and a little vermilion.
Brown ochre, ultramarine, and white.

Scarlet Coats.

Crimson, lake, and king's yellow.
Crimson, lake, and vermilion.
Vermilion.
Crimson, lake, and Indian red.
Extract of vermilion.
Carmine and yellow.

Black Cloth.

Lake, Vandyke brown, and indigo.
Black, white, and a touch of Venetian red.
Black, blue, and white.

Say you are now about to paint black cloth. Make a glaze of Vandyke brown, lake, and indigo, mixed to a rich warm black, and carry it over the whole: with the same proceed to strengthen the deeper shadows. This done, lay in the lights with black, white, and a little blue: and next the intermediate tints with various proportions of black, white, and Venetian red —using the same rather warmer for the reflected lights. With white and black lay in the high lights, and then soften and blend with a dry brush as before described,

taking care all the time to preserve the photograph by laying tint for tint and shade for shade. When this first painting is dry, you may finish with the same colours, using more medium and repeating the glazings.

And now suppose you are about to paint a scarlet coat. Use for the first glaze scarlet lake ; for the high lights, orange vermilion ; for the shadows, crimson lake and vermilion ; and for the intermediate tones, vermilion, vermilion and lake, and vermilion and orange vermilion. Soften, and when the first painting is dry, finish with a glazing colour (cadmium and lake) and orange vermilion. (See previous remarks on the character of cloth.) In the same way proceed with every other material, using each colour of the exact tone and depth of that it is laid over, and you cannot go wrong.

The whole of the photograph having received colour, it may be placed aside to dry in some place perfectly free from dust ; and thus ends the first painting.

At this stage the colours in your drapery should all be bright and clean, but short of their intended force and depth, to allow for the glazings and finishing touches. There should be nothing hard about the lines and markings of the features, and the likeness should be thoroughly preserved.

THE SECOND AND THIRD PAINTING.

If the colours have become, in the interval between
the last painting and your again commencing, too hard
and dry to receive the subsequent painting, you have
only to pass over them, first a damp sponge, and when
the surface is dry, a little poppy oil to make the second
colouring unite with the first. After applying the
poppy oil it must be wiped off with a soft old silk hand-
kerchief, carefully observing that no dust or threads of
the silk adhere to the surface.

Your task in repainting is, first, to strengthen the
lights by scumbling. For this purpose you may use
white, Naples yellow, and a touch of madder lake ;
following this with white, yellow ochre, and vermilion ;
and again with white and light red.

The carnations next claim attention. For these we
use madder lake and vermilion, or madder lake and
Mars orange, with or without a little white, according
to the complexion to be imitated ; or white and Indian
red, with a very slight touch of cadmium ; or white,
raw sienna and madder lake ; and for passages retiring
into shadows, white, madder lake, and ultramarine and
white, with madder purple.

The grays may next be attended to ; and in this
branch of our work we shall find all our knowledge and
experience put to the test. The tints for grays are the
same as those given under the head of half-tints in a

previous number, mixed to a cool or warm, a greenish
or bluish, purple, or violaceous tone, according to local
requisites, or the peculiar complexion of your sitter.
The most transparent of the tints given are the better
for this stage of the picture's treatment; and all
tints are to be used thin, that is to say, with a good
supply of medium.

The half-tints may next be treated with the more
transparent tints already given, used thin.

Among the tints incidental to certain passages in
various complexions will be found the following :—·

> Ultramarine and purple lake, with light red and a little white.
> Light red and purple lake, with a little white.
> Burnt sienna, madder lake, and a little white.
> Black lead, white, and Indian red.

For strengthening the shadows use glazings of

> Indian red and madder brown.
> Purple lake and Vandyke brown.
> Crimson lake and Vandyke brown.
> Indian red and brown ochre, with a touch of black.
> Burnt sienna and purple lake.
> Vandyke brown and Mars orange.

Select from these such as may, by their tone or depth,
be most suitable to the end in view. If, in your paint-
ing, you find any passages that appear too warm or
foxy, such may be corrected by working the follow-
ing cool tints—either used thin, or by stipple—over
them :—

Terre verte and white.
 Ditto with rose madder.
Emerald green and white.
Cobalt and white.
 Ditto and Naples yellow.

In applying these tints it is especially desirable that they should be laid on at once in the right place, and with as little touches as possible. *All the warmth, transparency, brilliancy, and freshness of colours disappear when teased by much working about with the brush.* The brushes themselves must also at this stage be more particularly examined, to see that in applying one tint you do not, especially in using the same brush, destroy its purity or character by mixture with another.

The reflections should also now be strengthened, and a little pure madder lake applied by a stipple to the brighter and deeper passages of the carnations.

BACKGROUNDS.

A set of tints having been already given for plain backgrounds the following are added for those consisting of sky, or sky and landscape, &c.

Grays for Skies.

Black-lead, white, Naples yellow, and madder pink.
Brown ochre and white.
Burnt sienna, black, and white.

Indian red, cobalt, and white.
White, black, and vermilion.
Ultramarine, white, and venetian red.

Lighter Tints for Skies.

Mars orange and white.
White, vermilion, and yellow ochre.
French blue, white, and vermilion.
　Ditto with a little Naples yellow.
Black lead and white.
　Ditto with madder lake.
French blue, raw umber, and white.

For Distances.

French blue, Indian red, and white.
White, terre verte, and light red.
White, black-lead, and Naples yellow.
Indigo, Indian red, and burnt sienna.

For Foliage, &c.

Raw umber and black lead.
Blue black and Naples yellow.
Terre verte and light red.
　Ditto and brown madder.
　Ditto and burnt sienna.
Naples yellow, and raw and burnt sienna.
Terre verte, black and Naples yellow.
Yellow ochre and blue black.
Terre verte and Naples yellow, &c.

For Glazing the above.

| Yellow lake. | Raw sienna. |
| Madder brown. | Gamboge, &c. |

For Stems of Trees, &c.

Black-lead and Naples yellow.
Black and burnt sienna.

For Twigs, and Deepest Shadows.

Madder brown. | Vandyke brown.

For Stone-Work.

Black, white, and yellow ochre, or burnt umber.
Black lead and white.
Black, white, and burnt sienna.
Brown ochre, black lead and white.
Black lead and Naples yellow.

In working a sky do not get the blues too *vivid;* but keep all subdued and indefinite, blending the clouds with soft light touches of the grays and flesh-tints, and striving to secure as much as possible the effect of air and space rather than that of blue paint or a mere screen of some blue material.

ON DRAPERY.

All the rules I have given in other portions of these articles are of course generally applicable to every description of colouring.

Using the tints I shall presently give, proceed with a full pencil and transparent colour to strengthen the

darkest shades : then take the same tints, made lighter with white, for the half-shades, adding more white as they grow lighter. Next lay in the local colour ; and lastly the half-light passages, with a full pencil and rather stiff colour. After this soften and blend the tints with the light feathery touches of a clean soft brush, as before described; lay in sharp and clean, with decided touches, of the proper shape and strength indicated by " the guide," the high lights and reflections. This done, the more distinct markings of the deeper shades may be touched in with spirit and force.

The degrees of force in the lights and reflections being dependent upon the nature of the material, the guide must be carefully consulted before such are rendered.

TINTS FOR WHITE SATIN.

High Lights.

Flake white, with a touch of cobalt.

Middle Tints.

White, Naples yellow, black lead, and madder pink, lighter or darker as circumstances may depend.

Shade Tints.

White, black, and little Indian red.

Reflected Lights.

If not decided by the colour of the subject reflecting the light, these may be got with white, light red, and a little black lead.

BLUE SATIN.

High Lights.

White and prussian blue (pale).

Middle Tints.

White and prussian blue used darker, with a touch of madder pink.

Shadows.

Black lead, prussian blue, and a little madder pink.

Deepest Shadows.

Indigo, lake, and raw sienna.

Reflected Lights.

White, prussian blue, Naples yellow, and madder pink.

GREEN SATIN.

High Lights.

White and verdigris.

Middle Tints.

Prussian blue and Naples yellow.

Shadows.

Prussian blue and brown pink.

Deeper Markings.

Prussian blue and raw umber.

Reflected Lights.

Burnt sienna and prussian blue.

PINK SATIN.

High Lights.

White, madder pink, and light red, using most white.

Middle Tints.

Lake and white.

Shadows.

Indian red, vermilion, and white.

Reflected Lights.

Light red, madder pink, and white.

YELLOW SATIN.

High Lights.

King's yellow and white.

Middle Tints.

White and yellow ochre; and white with yellow ochre, a
little black lead, and madder pink.

Shadows.

Burnt sienna, raw umber, and a little black lead.

Reflected Lights.

Ochre, light red, and white.

BLACK SATIN.

High Lights.

White, black, and a touch of light red.

Middle Tints.

Ditto, with more black.

Shadows.

Black and white, with a touch of lake.

Deep Shadows.

Indigo, Vandyke brown, and lake.

Reflected Lights.

Ditto, with a little brown ochre.

And now, I think, we may leave portraiture altogether for a new branch of the art never before treated by writers on photographic colouring, although likely to become its most pleasing, popular, and attractive branch.

CHAPTER XI.

ON COLOURING PHOTOGRAPHIC LANDSCAPES.

THIS branch of the art is, strange to say, one which has been, save by some few artists for their own private gratification, little if at all practised, for I cannot regard the few lamentable failures which have been from time to time exhibited by mere "print colourers" as steps in this direction.

There is not the slightest reason why photography should not provide the drawing and light and shade of a *landscape* for the purposes of the *artistic* colourist, as well as the original sketch for a portrait. A somewhat different print must be secured it is true, because it would with water colours be absolutely impossible to secure the more luminous greens of foliage, or the delicate and tender aerial tones of the distance upon the the dark surfaces representing these in the ordinary photograph ; but a proper print may very easily be secured by the simple process of placing the sensitized paper in the pressure frame for printing with the non-sensitized surface in contact with the negative. The landscape is then printed *through* instead of *on* the paper, and the proof so secured is a faint but perfectly distinct one, giving all the detail and gradation without the intense masses of dark in the foliage, or the

strong definition and undue depth of the distance: whilst if this print be held up to the light, the landscape will then have all the vigour and force of an ordinary proof on albumenized paper. Such proofs as these are frequently produced to serve as transparencies for decorating windows, lamp shades, &c., especially when rendered more transparent by waxing or coating with mastic varnish, after being coloured in water or other colours.

A print prepared as above after receiving the broader washes and touches may be fastened to a sheet of plate glass, so that by merely holding it up to the light all the minuter details and delicate half-tones can be clearly traced and secured, although when the picture is again seen by reflected instead of transmitted light, such are indefinite and faint until strengthened and brought up to the proper depth by the painter.

The following will be found among the most useful pigments for our present purpose :—

Chinese White.	Orange chrome.	Brown pink.
Vermilion.	Cadmium yellow.	Sepia.
Rose madder.	Lemon yellow.	Olive green.
Crimson lake.	Indian yellow.	French blue.
Indian red.	Yellow ochre.	Cobalt.
Venetian red.	Raw sienna.	Payne's gray.
Light red.	Gamboge.	Indigo.
Burnt sienna.	Brown madder.	Ivory black.
Mars orange.	Purple madder.	

The brushes most in use for landscape purposes are the brown sable and camel-hair ; but the red sable is of

service for body-colour effects, especially in large works. These brushes, being of various sizes, are named after the quills which contains them, viz. :—Eagle, swan, goose, duck, and crow quill. Beside these, flat brushes will be required for large washes, and even hog-hair and fitch brushes are of frequent service for certain purposes when using body colour.

PREPARING THE PICTURE.

The picture having been previously sized in the manner before described for colouring in water, is fastened to your desk by drawing-pins, or similar means, and a faint general wash composed of brown madder, and Indian yellow or yellow ochre, is carried over the whole surface. This wash should be applied with a large soft brush, the desk or drawing-board being sloped at an angle of say forty-five degrees. Keep the colour fully supplied in the brush until you near the bottom of the picture. The wash, if the brush has not been either too full of colour or too dry, should when completed be flat, even, and of an equal depth all over.

SKIES.

This dry, a wash of clean water may be carried over the whole, and absorbed with blotting paper, to leave the surface damp, but not wet, as in this state it will receive the other washes for the sky better.

A DAYLIGHT SKY.

After preparing with the wash of ochre, take a large soft brush charged liberally with pure cobalt, not too strong, and proceed to wash downward from the top, adding water as you approach the horizon but carrying the tint well down over the distance towards your foreground.

When this second wash is dry, a third and rather stronger wash of the same with a little madder pink, may be again carried over the whole surface, merely omitting the spaces occupied by clouds, if such there be, and the high lights of the more prominent objects, but, with these exceptions, covering the whole surface from top to bottom.

The clouds now demand attention. We will suppose them to be simple in form, warm in colour, and not too massive or elaborately defined, such being most easily described. The last wash being dry, use the clean water and blotting paper once more; and while the surface is still damp, carry over the lights of your clouds a dilute mixture of cadmium and madder pink, with a very little Chinese white. Letting this dry, after softening it well off with pure water as it recedes from the illuminated passages, the thin and delicate shadows of the clouds may be laid in with cobalt and light red, by a series of faint washes, reducing the comparative size of each succeeding wash, and keeping the surface damp, in order, as I have before said, that the

edges of the washes may not be too crude and hard. In washing, carefully prevent the colour from settling in pools at any spot, as it will then dry into a disagreeable hard-edged blot very difficult to get rid of by any after-process of washing with clean water or by stippling. For the sky washes use plenty of water with your colours, obtaining the effect rather by repetition than at once. The extreme high lights of the clouds are best "taken out," that is to say, by the following means:—

Take clean water and lay it on the high lights, preserving the same shape; let it remain for a few seconds and then apply the blotting paper, when, by rubbing the surface *lightly* with a piece of crumb from a rather stale loaf of bread, the colour will be entirely removed from the space covered by the water, and the white paper may afterwards be tinted with the requisite colour or colours, say with cadmium and rose madder. To obtain very soft gradation in clouds, begin with pure water, gradually adding colour until the darker or shadowed portions are reached; and if you desire to soften off again from these, add water gradually to the tint until the desired result is obtained.

I need hardly add, that the lighter portion of the sky will be that nearest the sun.

An appearance of brilliancy and force may be secured by occasionally relieving the sprays, branches, and twigs of trees against a luminous cloud.

TABLE OF TINTS, ETC.

I will now draw up a table of the more useful combinations of colour—

For Skies and Clouds.

Cobalt or French blue (the first is more easily managed).
Cobalt, a *little* indigo, and rose madder.
Cobalt and Indian red.

For Twilight Effects.

Indigo and cobalt.
Indigo and prussian blue.
French blue, Indian red, and yellow ochre.
Indigo, cobalt, and Indian red.
Indigo and purple madder.

For Sunrise and Sunset Effects.

Cobalt and rose madder.
Purple madder and French blue.
Indian red and yellow ochre.
Yellow ochre, pure.
Yellow ochre and Indian yellow.
Cadmium yellow.
Ditto, with rose madder.
Rose madder, with purple madder.
Cadmium yellow and Indian red.
Mars orange.
Mars orange and rose madder.
Raw sienna and rose madder.
Indigo and rose madder.

FOR CLOUDS.

For Stormy or Twilight Effects (warm and cold).

Indigo and Indian red.
Indigo, lake, and sepia.
Indigo and purple madder.
Lamp black and French blue.
Lamp black and light red.
Blue black and cobalt.
French blue, purple madder, and yellow ochre.
Lamp black and lake.
Sepia and indigo.

For more delicate Effects.

Cobalt and light red.
Light red, rose madder, and cobalt.
Cobalt, yellow ochre, and Indian red.
Rose madder, raw sienna, and cobalt.
Emerald green and pink madder.
Payne's gray (used thin).
Lamp black, light red, and cobalt.

For the Illuminated Clouds, or their High Lights.

Yellow ochre and a little rose madder.
Cadmium yellow and rose madder.
Light red and yellow ochre.

For Sunset and Sunrise Clouds.

Cadmium yellow and rose madder.
Indian yellow and rose madder.
Mars orange and Rose madder.
Gamboge and rose madder

Yellow ochre and rose madder.
Light red and ditto.
Lake and ditto.
Cobalt and purple madder.
Brown madder, indigo, and cobalt.
Purple madder.

SUNSET SKIES.

Sunset clouds, when more removed from the sun's influence, are frequently of a cold gray slightly bordering upon a greenish tone; and these may be got with a mixture of cobalt, yellow ochre, and madder lake.

The exhalations or vapours arising from the earth are recognized during the morning by their yellow colour; but as the sun acquires power, they rise above the earth and merely render the blue of the sky paler as it approaches the horizon.* Towards sunset they descend, and are then most dense, especially as they near the earth, becoming first yellow and then red, the latter colour being nearest the horizon. For this reason, also, the sun when high above the horizon, and seen through a less dense and smaller body of such vapours, appears white; when lower, of a pale greenish yellow; when lower still, pure yellow; descending yet lower, it is orange; yet lower, scarlet; and still descending, becomes crimson and purple, and finally sinks from sight as a partially and faintly-visible orb of violet gray.

* The air becomes more opaque when laden with the earth's grosser exhalations, and it is, consequently, more visibly lighted.

During its descent, not only will the light change in colour and intensity, but the shadows will also lose their sharp outlines, and become gradually diffused and indistinct. Clouds will alter in colour as they retire from the sun in similar gradations, according to the density of the vapour they are seen through. It is a common mistake with amateurs working from their own imperfect ideas, instead of consulting nature, to represent clouds above the earth's exhalations strongly tinted with crimson, orange, or yellow. Only those clouds which are seen through the light-coloured exhalations really take the hues of sunset.

Where the yellow of a sunset sky blends with the blue,* a pale but not too definite tint of a cool sea-green may be introduced, such as we may see in some of Claude's celebrated effects.†

THE KINDS OF CLOUDS.

As, in painting photographic landscapes, skies and clouds have very frequently to be introduced by the painter, the following hints, as to their character and form, may be important : amateurs frequently painting in clouds which are not seen together in nature from the want of such information.

The names of the various descriptions of clouds are seven in number :—

* The blue of a sunset sky should not be too pure or intense.
† Prussian blue and light red mixed thin.

1. *Cirrus.*—Applied to clouds of a thin and transparent character, generally forming a species of network, but sometimes running in parallel or transverse directions, and always associated with a clear atmosphere and a blue sky. These clouds occupy an elevated position.

2. *Cumulus.*—Huge masses having defined forms, and broad well-marked chiaroscuro. The base of such clouds are generally more or less horizontal. When these become fleecy and less regular in form, rain is indicated.

3. *Stratus.*—Low-lying clouds

4. *Cirro-cumulus.*—Massive and rounded clouds, arranged in horizontal layers, but well detached and most frequently seen in summer weather.

5. *Cirro-stratus.*—The cloudy effect so familiarly known as a mackerel-sky is produced by these long-streaky clouds, which indicate the approach of stormy weather.

6. *Cumulo-stratus.*—The most picturesque of all clouds, with their wild fantastic shapes forming sublimely grand piles of mountainous vapours with broad effects of chiaroscuro.

7. *Nimbus.*—Generally seen in broad masses of tempestuous-looking cloud, drifting in jagged fragments before the wind, or shutting out the bright blue with their huge and gloomy masses.

The sky, whatever its character, must always harmonize and melt softly into the distance.

In painting sunset or sunrise effects, it is best to secure a photograph which gives you somewhere near the foreground a piece of water, as you thus repeat the colours of the sky, and secure a secondary light in the gloom of the darkening landscape. The water should be painted at the same time with the sky.

I have told you how the light changes as it traverses the different densities of the earth's exhalations; and you will, therefore, understand how the objects illuminated will change from golden into orange and red, until the cold grays of twilight veil the earth from the sun's last lingering rays, and the gorgeous hues of the dying light become extinguished in the gloom of coming night.

The distance in a sunset scene will fade away into the evening mist, growing more and more indistinct and soft as the objects retire from the foreground. Shadows will be in masses, and cast shadows much elongated : high lights will be small and glittering ; broader lights, luminous, rather from contrast with shade, than from their own intensity ; and, consequently, where wanting such contrast, weak and dusky.

Rays of light are sometimes seen spreading up into the sky like the folds of a gigantic fan. These may be produced by laying a piece of paper having a sharp-cut straight edge in the required direction, and gently washing away the colour with clean water and a flat camel-hair brush.

In painting clouds, remember that those nearest to

the spectator are also nearest the top of the picture, and that the more removed are near the horizon. For this reason, you must not render them all equally distinct and clear as if on one plane.

MORNING SKIES.

A morning sky differs from that of evening in the light being more yellow and less red; the mists through which the sun's light travels being much less dense or gross. The prevailing colour about the horizon, and spreading up into the sky,* therefore, will be a pale yellow: the wash for securing which may be made with Indian yellow tinged with gamboge.† For the bluish gray portion of the sky, use cobalt, with a little madder pink and light red.

Begin with the yellow wash, which is carried over the whole surface of your picture; and when this is dry, turn the picture upside down, and take the gray wash over the top of the sky, beginning with a very dilute wash, and gradually strengthen it. A clean brush with a little water may be used to render that portion of the sky which is nearest the sun lightest. The sun itself may either be scraped out with the lancet, painted in with Chinese white, or left untouched by the primary washes. Clouds are of a pale

* Be careful that this sky is not blue, which would appear crude, harsh, and unnatural so situated.

† Lemon yellow is sometimes used.

pinky or pale golden hue, and their shadow of soft, warm, delicate grays.

DISTANCES.

The vapours arising from the earth, of course, affect all objects as they retire into their depths ; so that distances always partake of the nature and colour of such to a greater or lesser degree.* When the sky is most charged with clouds and least luminous, the distance will be darkest. If lofty remote mountains close the view, remember, that, the air becoming more and more dense or opaque as it approaches the earth, the loftier portions of such will, consequently, be more distinct than their bases, which are more or less lost in vapour. Still the tops of distant mountains should not cut harsh and hard against the sky. In early morning the tops of such mountains will first catch the light.

In painting the distance you must consider that the transparent colours, being the most rich and powerful, are least fitted for it. Opaque colours are here, therefore, most frequently used.

As a general rule, the distance will be rather cold than warm in tone, although in a great degree, as I have said, dependent upon the cold or warm tint of the atmosphere through which they are visible. In the above remarks I refer to the extreme distance.

* The colour of such vapours indicating their relative degrees of density should also at once suggest the amount of detail and definition which should characterize retiring objects.

TABLES OF TINTS FOR DISTANT EFFECTS.

*Mountains or Hills.**

Rose madder and French blue.
Cobalt and rose madder.
Light red, cobalt, and rose madder.

Mountains when nearer.

Yellow ochre (for the lights).
Madder brown and French blue (for shadows), or
Yellow ochre and rose madder (for the lights) ; with
French blue, indigo, and brown madder (for the shades), or
Rose madder, cadmium yellow, cobalt, and purple madder.

Mountains if still nearer.

Brown madder and cobalt.
Light red and cobalt.
Indigo and rose madder.
French blue, rose madder, and yellow ochre.
Indian red and cobalt.
Cobalt, Indian red, and yellow ochre.
Indian red and indigo.

For distant Foliage, &c.

Yellow ochre, light red, and French blue.
Roman ochre, cobalt, and rose madder.

* " Mountains only become pure blue when there is so much air between us and them that they become mere flat shades, every detail being totally lost. They become blue when they become air, and not till then. * * * * A mass of mountain seen against the light may at first appear all of one blue, and so it is, as a whole and by comparison with other parts of the landscape ; but look how it is made up. There are black shadows in it under the crags—there are green shadows along the turf—there are gray half-lights upon the rocks, and there are faint touches of stealthy warmth and cautious light along their edges."—RUSKIN.

Yellow ochre, indigo, and light red.
Raw sienna, indigo, and Indian red.
Cobalt, raw sienna, and a little rose madder.

The latter tints may afterwards be glazed over with any of the transparent browns and yellows; such as Indian yellow, Italian pink, Mars orange, brown or purple madder, raw sienna, &c.

We will next consider the painting of water in its various conditions.

WATER.

Suppose you are painting clear bright water, rippling brightly over a pebbly bed. The small stones are indicated by marking out their shapes in the shadows dividing them, with a little sepia, and indigo. Over these pebbles then carry a wash of indigo and burnt sienna,* with some touches of madder and Vandyke browns, touched into it while wet to indicate the deeper shadows of the masses. To help the effect, let some of the stones or pebbles, be out of the water, and indicate that their companions in it are wet, by being themselves of a lighter and less glossy

* The water will be of various tints and tones, according to its nature and to the character of its bed. Indigo and brown pink, or indigo and raw sienna, will sometimes give the peculiar hue. In other cases, raw sienna and madder brown; in others, again, cobalt and burnt sienna; and, in others, brown madder and Indian yellow, or Vandyke brown and madder brown.

appearance. The bright lights of the running water with the reflections and shadows may then be got in. The first either with Chinese white,* by erasing the colour with a lancet, or by damping the surface and using stale bread as before directed ; glazing afterwards with such colours as may be suggested by the objects reflected under the modifying influence of the waters, local colours and its peculiar condition as to surface.

REFLECTIONS.

These will be lower or darker in tone, and being, of course, transparent will be more or less affected by accidental causes, such as the colour of the waters bed, weeds under the surface, &c. It must also be remembered in colouring reflections, that as they retire from the eye they vary in appearance to a larger extent than the objects themselves do according to the laws of ærial perspective (but in this case much will depend upon the purity and clearness of the water itself). In a strong light reflections become uncertain in form, and, if the sun-beams fall direct upon the surface of the water, they will then appear as mere descending rays giving no idea of the real shapes of the reflected objects.

* In thus using Chinese white, the touches must be put in quickly with a firm unhesitating touch ; a tremulous, uncertain, and slowly-given touch destroys that definite form and sharpness essential to the character or expression.

The refractions and reflections of water affect the images in different manners and degrees, but such images only present their true forms when the surface is perfectly still and undisturbed. When the water, influenced by wind or from other causes becomes broken into small waves, the sides of which vary in their inclination to the view, forms are reflected in zig-zag directions, and in colour and general appearance become distorted. In such a case the images are reflected on one side only of the waves or ridges; and it must be remembered in painting such reflections that, if the view has been so taken as to get only those sides of the waves which are farthest from the reflected objects, neither the form nor colours of such objects should be visible in the water.*

Again you must consider that broken reflections of course very much elongate the images: and yet again that the two sides of waves varying in their inclination may reflect objects of two different colours; for instance, that side of the liquid ridge which is nearest the spectator may, if the sun be behind him, repeat the rosy or golden hue of the descending luminary, while the other side may bear the hue of some reflected image or that of the sky, &c. &c.

* I am induced to extend this warning by having recently seen several drawings, in which, judging from the direction from which the wind appeared to act, and the point of sight selected, such reflections could not have been really visible, although existing in the drawings.

In painting reflections from the sky and clouds, as in representing all other reflections, remember that light objects are less changed in tone when thus repeated than darker ones are. If the water be exposed to the sky, the reflection thereof must always be considered as modifying the colour of the reflected image, just as this image is modified in tone and colour by the character and hue of the water itself.

Reflections vary according to their distance from the spectator. In some cases the whole of the object will be reflected, in others only such portions as are more immediately over the water. In the latter case only the under or shadowed portion will be visible.*

Water reflects light in proportion to its smoothness, clearness, and the amount of light it recieves, thus objects rising from its surface, recieve a strong reflected light therefrom. Objects beneath the water also reflect a certain amount of light.

CALM WATER.

On such a surface there will be no strong contrasts of light and dark (*chiaroscuro*), because, in common with all such smooth highly polished and transparent

* I am more particular in these details, because water is very seldom secured in our photographs, and the colourist has frequently to reason out what its appearance ought to be from the peculiarities of surrounding influences.

surfaces, it receives little or no shade, and that little will be discovered only where the banks meet the water's edge, (especially if clothed with overhanging foliage).

WATER AT SEA.

If you wish to procure photographs of waves in motion, in order to colour the same, I cannot do better than recommend you to Mr. S. Fry, who has some excellent negatives of such effects.

In painting these be specially careful to preserve the thin liquid transparency of such a material. I have already shown that in rough water reflections are scarcely, and frequently not at all, visible: and as these reflections are our great aids in expressing transparency, there will be found in the amateur's practice, no little difficulty in securing such a quality without them. Careful study of the photograph you are engaged upon cannot therefore be too strongly urged. And this reminds me, by-the-by, that I have omitted mentioning, that a second copy of the photograph should be procured as a guide. By raising the original against the light you may easily detect any errors in your colouring, and this, combined with the use of a guide, ought to enable you to preserve all the truth of the original.

The drawing of the waves may first be strengthened with indigo, rose, madder, and yellow ochre, and

over these may be washed any of the tints given in the following tables, the choice to be regulated by the colours of the sky or clouds above, or the sand, or rock, or weeds beneath: the former, if the water be shallow; the latter, if either of the other two be visible.

The deepest shadows, such as those found on the under portion of some overhanging wave, &c., may be put in with indigo and Vandyke brown, or sepia and raw sienna.

Foam and spray may be secured by either of the processes already described for obtaining lights.

WATER-FALLS OR CATARACTS.

These will receive a similar treatment to that adopted for expressing waves at sea.* Keep (in both cases) the edges of your washes sharp and clear, preserving the comet-like shapes of the waves, the various degrees of transparency, and the separation of the masses of falling water. The spray and foam must also have all their characteristics skilfully preserved.

* Coniston Falls, a magnificent photograph, published by Mr. Mudd, of St. Ann's Square, Manchester, is an excellent subject for colouring upon.

I will now give—

Still Water in Clear fine Weather.

Cobalt and raw sienna
Cobalt, rose madder, and raw sienna.

Still Water in Cloudy Weather.

Indian red and cobalt.
Brown madder, cobalt, and raw sienna.
Light red and indigo.
Indigo and brown madder.

For Brooks and Streams.

Raw sienna
Raw sienna and brown madder, } if yellowish.

Raw sienna and indigo,
Indian yellow, indigo, and burnt sienna, } if greenish.
Indigo and brown pink,

Cobalt and burnt sienna,
Raw sienna, cobalt, and brown madder, } if grayish.
Raw sienna, cobalt, and purple madder,

Vandyke brown and brown madder, } if brown, or very
Lake, indigo, and Vandyke brown, } dark.
Sepia, lake, and raw sienna,

For the Sea.

Raw sienna and French blue.
Raw sienna and indigo.
Raw sienna and cobalt.
Raw sienna and prussian blue, with a touch of madder pink
Bistre, prussian blue, and gamboge.

Brown madder, indigo, and raw sienna.
Cobalt and gamboge.
Indigo and Roman ochre.
French blue and cadmium yellow.
Sepia and gamboge.

For the Lights.

Yellow ochre. Raw sienna and sepia.
Raw sienna. Brown madder and raw sienna.

If under a Stormy Sky.

Cobalt and Vandyke brown.
Cobalt, with indigo.
Cobalt, with burnt sienna.
Raw umber and indigo.
Sepia and raw sienna.
Raw umber and indigo.

Of course, a judicious selection, consistent with considerations already urged, must be made from the above tables, which the student himself may soon render more comprehensive if he be an artistic observer of nature.

BOATS OR SHIPPING.

These are very important accessories, which not only help us to express the characteristics of water, but give animation and interest to the view. The rich warm browns of their pitchy sides, and the subdued and generally warm colours which their insides

have, together with the various hues of their sails, &c., help us very materially to the picturesque.

For the Outsides of Boats.

Madder brown and raw sienna.
Raw sienna and Vandyke brown.
Lake, sepia, French blue, &c.

For their various Sails.

Sepia, lake and indigo.	Yellow or Roman ochre.
Lake and indigo.	Yellow, with burnt sienna.
Light red and lamp black.	Raw umber.
Payne's gray and burnt sienna.	Burnt umber.
Burnt sienna and French blue.	Burnt sienna.
Raw sienna and brown madder.	Burnt sienna, with Indian red,
Raw sienna.	&c. &c. &c.

In concluding these remarks upon water, it must not be supposed that anything like justice has been done to such an important element of the picturesque. In all its various phases it is full of interest or beauty. Now its invading waters overflow its banks and spread widely over the landscape, and now it leaps flashingly or falls headlong over the rocks of some wild precipice, falling with a roar and dash into the foam below, and rebounding white and angry, from its flinty base, as it fills the air with misty vapour and spray. Now gushing forth in silvery rills, it veins the flowery meadows

with its gleaming threads, and now gliding, bright and
calm, over the smooth sand it scarcely seems to move,
as it lies like burnished steel under the blue and sunny
sky; rippling with a low chattering whisper, and with
soft drops of liquid music, amid the gleaming pebbles, it
is the very embodiment of all that is pure and childlike
and innocently gay and beautiful; rising in its angry
might within old ocean's spacious bed, it is sublime and
grand ; and when in peaceful rest, it spreads out its
smooth and polished lake beneath the sunny sky, what
more fitting emblem of peaceful calmness can be found !
Study it well and imitate it closely, I pray you,
for there is a world of pleasant happiness in painting
such successfully, which only the artist lover of nature
can experience or appreciate.

ROCKS.

I have seen the artist's face with a smile of soft and
tender interest upon it, while expressing on his canvass
the placid glories of some delicate passages of dis-
tances, grow suddenly stern and hard as he touched his
pencil with a firmer hand, and turned to the rugged
grandeur of some rocky foreground associated with
his subject. This indicated just the feelings to be
encouraged by the amateur beginner. If he learns
to understand the nature of every object imitated, he
will have such feelings ; and if he has such, they will
surely find expression in his work.

Different rocks of course have different characteristics, all of which must be carefully preserved in the colouring. Hills and mountains will, in certain cases, exhibit the general characteristics which are peculiar to smaller fragments of the same.

STRATIFIED ROCKS.

The most obvious difference in rocks will be found to exist in some being stratified and others not; the first will be more regular and less varied in their forms, the second most rugged and irregular. The first will be common in the abrupt breaks and pre-cipices of mountainous scenery, and are most frequently associated with water; and when vegetation has taken root and flourishes in the transverse fissures of the irregular thicknesses of layers characterizing the first, it will impart a great charm to its appearance in a picture. These layers or strata of rock sometimes form step-like descents, over which streams frequently form a series of small cascades or waterfalls; these are much loved by painters. Their fissures are angular and abrupt in shape, and serve well to contrast the graceful and drooping lines of many trees frequently seen in such localities.

The colours proper for rocks of this character are, generally speaking, cold and brownish grays, but a great variety of causes create all sorts of stains, patches, and spots. Here the rock being exposed to air, patches of

greenish gray mass may have collected, there stains of ochre and sienna may appear, &c.

GRANITE ROCKS.

These are remarkable for their huge bulky masses, and the many coloured mosses and lichens on their surface. These also are of a cool brownish or neutral gray.

LIMESTONE ROCKS.

These, from their variety of form and colour, are great favourites with the landscape artist. Their shapes are singularly varied and picturesque. Sometimes they rise in cliffs, sometimes they appear like the pendant icicles of a frozen waterfall; at other times they seem like the rudely-carved pillars and dilapidated ruins of some remotely ancient temple, here as a porous mass, there like branches of coral; and again like the basin of a natural fountain, into which the trickling water falls drip, drip, drip, a musical tinkling splash chronicling the fall of each bright drop.

Such rocks are usually associated with luxurious vegetation, and when in the foreground are delightfully effective, but their wonderful varieties of detail, &c., render them of little service, when situated in the more distant portions of your picture.

The colours of limestone rocks are greatly varied, being sometimes made up of a warm rich tints and

tones, and at others of cool grays and pale yellowish browns.

As I have not here the time or space to pursue this subject, I will at once come to a—

TABLE OF COLOURS FOR ROCKS.

Various, for Cold and Warm Effects.

Lamp black and French blue.
Lamp or blue black.
Light red and indigo.
Indigo and Indian red.
Indigo, burnt sienna, and lake.
Indigo, lake, and Indian yellow.
Emerald green and lamp black.
French blue and burnt umber.
Lake and lamp black.
Payne's gray.
Raw sienna and brown madder.
Prussian blue and raw umber.
Light red and yellow ochre.
Indigo, Indian yellow, and burnt sienna.
Brown madder.
Vandyke brown and lake.
Sepia and purple madder.
Brown pink, burnt sienna, &c. &c. &c.

To give these stray hints and tables of colour practical value, however, the student must go to nature, seeking out the sloping and shrub-bearing banks, and the huge shapeless blocks, &c., with all their diversity of water stains, weather stains, and creeping

vegetation ; their crevices, fissures, angular breaks, and cavernous hollows, their hardness, roughness, angularity, &c.

TREES.

Begin these by strengthening the broader divisions and more prominent markings of the foliage, and the details of their stems and branches. Then wash in the shadows, lights, and local colours in broad masses ; but leave the strengthening of the deeper shadows and markings. After this get in the shadows cast by projecting boughs upon parts less prominently situated. The foliage on the farther side of the tree must next claim attention. Loose sprays and leaves may be taken out, or put in with body colour where in light, and with darker and more transparent touches where in shadow. Touches of sun-light, penetrating with more or less purity through the crowded leaves, may also be secured with touches with chrome or lemon yellow, Naples yellow, or pure white, to be afterwards glazed over with transparent colour. The deep gloom under the heavier masses may now be got, preserving them cool and transparent, and deeply strong without opacity or blackness. The shadows cast by trees are of course more or less intense according to the opacity or density of the foliage.

We will now glance at the peculiarities of the various descriptions of trees, it being essential that such char-

acteristics should be scrupulously preserved, beginning
with the brave old—

OAK.

The vigorous and picturesque character of this noble
tree, with its well-defined masses of light and dark,
will be frequently found in landscape photographs. Its
foliage is of a cool olive green in summer, and is full
of warm rich colours when autumn begins to usher in
the dreary winter months.* Even when the fresh cool
colours of its polished spring leaves bedeck its then clear
and glossy boughs, the frequency of decayed twigs or
of some large, twisted, and angular old limb, severed or
blighted perhaps in a storm, render the whole extremely
picturesque. The rough furrows of its strong and
massive trunk, the wide horizontal spread of its giant
lower limbs,† render the oak conspicuous even in
the distance.‡ In spring, its leaves are of a yellowish
olive colour.

THE ELM.

A tall, stately, and graceful tree, with elegant,
sweeping, plume-like branches, and smoothly-flowing
curves; ample and spreading, but depending, and not

* The autumnal colours do not appear so soon as in other trees.
† Those nearer the top grow more upwards.
‡ Where this tree is not shut up into a confined space, it so
spreads that its width is frequently considerably greater than its
height.

so strongly marked in its characteristics as other trees. The foliage is small in leaf, devoid of gloss, and does not combine in very large masses. It is of a warm olive green. The leaves fall early. The straight stem and pendant branches are of a smooth silvery gray, varied with the pale greens, yellows, and russets of mosses and lichens. Sometimes the irregular and subdivided bark may display wen-like excrescences bristling over with minute twigs ; and its roots swelling from the ground may also display " immense spurs and fantastic knobs," but it is never altogether dark, fur-rowed, or rugged.

THE BEECH.

A large handsome tree, cheerful in colour, with smooth silvery grey bark, glossy foliage of a tender green, and pendulous boughs, the branches and spray turning gently upwards at its extremities. The foliage is especially beautiful when clad in its rich autumnal sunset tints of gold, orange, russet, and red. It must be remembered that in consequence of the deep gloom cast by its branches, the grass beneath them is generally changed to a short thick dry moss. Although its bark, like that of other trees, is frequently altogether concealed in a coat of moss and lichen, these at times make their appearance in spots and markings, which sometimes encircle the trunk, and thus aid the expression of rotundity. Poets have described the nodding beech,

wreathing "its old fantastic roots so high," with "the gray smooth trunk" gleaming out "within the twilight of their distant shades," and have dwelt lovingly upon its beauty; painters, too, have luxuriated in depicting the same from the remotest periods of "once upon a time;" but there have been and are still those who denounce it as unpicturesque and insignificant. The foliage presents a stratified appearance, the masses shelving out one over the other; but the chiaroscuro gives a large amount of breadth, which the colourist should most carefully preserve.

THE ASH—

rises with an easy flowing outline, and with light airy foliage; the boughs, sweeping elegantly forth, form almost acute angles with the trunk, and in form and arrangement resemble the branches of a lustre: the foliage assumes very graceful depending forms of an oval character, and is, in colour, of a warm olive green. Its leaves appear late and fall early. The bark is of a fine gray, broken with small furrows, and spots of gray lichens and mosses, when full grown; but while young it is of a pale greenish tint. Its autumnal tint is a bright yellow.

THE ACACIA.

The branches are somewhat stiff in appearance; the foliage feathery, light, and thin, and of a very bright cheerful green. The bark is dark and rough.

THE LIME OR LINDEN.

A tall, cultivated, somewhat formal, but beautiful tree, resembling, in its general appearance and fresh colour, the elm. Its shape partakes of the pyramidical, and the trunk is subject to wen-like excrescences.

THE BIRCH.

A most beautiful and graceful tree, its dark green feathery foliage drooping in elegant curves, and its trunk of a silvery whiteness, like the beech, frequently richly marked with spots and rings of dark warm colours.

THE WALNUT.

Somewhat resembling the oak in its branches and the ash in its foliage, which is of a rich warm colour.

THE SYCAMORE.

The trunk is rough, furrowed, seamed, and cracked, displaying a rich variety of colour. The foliage is, in summer, of a deep green, and very massive; and, in autumn, of rich dull browns and reds.

THE HORSE CHESNUT.

The foliage sombre in colour during summer, but rich in yellow and russet hues and tints in autumn.

Its general form too regular and stiff to be very picturesque, although the stem is finely shaped.

THE COMMON POPLAR.

Somewhat too formal alone, but, by contrasting other trees, it frequently becomes of great value.

THE ASPEN.

The stem gray, darker at the roots. The foliage an olive green; the under surface of the leaves being considerably lighter.

THE COMMON WILLOW AND THE OSIER.

The bark rough, the foliage of a pale silvery green. The osier, which closely resembles this tree, has leaves of a grayish or bluish green ; their under surfaces being white.

THE LARCH.

The stem tapering rapidly as it rises, is peculiarly thick at the roots. As it invariably shrinks, more or less, according to the amount of shelter from the more prevalent wind, it is frequently very much bent, and its branches then point from the wind. The foliage is of a bright and pleasant green, its spray long, slender, and very flexible.

THE HAZEL

Is more like a bush than a tree, its suckers spring up so thickly about it. The leaves are a clear warm green, the bark light in colour and rough ; its suckers and smaller branches of a warm rich brown.

THE BLACK ALDER,

More frequently found in photographs than paintings. It flourishes only in damp situations, and grows in clumps reaching a good height.* The foliage is of a dark green ; the trunk almost black.

THE HAWTHORN.

A most picturesque tree, full of excellent qualities for the painter and photographer. The twisted trunk, fantastic branches, straggling roots, and the dark cool green of the foliage, give it great value.

SCOTCH FIR.

The trunk and branches of rich warm tints of ochre, russet, and gray. The foliage, spreading out like a sombre canopy at the top, is of a dark, dull, bluish green.

* About thirty or forty feet, but sometimes many more.

R

> " The lofty fir crowns Scotland hills,
> Nor recks the winter's blast;
> His root clings firmly to the rock
> Like an anchor stout and fast."

THE ELDER.

Too common in our photographs not to be briefly
described. The foliage is of a dark warm olive, and
its blossoms, which appear in June, are a pale yellowish
white.

I must here rest contented. There is a large
variety of trees which are not mentioned ; but the limits
of this little book will not permit an extension of my
brief and imperfect list, which I, nevertheless, hope
will help the colourist so to distinguish the different
kinds of bark and foliage that he may give them their
proper colours and preserve their natural characteristics.

> " No tree in all the grove but has its charms,
> Though each its hue peculiar ; paler some,
> And of a warmish gray ; the willow, larch,
> And poplar, that with silver lines his leaf,
> And ash far stretching his umbrageous arms ;
> Of deeper green the elm, and deeper still—
> Lord of the woods—the long-surviving oak."
> COWPER.

When painting leaves in foreground foliage, remem-
ber that it is not only their flat surface, nor only their
edges, that are seen ; but endeavour to preserve the
diversity of shape and appearance which, by holding

your photograph up to the light, you will perceive is there represented.

It should not be forgetten, too, that the trees not only vary greatly with age, but that they are also affected by peculiarities of position and growth, as also by the different phases of the seasons as already hinted.

TABLES OF COLOURS FOR TREES.

A variety of Greens for Foliage from which to select.

Gamboge and indigo.
Gamboge and sepia.
Gamboge, burnt sienna, and indigo.
Cobalt, gamboge, and madder pink.
Lake, French blue, and Roman ochre.
Black and Indian yellow.
Brown pink, indigo, and lake.
Bistre and prussian blue.
Indian yellow, prussian blue, and madder lake.
Raw sienna, cobalt, and indigo.
Gamboge, brown pink, and indigo.
Olive green.
Sepia and prussian blue.
Vandyke brown and indigo.
Burnt sienna, indigo, and yellow ochre.
Indigo and yellow ochre.
Indigo, Indian yellow, and burnt sienna.

Autumnal Tints, or for Glazings.

Brown madder and gamboge.
Raw sienna and rose madder.
Burnt sienna.
Purple madder.

Brown madder.
Brown pink.
Indian yellow.
Indian yellow and Indian red.
Cobalt and Italian pink.

For Stems and Branches.

Lamp black and rose madder, ⎫
Lamp black, ⎪
Payne's gray and light red,ᵃ ⎪
Indigo, lake, and yellow ochre, ⎬ if gray.
French blue and burnt sienna, ⎪
Indian yellow, burnt sienna, and indigo, ⎪
Vandyke brown. ⎭
Brown madder.
Sepia and purple madder.

In manipulating foliage it is not necessary to obtain all the detail of the photograph, but rather to preserve and bring out the more striking and expressive features. The methods of describing the leaves are so various and numerous that I think I had better leave this bit of teaching to the photograph itself, as being by far the most practical and intelligible.

Be careful to preserve each tree's peculiarities, rather strengthening than destroying them. Some foliage hangs in pendant masses of a long, oval form ; another kind hangs in grape-like bunches ; and another juts out like over-hanging shelves. Some again point upwards in tufts or swelling masses, &c. &c.

Age affects trees, more or less, according to their

nature. In some this will be apparent in the bark only; in others, in this and the ramification of the boughs; but it is very seldom that any alteration is affected in the foliage itself.

When the sun-light reaches the supposed spectator through the sprays and thinner-clad branches of a tree, they should stand out light against dark; but if the landscape form the background, as dark against light.

FOREGROUNDS.

The foreground of a photograph will be found to require vigour and force, and it may be very largely improved by the introduction of figures and other suitable objects.

Grass may be rendered by touching in the blades as either light against dark or dark against light, according to the inequalities or chiaroscuro of the surface, sometimes making them straight, and sometimes curved and pointing in different directions. Grass bending in the wind displays a nice variety of colour, but it is generally somewhat monotonous. In colour is sometimes a bright green; and sometimes a greenish russet or gray. Grass, when seen at a distance, loses much of its brilliant green, not only because influenced by aerial perspective, but also from the fact of the smooth bright blades reflecting the colour of the sky. The monotonous colour of grass is frequently relieved with the delicate tinge of blue given by groups of the hyacinth, and by.

buttercups and other wild flowers, and also by the various colours of different species of grasses.

The Furze, Broom, and Heath plants make excellent foregrounds, especially when in flower. The former has golden blossoms, seen nearly all the year round; the latter is of a pale red purple; and the third bears large flowers of a bright yellow colour.

Ferns form the best of all good foreground plants, having beautiful forms and broad masses of colour. They are of a bright green in summer, but change to all the more gorgeous of autumnal tints very early.

The Mallow Plant.—A large, straggling, common plant, bearing groups of pink flowers. Its leaves are of a cool green, and it blossoms in July, or rather earlier.

Foxglove.—Very effective and showy. Its flowers are large, and of a purple or white colour, and appear in July.

The Burdock.—The large cool green leaves and dull purple flowers of this pyramidical plant are great favourites with the painter, and are frequently represented.

The Nettle.—Of a greenish gray colour, bearing a bright purple flower.

Dandelion.—Its general characteristics and feathery ball of seeds are too well known to need description.

In painting a foreground, proceed to wash in their local colours in broad masses. The larger masses of shadow and half-tint are next washed in, and then the

smaller details, markings, cast shadows, high lights, &c., are secured.

TABLE OF COLOURS FOR FOREGROUNDS.

Greens for Grass in Light and Shadow.

Raw sienna and indigo.
Indigo and Indian yellow.
Yellow ochre and indigo.
Indigo and gamboge.
Sepia and prussian blue.
Burnt sienna and indigo.
Burnt sienna and indigo, with Indian yellow.
Lake, yellow ochre, and indigo.
Sepia and gamboge.

For decayed Leaves in the Foreground.

Brown madder and burnt sienna.
Brown madder, with gamboge.
Brown pink.
Burnt sienna.
Burnt umber and burnt sienna.
Gamboge and Vandyke brown.
Italian pink.
Madder brown.
Rose madder and gamboge.

A gravel-pit, quarry, crumbling bank, shady hollow, lane, or winding road frequently form individually a portion of the foreground; and each have their own characteristic peculiarities of colour, which can best be learnt from nature. The following table will,

however, suffice for all the more general of such effects.

FOR BANKS AND ROADS.

Chiefly for the general Wash.

Light red and yellow ochre.
Yellow ochre.
Burnt sienna.
Sepia.
Vandyke brown.
Purple madder.
Indian red and yellow ochre.

For Darker Passages and for Shadows.

Lamp black and burnt sienna.
Lamp black and rose madder.
French blue, Indian red, and raw sienna.
Payne's gray.
Purple madder.
Indigo and light red.

FOR BUILDINGS.

Stone and similar Surfaces.

Yellow ochre.
Lamp black, raw sienna, and rose madder.
Yellow ochre and sepia.
Yellow ochre, sepia, and Payne's gray.
Raw umber.
Burnt umber.
Cobalt, light red, and yellow ochre.

Bricks or Tiles.

Burnt sienna.
Brown madder.
Light red.
Yellow ochre and Indian red.
Brown madder and Indian yellow.

Bricks or Tiles in Shadow.

Brown or purple madder and burnt sienna.
Vandyke brown, French blue, and purple madder.
Indigo and Indian red.
Lamp black and Indian red or lake.

For Wood.

Lamp black and yellow ochre.
Light red and cobalt.
Light red and indigo.
Sepia or Vandyke brown.
Raw or burnt umber.
Brown madder and French blue.
Payne's gray and burnt sienna.

For Slate.

Lamp lack.
Lake, indigo, and raw sienna.
Sepia, indigo, and lake.
Payne's gray.

For Thatch.

Brown madder and yellow ochre.
Sepia.
Sepia and yellow ochre.
Vandyke brown.
Lake and indigo.
Purple or brown madder.

ÆRIAL PERSPECTIVE.

It has always been a subject of regret with me that
photographers—misled by a love of the quality they
commonly miscall "sharpness"—should at every step of
their progress, when taking a landscape, conspire against
the extremely beautiful effects of atmosphere, thus de-
stroying the representation of space, and crowding all
the various planes of a view so closely together as to
produce a mere flat map of a scene, instead of objects
in relief and proper perspective. To remedy this
fault, when it exists in the specimen you have to colour,
should, therefore, be your first care.

The distinctness of distant objects will be dependent
upon the condition of the atmosphere. In the clear
pure air of Italy even comparatively minute objects in
the extreme distance would be easily detected; but in
the vapour-laden atmosphere of our own land receding
objects are very materially changed by the opacity and
colour of the atmosphere. Veil after veil of thin air
of a bluish gray fill the space between us and the dis-

tance, and as they accumulate in number the various objects grow more and more faint and indistinct. Mr. G. Barnard calculates that each hundred yards of space may be regarded as one such veil.

With a view to securing the effect of space, I therefore instructed you to bring the sky-colours over the distance, and well down into the landscape.

CHAPTER XII.

COLOURING IN CRAYON.

PHOTOGRAPHS coloured in crayons becoming more popular and common, now that the introduction of the solar camera has rendered large and life-size prints more easily procurable, I shall proceed to give instructions in the method to be adopted, and point out how you may command an amount of success equal to your ability and perseverance.

Crayons or pastels, assorted for portrait or landscape, are sold in boxes complete, with crayon holder, stumps, &c.* A palette of wash leather, upon which tints may be mixed before application, is also of great service.

PREPARATION OF THE PHOTOGRAPH.

The photograph should be a good, bold, vigorous print, upon plain salted paper, of a strong and coarse texture, containing little or no size. To prepare this for the crayon, it is sometimes usual to make a hot solution of gelatine, and with a large flat camel-hair brush apply it to the surface. Impalpable pumice stone, pounce, or cuttle-fish powder, may then be dusted over the print through a very fine sieve, so as to get an even tooth which will retain the powder colours and

* As in purchasing crayons you have to get not only the colours themselves, but also their various shades and tints, a very large number of crayons are required to constitute a complete set. For the flesh only, at least three dozen are required.

enable the colourist to retouch upon, without fear of removing, the first tints.

Instead of mounting the photograph on card, it should be strained upon a wooden frame, such as is used for the oil painter's canvas, the frame or stretcher having been previously covered with linen, on which the print is to be mounted with starch* or paste.

METHOD OF WORKING.

The method of manipulating pastels is so simple that but few words will suffice for its description.

The tints being arranged for the passages you are about to colour you begin to lay them in with the stump,† using it lightly and graduating from the highest lights to the shadows and reflections, without attempting to soften one into the other. If, in consequence of the opacity of your preparation mixture, and powder, or the original state of the negative, the print appears faint and indistinct, your best plan will be to begin by strengthening the outlines with a pointed red crayon,‡ and then laying in the shadows with a warm brown ; but should the print be tolerably vigorous, it will, perhaps, be better to work from the lights.

As dry colours are very vivid and bright, you will

* Starch is best, as least likely to injure your print.

† A roll of paper or leather pointed at either end.

‡ In scraping a point to your crayon do not scrape from you, as in cutting a pencil, but towards you, the chalk being then less liable to break. Use a very sharp knife.

require many cooling tints to break and subdue them. The colours must be very lightly laid, in order that they may not so destroy the character of the surface, that the after-colours no longer adhere properly.

When all the tints are laid in—side by side, mosaic wise—with the forefinger, either bare or covered with a portion of a clean white kid or doe-skin glove, rub in the colours, lightly and carefully, blended all together without weakening or enfeebling them, being careful also, that too much colour is not removed in the process. If you use a stump for this purpose instead of the finger, clean it frequently, or exchange the soiled for another fresh one, whenever there seems any danger of losing the cleanness and purity of your tints. Especial care must be used not to soil the more luminous colours of the lighted passages. The finger, however, is better than the stump when you are working flesh, in fact, nothing else is *half* so effective.

But, however careful you may have been in thus harmoniously blending the tints when they are sufficiently softened, the fresher and brighter will be sure to have become less bright and fresh, and the outlines and shadows also will have lost much of their former vigour and spirit.

You next, therefore, begin to model out the features, and recover the brilliancy and force thus lost by retouching, hatching, and stippling up the whole with the crayons themselves, touching the surface lightly and tenderly ; strengthening the lines and markings judi-

ciously, and communicating increased force and depth
to the shadows. During this portion of your work, you
should have beside you a good plain print on albumen-
ized paper as a guide. If you chance to be colouring a
large picture copied from a smaller, I would advise that
the original be also retained as a guide.

Too much must not be left to the crayon, which
should not be used alone until the stump or finger has
thoroughly done its work, nor again must you rely so
much upon the former that you lose power and relief.
A judicious combination of the crayon and the stump
must be your aim.

Where touches of a more vigorous character are
required, the harder instead of the softer crayons should
be made use of.

If, when you have first laid in the colours of the flesh,
they are judiciously graduated and softened in themselves,
there will, of course, be the less work for your stump or
finger, and the effect will be more beautiful and trans-
parent Too much working deprives them of their
freshness and brilliancy, and renders them more opaque-
looking and chalk-like.

Tints should melt, as it were, into their respective
gradations as they are laid on, rather than as they are
softened by rubbing them one into another. " The
office of the finger is only to reconcile the colours, and
give breadth to the whole by removing any crude dis-
tinctions of tone or colour that may appear."

If you are not a skilful draughtsman, and able to

recover the lost outlines, the altered forms of shadows, or the perfectly destroyed half tints, use the finger as little as you possibly can, and rely more upon assimilating the tints you apply upon the palette.

Before preparing the photograph and applying the crayons, a few broad washes of water colours are some-timer applied over the flesh, &c.*

Reserve the hightest lights and the more firmly given touches of pure colour in various passages of the flesh, until after the finishing hatch or stippling is executed with the crayon ; as these should be sharp, distinct, and clean, and without any risk of being again disturbed.

<div align="center">COLOURS USED.†</div>

The following colours are those most generally adopted for crayons :—

Black	Brunswick green	The chrome yellow
Blue black	Green oxide of chro-	Cadmium
Lamp black	mium	Gallstone
Ivory black	The umbers	Yellow ochre
Indigo	Vandyke brown	Burnt sienna ‡
Prussian blue	Cologne earth ‡	Venetian red
Smalt	White chalk	Chrome red
Cobalt	Spanish white	Chinese vermilion
Terre verte	Oxide of zinc	Carmine
Copper greens	Naples yellow ‡	The various lakes ‡
Cobalt green	Mineral yellow	

* When this is done the papers should not be so entirely without size.

† In portraiture the softest and most powdery crayons are made use of.

‡ Colours thus indicated, are more difficult of management than others.

THE COLOURS AND THEIR COMPOUNDS.*

For Flesh.

For the high lights use white, or white with a little cadmium.

For lights, use white and yellow ochre, with a little carmine; white and light red; white and vermilion; white, vermilion, and a little cadmium; white and madder; the prepared flesh tints, &c. &c. The yellows to be worked into the reds so that no one colour shall predominate.

For the local colours, use light red and yellow ochre; vermilion, madder lake, and Indian red. The lighter or stronger tones as may be suggested by the complexion imitated.

For the cheeks, &c., use selections from the various degrees of vermilion, lake, carmine, madder, Indian red, &c., blended and softened into the local colours both by previous composition and by the finger.

For the grays, use light red, prussian blue, &c., or they may be selected from the variety of grays prepared in the crayons, either pure or more or less qualified with yellow, brown, lake, or Indian red.† A few touches of

* Some of the mixtures are here given for tints are already compounded into crayons, and sold ready for use; but occasional necessitus may arise for compounding them.

† To be qualified with the colours they are placed beside or upon, in order that they may blend and harmonize to secure the keeping.

the azure or pale blue worked into the flesh tints will give the more pearly tones.*

For the shades, use raw umber, burnt umber, lake, and black. The warm browns and Cologne earth, &c., with touches of vermilion, carmine, yellow, or blue.

The strength to be dictated by the character of the head and nature of the complexion. It is best, however, always to keep the shadows more or less warm,† according to the general tone of the flesh.

For reflected lights, use burnt sienna, yellow ochre, ochre, and Indian red, &c.

For light hair, use white, the umbers, black, yellow ochre, Naples yellow, black, &c. Mixed in such proportions as may produce the desired effect.

For dark hair, use the darker tones of the above with Vandyke, Cologne earth, black, &c.

DRAPERIES, BACKGROUNDS, ETC.

The method of using the colours having now been explained, to enter into a description of all the various combinations of colour for draperies, &c., would be a tedious

* Should the gray, when applied, seem too cold or too warm, in the first case it will be touched upon with red and yellow, or, in the second place, with blue or gray.

† In my previously given instructions for powder, water, and oil colours, I have entered fully into the peculiar characteristics of various complexions and pointed out how the half-tints, shadows, grays, carnations, &c., vary therewith, I therefore need not here repeat such directions. See also the Maxims.

waste of time. Such as you see the colours in the crayon such are they on the photograph, save that where the darks of the latter are yet uncovered they *slightly* affect the purity of the tints. Mixtures, too, may very easily be tested on the palette ; and in this branch of colouring a little experience will be the chief thing necessary for your purpose. The accessories and draperies may be treated with more freedom in crayon pictures than in any other, and a broad, bold, vigorous method of laying them in will give increased effect to the softness and delicacy of the more carefully-executed flesh.

CONCLUDING HINTS.

Sometimes, when the finger or crayon has been too heavily or too frequently used, the surface becomes so smooth and greasy that great difficulty is experienced in the application of fresh colour. When this is the case the paper is rubbed very gently and carefully with cuttle-fish to restore the surface.

Another annoyance is sometimes experienced from the paper becoming loose on the strainer, and so yielding to the touch. In this case wetting the back will prove an excellent remedy.

It is best, in commencing, to keep all the tints of a warm tone and rather high in colour, as they lose much of these qualities in the softening.

If the colours do not harmonize to some extent when

first laid in, they will require too much rubbing with the finger or stump, and then some of the many evils thus engendered are sure to damp your hopes and dishearten you in your progress.

Be sure to keep a general breadth of effect rather than attempt to secure minute detail or finish, for which this process of colouring is not at all adapted, and will never answer.

A harder kind of crayon will be found useful for landscape backgrounds and similar effects.

When passages which require much force and decision in their treatment are met with, it is sometimes usual to employ with the powdered pastel a mixture of book-binders' varnish and spirits of wine. Mr. Murray, in his excellent little hand-book on this subject, recommends for the same purpose the following composition :—

> Spirits of wine, 4 oz.
> Powdered white rosin, 1 drm.
> Essential oil of spike (lavender), 1 drm.
> Camphor, 4 grs.

The whole to be carefully digested in a water-bath.

Crayon pictures must be placed under glass directly they are finished, the colours being liable to be removed by very slight causes—even a breath of wind might remove the colour where, in the more brilliant lights, the surface has been loaded by repeated applications.

Crayon pictures should be kept free from damp, out

of strong sun-light, and where they are not exposed to noxious vapours.

A good crayon should be free from grit, and work with a smooth, even surface. The softer crayons should yield colour with the lightest touch, and yet bear handling without crumbling into powder.

When a crayon appears lighter than it really is, and so is apt to deceive and mislead you, remove the outer surface with very fine glass paper, as such arises simply from the vendor having neglected this operation.

Care and systematic order are essential to success in pastel painting.

It is well to keep by you during work a damp cloth, upon which the fingers may be wiped clean now and then.

To get sharp, clean touches, merely break the crayon, and use some keen-edged portion of the fracture.

CHAPTER XIII.

CONCLUSION.

I HAVE now laid before you the garnered experience and tediously-acquired information of many years, briefly, and consequently, imperfectly; but with earnest and studious care, and with every desire to be practically useful: and I must now make my bow and ring down the curtain.

I have been very serious in my own studies, and have pursued them through very numerous and great difficulties, which—I take it—*ought* certainly to make me the better teacher.

Conflicting opinions exist with regard to the art of photographic colouring, allied as it is to an art itself not yet properly appreciated as an art, either by the great mass of its professors or the general public; but I hope I have shown how it may rise superior to such into more general and lofty appreciation.

Grateful for being received as your teacher, I can now only thank you warmly for the privilege, and retire with earnest wishes for your success in the practice of Photographic Colouring.

INDEX.

T

THOMAS PIPER, PRINTER, PATERNOSTER ROW.

The recognised Organ of the Professional and Amateur
Photographer.

The Photographic News,

A WEEKLY RECORD OF

THE PROGRESS OF THE ARTS AND SCIENCES ALLIED TO PHOTOGRAPHY.

Published every Friday, Price 3d., Stamped, 4d.

THE PHOTOGRAPHIC NEWS being devoted to the publication of all intelligence instructive or interesting to Photographers, its contents necessarily include Articles upon Chemistry, Optics, Astronomy, Mechanics, Painting, and other Arts connected with Photography ;—Reports of the various Photographic Societies ; —Notices of New Inventions and Discoveries ;—Foreign Correspondence on Scientific Subjects ; — Interesting Narratives by Travelling Photographers ; — Discussions by Correspondents on Disputed Points ;—Notes and Queries, &c. &c.

" Whether for the practical man or the deep-thinking philosopher, there are few journals more interesting than this weekly paper."—*Spectator.*

A few copies of Vols. I. and II. of THE PHOTOGRAPHIC NEWS, handsomely bound in cloth, price 8s. 6d. each, are still on sale. Also of Vol. III., price 10s. 6d.

To ADVERTISERS.—THE PHOTOGRAPHIC NEWS is circulated through appointed agents in Adelaide, Allahabad, Bombay, Boston, Calcutta, Hobart Town, Melbourne, Montreal, New York, Paris, and Sydney, and therefore affords an excellent medium for advertisements.

TERMS FOR ADVERTISING.

						£	s.	d.
Outside Page	per column	1	10	0
Inside Page	,,	1	5	0
Half Column, outside	0	17	6
,, ,, inside	0	15	0
Quarter Column, outside	0	10	0
,, ,, inside	0	8	0
Five lines and under (single column)	0	3	0	

N.B.—These prices are subject to a Discount for Repeated Advertisements.

TERMS OF PAYMENT—CASH MONTHLY.

LONDON:

PRINTED AND PUBLISHED BY THOMAS PIPER,
AT THE OFFICE, 32, PATERNOSTER ROW.

THE LITERATURE OF PHOTOGRAPHY
An Arno Press Collection

Anderson, A. J. **The Artistic Side of Photography in Theory and Practice.** London, 1910

Anderson, Paul L. **The Fine Art of Photography.** Philadelphia and London, 1919

Beck, Otto Walter. **Art Principles in Portrait Photography.** New York, 1907

Bingham, Robert J. **Photogenic Manipulation.** Part I, 9th edition; Part II, 5th edition. London, 1852

Bisbee, A. **The History and Practice of Daguerreotype.** Dayton, Ohio, 1853

Boord, W. Arthur, editor. **Sun Artists** (Original Series). Nos. I-VIII. London, 1891

Burbank, W. H. **Photographic Printing Methods.** 3rd edition. New York, 1891

Burgess, N. G. **The Photograph Manual.** 8th edition. New York, 1863

Coates, James. **Photographing the Invisible.** Chicago and London, 1911

The Collodion Process and the Ferrotype: Three Accounts, 1854-1872. New York, 1973

Croucher, J. H. and Gustave Le Gray. **Plain Directions for Obtaining Photographic Pictures.** Parts I, II, & III. Philadelphia, 1853

The Daguerreotype Process: Three Treatises, 1840-1849. New York, 1973

Delamotte, Philip H. **The Practice of Photography.** 2nd edition. London, 1855

Draper, John William. **Scientific Memoirs.** London, 1878

Emerson, Peter Henry. **Naturalistic Photography for Students of the Art.** 1st edition. London, 1889

*Emerson, Peter Henry. **Naturalistic Photography for Students of the Art.** 3rd edition. *Including* The Death of Naturalistic Photography, London, 1891. New York, 1899

Fenton, Roger. **Roger Fenton, Photographer of the Crimean War.** With an Essay on his Life and Work by Helmut and Alison Gernsheim. London, 1954

Fouque, Victor. **The Truth Concerning the Invention of Photography:** Nicéphore Niépce—His Life, Letters and Works. Translated by Edward Epstean from the original French edition, Paris, 1867. New York, 1935

Fraprie, Frank R. and Walter E. Woodbury. **Photographic Amusements Including Tricks and Unusual or Novel Effects Obtainable with the Camera.** 10th edition. Boston, 1931

Gillies, John Wallace. **Principles of Pictorial Photography.** New York, 1923

Gower, H. D., L. Stanley Jast, & W. W. Topley. **The Camera As Historian.** London, 1916

Guest, Antony. **Art and the Camera.** London, 1907

Harrison, W. Jerome. **A History of Photography Written As a Practical Guide and an Introduction to Its Latest Developments.** New York, 1887

Hartmann, Sadakichi (Sidney Allan). **Composition in Portraiture.** New York, 1909

Hartmann, Sadakichi (Sidney Allan). **Landscape and Figure Composition.** New York, 1910

Hepworth, T. C. **Evening Work for Amateur Photographers.** London, 1890

*Hicks, Wilson. **Words and Pictures.** New York, 1952

Hill, Levi L. and W. McCartey, Jr. **A Treatise on Daguerreotype.** Parts I, II, III, & IV. Lexington, N.Y., 1850

Humphrey, S. D. **American Hand Book of the Daguerreotype.** 5th edition. New York, 1858

Hunt, Robert. **A Manual of Photography.** 3rd edition. London, 1853

Hunt, Robert. **Researches on Light.** London, 1844

Jones, Bernard E., editor. **Cassell's Cyclopaedia of Photography.** London, 1911

Lerebours, N. P. **A Treatise on Photography.** London, 1843

Litchfield, R. B. **Tom Wedgwood, The First Photographer.** London, 1903

Maclean, Hector. **Photography for Artists.** London, 1896

Martin, Paul. **Victorian Snapshots.** London, 1939

Mortensen, William. **Monsters and Madonnas.** San Francisco, 1936

*__Nonsilver Printing Processes:__ Four Selections, 1886-1927. New York, 1973

Ourdan, J. P. **The Art of Retouching by Burrows & Colton.** Revised by the author. 1st American edition. New York, 1880

Potonniée, Georges. **The History of the Discovery of Photography.** New York, 1936

Price, [William] Lake. **A Manual of Photographic Manipulation.** 2nd edition. London, 1868

Pritchard, H. Baden. **About Photography and Photographers.** New York, 1883

Pritchard, H. Baden. **The Photographic Studios of Europe.** London, 1882

Robinson, H[enry] P[each] and Capt. [W. de W.] Abney. **The Art and Practice of Silver Printing.** The American edition. New York, 1881

Robinson, H[enry] P[each]. **The Elements of a Pictorial Photograph.** Bradford, 1898

Robinson, H[enry] P[each]. **Letters on Landscape Photography.** New York, 1888

Robinson, H[enry] P[each]. **Picture-Making by Photography.** 5th edition. London, 1897

Robinson, H[enry] P[each]. **The Studio, and What to Do in It.** London, 1891

Rodgers, H. J. **Twenty-three Years under a Sky-light,** or Life and Experiences of a Photographer. Hartford, Conn., 1872

Roh, Franz and Jan Tschichold, editors. **Foto-auge, Oeil et Photo, Photo-eye.** 76 Photos of the Period. Stuttgart, Ger., 1929

Ryder, James F. **Voigtländer and I:** In Pursuit of Shadow Catching. Cleveland, 1902

Society for Promoting Christian Knowledge. **The Wonders of Light and Shadow.** London, 1851

Sparling, W. **Theory and Practice of the Photographic Art.** London, 1856

Tissandier, Gaston. **A History and Handbook of Photography.** Edited by J. Thomson. 2nd edition. London, 1878

University of Pennsylvania. **Animal Locomotion. The Muybridge Work at the University of Pennsylvania.** Philadelphia, 1888

Vitray, Laura, John Mills, Jr., and Roscoe Ellard. **Pictorial Journalism.** New York and London, 1939

Vogel, Hermann. **The Chemistry of Light and Photography.** New York, 1875

Wall, A. H. **Artistic Landscape Photography.** London, [1896]

Wall, Alfred H. **A Manual of Artistic Colouring, As Applied to Photographs.** London, 1861

Werge, John. **The Evolution of Photography.** London, 1890

Wilson, Edward L. **The American Carbon Manual.** New York, 1868

Wilson, Edward L. **Wilson's Photographics.** New York, 1881

All of the books in the collection are clothbound. An asterisk indicates that the book is also available paperbound.